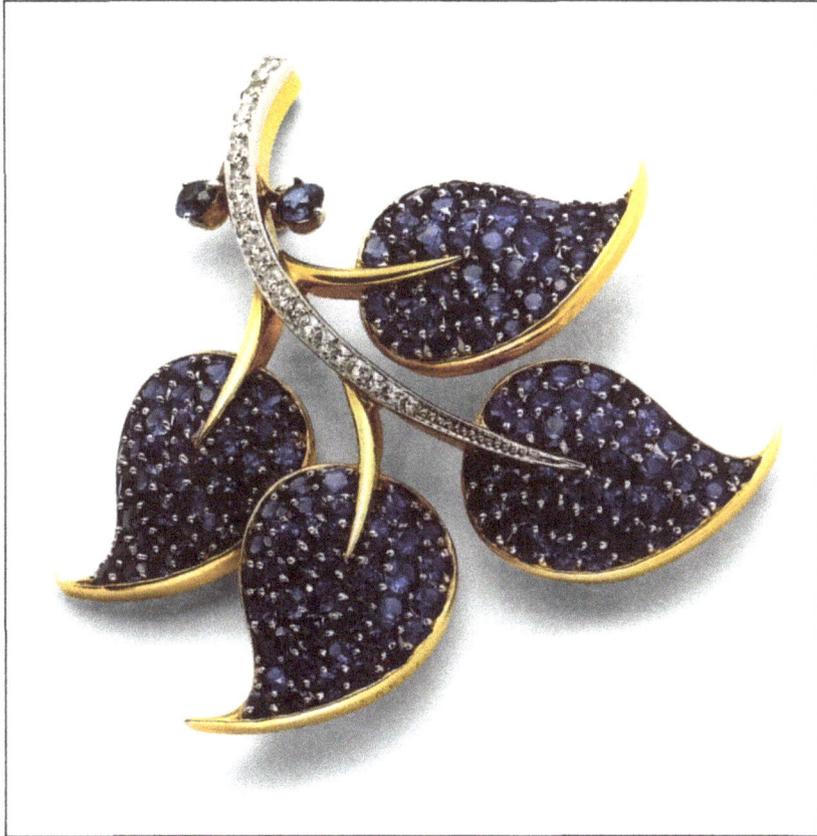

MASTERPIECES OF
AMERICAN
JEWELRY

by Judith Price,
President of the National Jewelry Institute

EPBM
ECHO POINT BOOKS & MEDIA, LLC
BRATTLEBORO, VERMONT

Published by Echo Point Books & Media
Brattleboro, Vermont
www.EchoPointBooks.com

Masterpieces of American Jewelry
ISBN: 978-1-63561-033-8 (casebound)

Interior design by Corinda Cook
Edited by Jennifer Leczkowski
This book is set using Calson, Dorchester Script, Requiem, and Univers

Cover design by Adrienne Núñez

(Contents page) Tigers
Newark Group
Patented 1902
Enamel, diamonds, and 14k gold

CONTENTS

ACKNOWLEDGMENTS

First and foremost, I would like to thank Ashton Hawkins, our Founding Board Chairman of the National Jewelry Institute for his support and encouragement during the 15 years of our history. Ashton remains a distinguished member of the arts and design community having served for decades as Executive Vice President and General Counsel of the Metropolitan Museum of Art in New York City. Joining him in our expansion over those years has been our loyal and committed Board of Directors which includes Christiane Fischer, Christopher Forbes, Edward LaPuma, and Chantal Miller.

Secondly, I would like to thank Cleo Nichols for his creativity in the installation of the exhibit *Masterpieces of American Jewelry*. I first met Cleo when he was installing an important show at the Japan Society. His mind is not just creative; he possesses the ability to "wink" at various periods at one time.

Thirdly, I would like to thank Zane White for his photography of most of the jewels. When I first met Zane and his diligent agent, Connie Saint, I realized that this exhibition and book might change the way people look at jewelry. Exactly such a reaction came from Zane when he first looked at the objects and spontaneously said, "Wow, these are things I would want to buy!"

We are most appreciative of the help from our lenders, advisors, trustees, and contributors. They include:

The American Folk Art Museum and its trustees and staff, especially Gerard Wertkin, Linda Dunne, Stacy Hollander, and Ann Marie Reilly

Cartier: Stanislas de Quercize, Oliver Stip, Bonnie Selfe, Pascale Milhaud, Renée Frank, and the late Eric Nussbaum

Tiffany & Co.: Michael Kowalski, Fernanda Kellogg, and Annamarie Sandecki

Others: Salvador Assael, David Behl, Janet Bliss, André Chervin, Jane Forbes Clark, Marion Faisel, Fred Leighton, Tiffany Miller of Corbis Photos, John Ortved, Penny Proddow, Anthony Petrillose of Condé Nast, Paul Schaffer, Peter Schaffer, Smithwick Dillon, Inc., Judy and Michael Steinhardt, Michael Stier of Condé Nast, Alice Turner, Kathleen and John Ullmann, Nishon Vartanian, Paul Vartanian, and anonymous lenders

Our Trustees: Ashton Hawkins, Chairman of the National Jewelry Institute, Hervé Aaron, Yvonne Brunhammer, André Chervin, Christopher Forbes, and Chantal Miller

Our Sponsors: Assael International, Inc., AXA Art Insurance Corporation, Cartier, Champagne Moët & Chandon, Christian Dior Couture, The Citigroup Private Bank, Sotheby's, and The Tiffany & Co. Foundation

INTRODUCTION

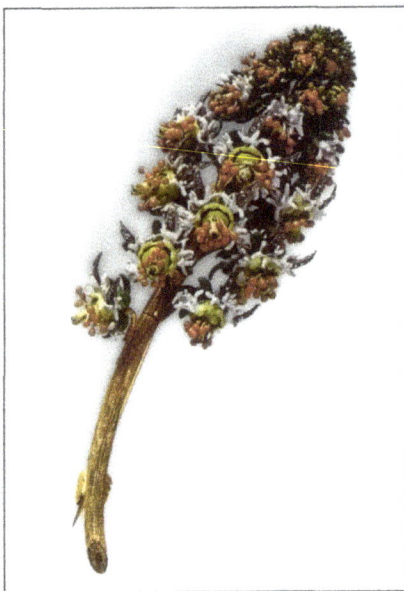

Reseda odorata Mignonette Brooch
Paulding Farnham
Tiffany & Co.
New York, 1889
H: 9 x W: 3 cm / 3¹/₂ x 1¹/₈ "

One of the great misrepresentations of jewelry is the name itself. To many, jewelry represents a lifestyle none of us will ever touch, something only for the very wealthy. But jewelry is not just for the wealthy. In fact, close to $2 billion dollars worth of 14-karat jewelry is sold every year on television through major networks like QVC. Jewelry is not out of reach, it is very near to all of us, touching the moments closest to our hearts: when we graduated from high school and received a watch, or when we had a boyfriend or girlfriend and bought a friendship ring. To most people, jewelry embodies dreams and aspirations. It is full of emotions—expressed through the engagement ring, the anniversary ring, or the jewelry commemorating the first professional success. Jewelry is not just for movie stars. Often times, want to be a part of what we see on the screen, and jewelry allows us to do so. When there is a jewelry show, we watch lines form. People buy tickets to see and experience the dream.

Jewelry is certainly not just about money. For instance, an expensive ring might be unique, or completely unoriginal. An inexpensive trinket might be one in a million. However,

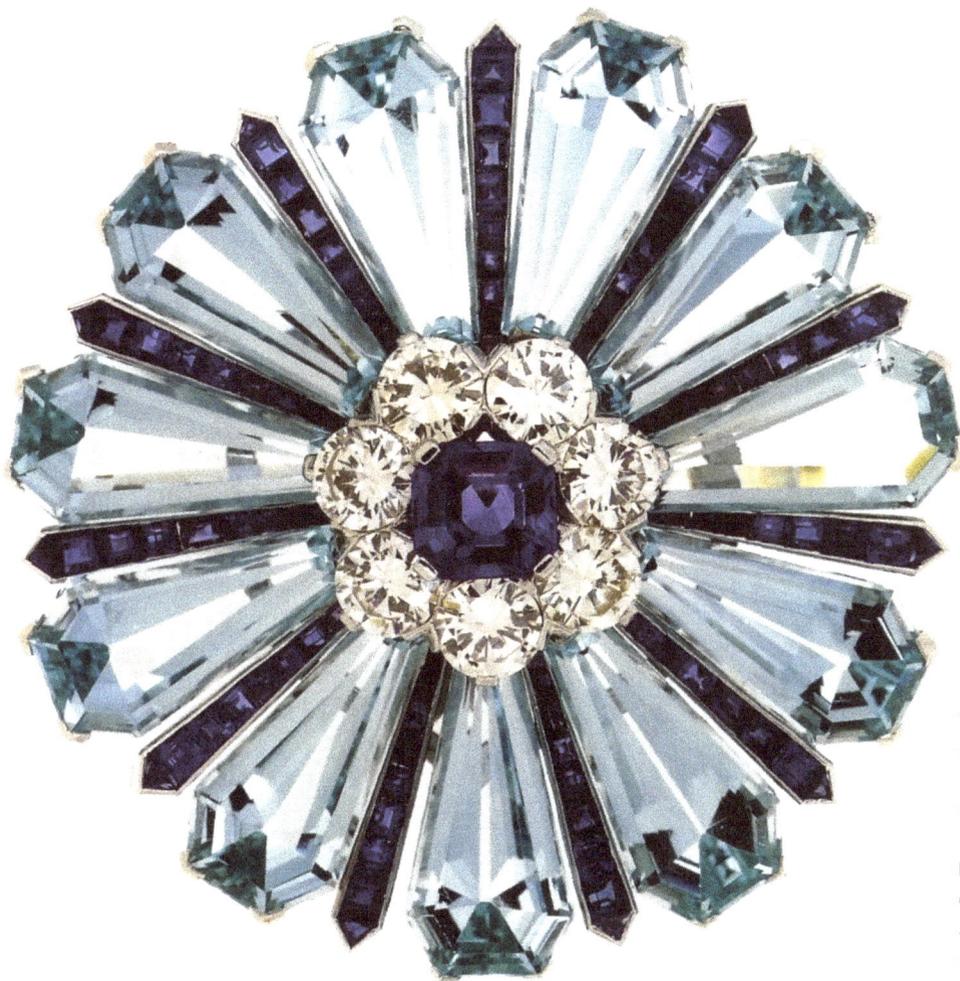

Pinwheel Brooch
c. 1950
Aquamarine, sapphire, diamond, and platinum
L: 5 x W: 5 cm / 2 x 2"

most people tend to feel better when they are spending more for a stone. In fact, the sales people in jewelry stores think of themselves as doctors or psychiatrists to their clients. Jewelry is never about the cost; it's about what it means to you.

Ideally, jewelry should set your personali-ty off, but not dominate you. It should be like a work of art you choose for your wall that shows off your personality, your temperament, and your uniqueness. Jewelry should be like architecture for the body—well-designed, reflecting your personal aesthetic, and more interesting each time you look at it.

This is not a book that merely traces the history of jewelry; rather, it will tell how jewelry, itself, chronicled the changes within American society, arts, and culture over the last 150 years. In that time, America has grown from an uncertain country into a world leader, both economically and culturally.

The enthusiasm, strength, determination, and whimsy that characterizes American society is mirrored in the jewelry worn throughout these formative times. As with the changing themes within America's history, these pieces reflect the confidence and optimism of a nation still discovering its identity.

For instance, older jewelry pieces, such as the animal brooches set with diamonds featured in the Nature section of this book, echo America's fascination with nature during the late nineteenth and early twentieth centuries. Similarly, the pieces from the 1950s in the High Style section express America's love affair with glamour and Hollywood film, an industry that had just begun to mature. Americans wanted to replicate the allure of Hollywood within their own jewelry, and therefore created timeless pieces displaying

as many jewels as possible. In the Pastimes section we see how American sports fans showed their devotion to that special team by adorning jewelry in its honor. From the silver screen to the baseball diamond, Americans have always found good reason to express themselves through jewelry.

To put the objects pictured in this book in context, included are profiles of several American women with distinctive style. These women all have one thing in common: they were models of inspiration for women of their time. Whether it be Jackie Kennedy Onassis wearing simple gold cuffs, or Georgia O'Keeffe wearing a Calder pin, we stop, look at those photos, and imagine being part of the dream. The jewelry never outshines the woman. The two, in fact, compliment one another. Their jewelry doesn't shock, doesn't bewilder,

but is eye-catching and arouses interest. We ask ourselves, why do we look up to these women? Does their jewelry represent a lifestyle all of us wanted? While their jewels don't completely define them, they certainly make us take notice. Their jewelry showcases these women as icons of American society.

It is precisely this fusion between individuality and impeccable taste that reverberates through the pages of this book. No matter the inspiration for the creation of any of these stunning pieces, their elegance transcends specific concepts to touch a greater truth. This is an American dream, found in the jewelry adorned by its citizens. Although fashion trends and ideas change throughout the times, the beauty of incredibly crafted jewels is eternal.

The concept of jewelry as inspiration for dreams is echoed in the writings of the

quintessentially American stories of F. Scott Fitzgerald. In his short story, "The Diamond as Big as the Ritz," Fitzgerald muses about jeweled masterpieces: "He would give to God, he continued, getting down to specifications, the greatest diamond in the world. This diamond would be cut with many more thousand facets than there were leaves on a tree, and yet the whole diamond would be shaped with the perfection of a stone, no bigger than a fly."

The National Jewelry Institute is a highly regarded non-profit organization established to create and support exhibitions of the most important jewelry of the eighteenth, nineteenth, and twentieth centuries. The institute, located on Fifth Avenue in New York City, also endorses the education of those studying the jewelry trade in order to perpetuate and maintain the integrity of this artistic tradition.

In this book you will find familiar names like Tiffany and Harry Winston. However, you will find many surprises like Cartier, Van Cleef, or Bulgari. These surprises occur because at some point in their history, these foreign-based jewelers decided to design, manufacture, and distribute in the United States. There are also rare exceptions where an American worked overseas but still had a profound impact on the domestic market. One such exception included is JAR—Joel Arthur Rosenthal of New York who works in Paris.

This museum exhibition spotlights the creativity and design excellence of American jewelry from its beginnings. The focus is on the past. The recent objects that are included are one of a kind and not commercially available today.

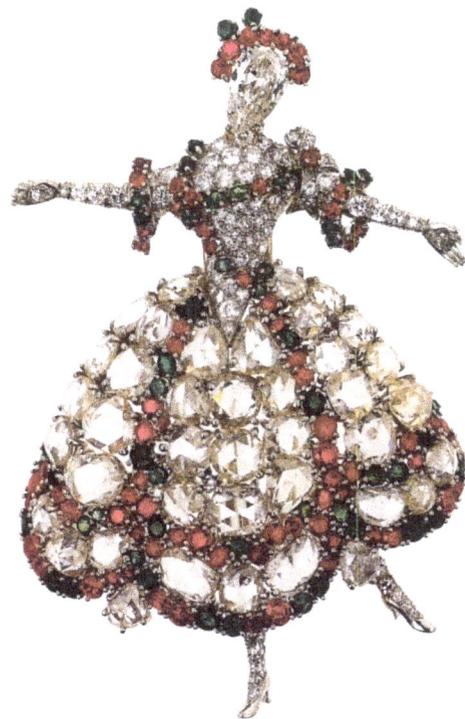

During the eighteenth century, the French genre painter Nicolas Lancret painted courtly pastimes. This Van Cleef & Arpels brooch was inspired by the famous ballerina Maria Camargo.

Ballerina of the Ballet Series
Van Cleef & Arpels
New York, 1940
Rubies, emeralds, diamonds, and platinum
H: 7 x W: 4 cm / $2^{3}/_{4}$ x $1^{3}/_{4}$"

AMERICANA

It is impossible to understand the origins of American jewelry without looking at what America stood for in those days. Before the American Revolution, the early pioneers came to a new land to escape religious persecution and create new opportunities for themselves. These early Americans were frugal, hardworking, and focused on their families. In their former land, only the aristocracy counted. In America, their new homes, and the free individual meant something. In some cases, individuals came to America to escape the law.

Thus many of these pioneers were merely "troublemakers" when they arrived on America's shores, which helped them survive the tough early frontier.

In 1781 the American Revolution ended in victory, but a second war erupted with Great Britain in 1812 over similar issues of territorial expansion. British Admiral Alexander Cochrane and General Robert Ross knew that if the British successfully attacked Washington D.C., American pride would definitely be hurt.

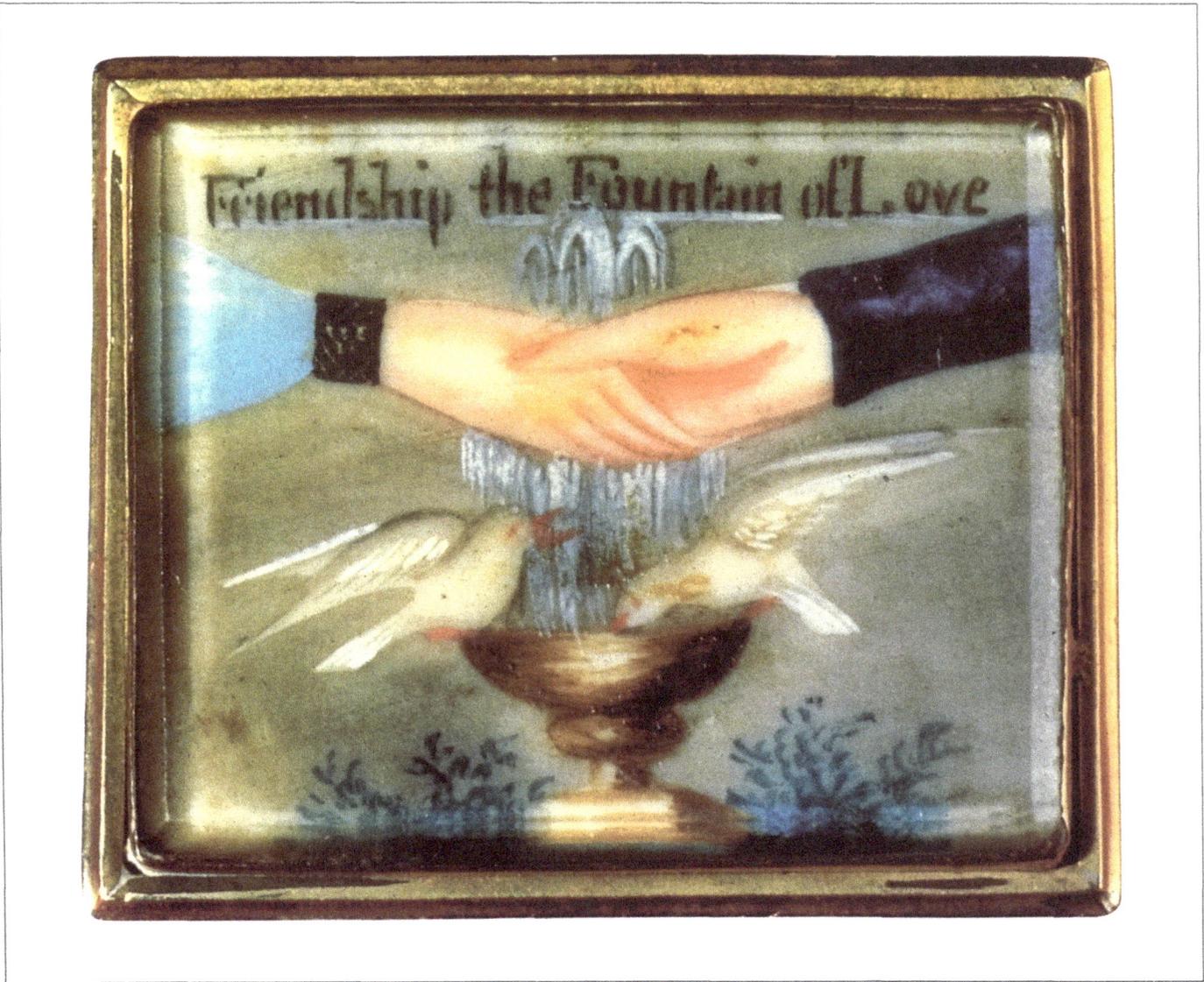

Friendship the Fountain of Love

Friendship pin with clasped hands
Unidentified Artist
United States, c. 1830–1840
Watercolor on ivory set in metal pin
⅞ x 1⅛"
Collection, American Folk Art Museum, New York
Joseph Martinson Memorial Fund
Frances and Paul Martinson 1981.12.31

13

By 1814, the British blockade kept American warships at bay. From September 7 to September 14, 1814, the British attacked Washington, D.C., Baltimore, and Alexandria, Virginia. Just before dawn on September 14, after a heavy rain, the British gave up the assault. Fort McHenry in Baltimore had not surrendered. Francis Scott Key, who was a Georgetown lawyer, was inspired by the sight of the United States flag flying over the fort. He immediately wrote a poem that became America's national anthem.

The words of the first stanza are as follows:

Oh, say can you see, by the dawn's early light,
What so proudly we hailed at the twilight's last gleaming?
Whose broad stripes and bright stars, through the perilous fight,
O'er the ramparts we watched, were so gallantly streaming?
And the rockets' red glare, the bombs bursting in air,
Gave proof through the night that our flag was still there.
O say, does that star-spangled banner yet wave
O'er the land of the free and the home of the brave?

War of 1812 scene
Unidentified Artist
United States, c. 1812
Watercolor on ivory set in metal pin
1¹⁄₄ x 1"
Collection, American Folk Art Museum, New York
Joesph Martinson Memorial Fund
Frances and Paul Martinson 1981.12.29

In short, the history of America—and the history of American jewelry—echoes in the last line of the National Anthem: "*the land of the free and the home of the brave.*" The entire history of American jewelry celebrates patriotism, and often the belief in a higher power. This developed into the optimistic American belief that we can overcome anything. We may be understaffed, or in the words of Hollywood, "outgunned," but "we shall overcome." Americans feel they will make it, and with this confidence we focus on exploring the unknown.

Despite all of the obstacles during this early time in history, the jewelry business flourished. Charles Tiffany and John Young opened shop together in 1837. Rhode Island's Gorham Company (1841) and Sheve, Crump & Co. were established (1840–1855) and became household names. In Philadelphia, J. E. Caldwell was established (1868), and in 1878, Bailey Banks & Biddle set up shop at Thirteenth Street and Chestnut. Right up to the 1960s Bailey Banks & Biddle had such a lock on Philadelphia's high society that no self-respecting matron would shop anywhere else.

In Baltimore, Samuel Kirk & Son Company opened in 1814, along with Galt and Brothers in Washington D.C. In 1867, Greenleaf & Crosby opened stores in Jacksonville, Palm Beach, and Miami, Florida, and they became one of the state's most important jewelers. In St. Louis, Louis Jacquard opened his doors in 1829, and was joined some twenty years later by his relatives, the Mermod family. And in 1837, Elijah Peacock (later to be known as C.D. Peacock) opened his jewelry store in Chicago.

Mourning Locket
Attributed to Samuel Folwell (1764–1813)
Philadelphia, Pennsylvania, 1793–1813
Watercolor on ivory set in metal locket with human hair
2½ × 1¾"
Collection, American Folk Art Museum, New York
1981.12.27

In 1894, Tiffany staged an exhibition of miniature portraits. This brooch was made in preparation of that show and depicts Maria de Medici's coronation portrait. It relates to America's interest in European history.

Maria de Medici Brooch
Tiffany & Co.
New York, 1888
Foil-backed, rock crystal, diamond,
sapphire, emerald, seed pearl,
opal, agate, enamel, and gold
H: 6.4 x W: 4.1 cm / 2.5 x 1.6"

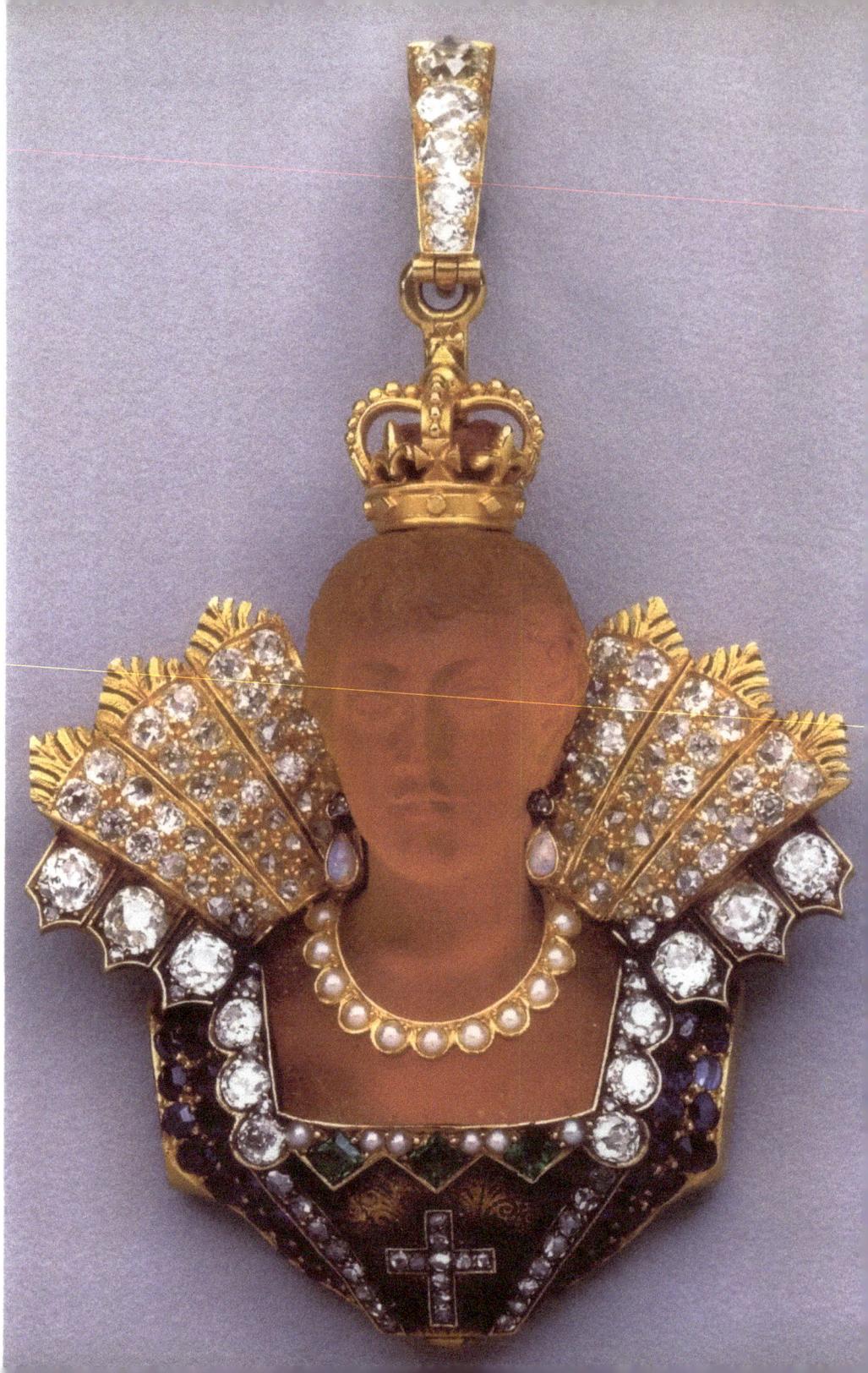

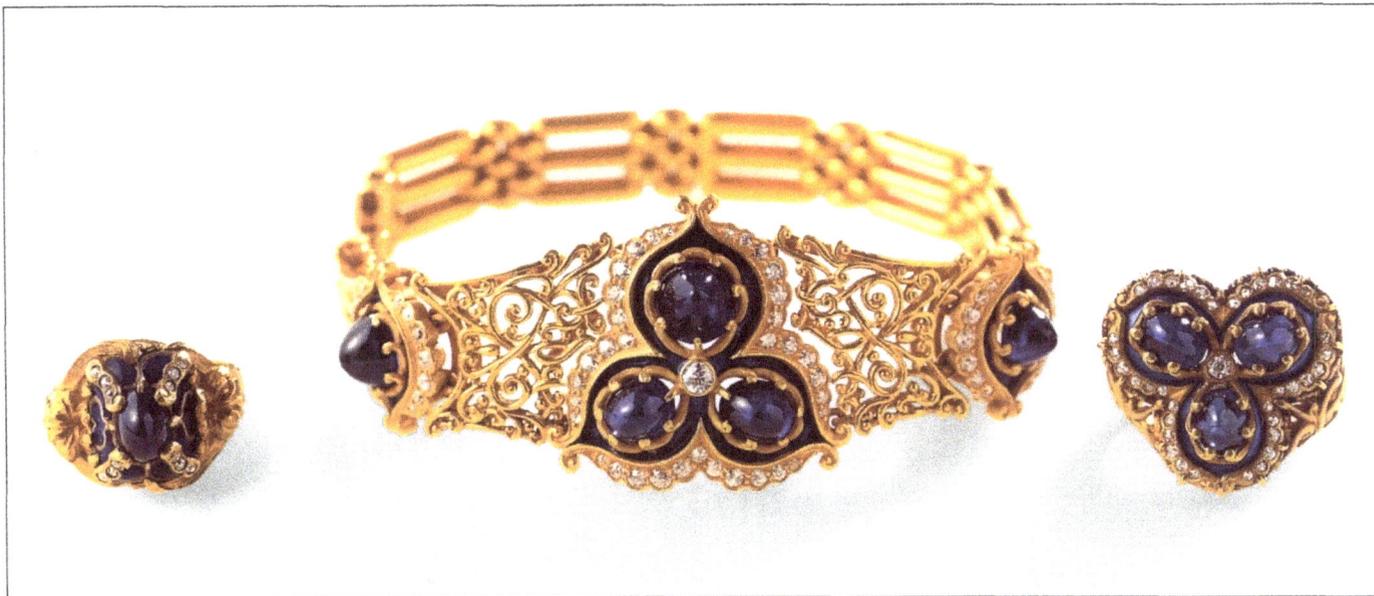

Rings and Bracelet
George E. Marcus for Marcus & Co.
New York, 1900
Bracelet: W: 3.7 cm / 1½"; Rings: W: 2.5 cm / 1"

The demand for jewelry kept growing with the population. By 1869 Solomon Gump was trading in jade jewelry, and by 1889, H.A. Spaulding had opened in Chicago. Jewelers came to America from Europe, bringing with them designs and a jewelry-making tradition. The spirit of the New World, and the immediate growth of a middle class inspired them to adapt and simplify the old jewelry traditions.

Americans would be showing off their creativity and their Old World experiences in a new art—that of jewelry making.

After the Civil War, the money in the North was substantial, and people wanted to show off their new wealth. They now bought cameos—but this time with diamonds—and gold watches with elaborate designs.

By the middle of the nineteenth century,

archeology was developing as a science, and through major discoveries in Europe and the Middle East, the European and American jewelers created an archeological style. This jewelry style was based on original jewels excavated from ancient tombs.

Side-by-side with the archeological style was the continuing influence of Mogul Indian jewelry. These designs were lavish and used

Gold Classic Revival Bracelet
Tiffany & Co.
New York, 1877
H: 7.6 x W: 8.4 cm / 3 x 3.4"

many colored stones such as rubies and emeralds. By the 1860s, trading with Japan had begun, which brought another new culture to Europe. For the first time, foreign jewelry-making techniques and designs began leaving their marks on Western creators.

The American jewelers began to incorporate these themes into their designs, but in typically American fashion, they refined them.

If we look at some of the jewelry, we can see how each piece can say a little about itself. The Maria de Medici Brooch (page 16) from

Tiffany, dated 1888, with agate enamel and diamonds, evokes the feeling of jewelry from the Renaissance. In the classical revival, we admire the bracelet pictured above, appearing as if it had just been excavated from Pompeii. From 1898, the gold bamboo set with birds and

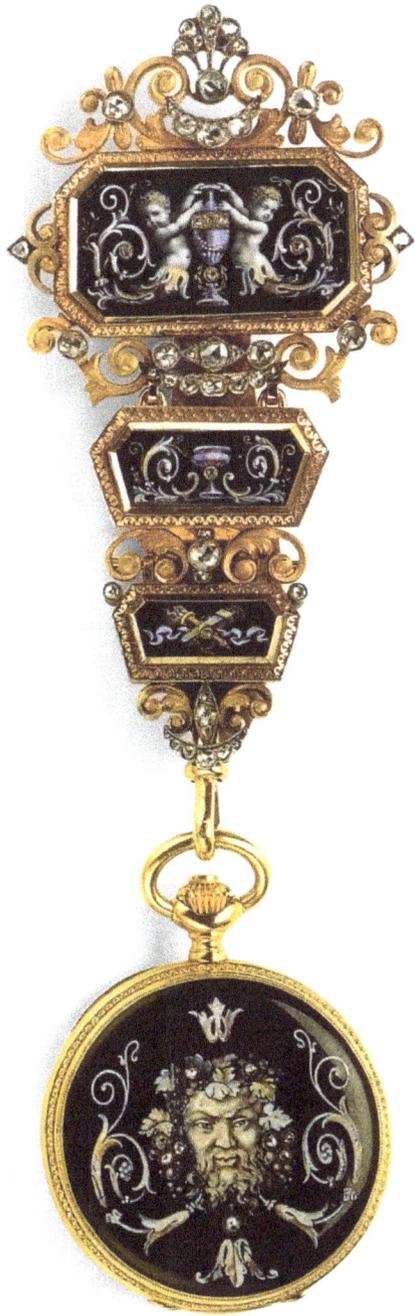

"Bacchus" Renaissance Revival Lapel Watch
Tiffany & Co.
New York, 1872–1879
Enamel, diamond, crystal, and gold
H: 13.6 x W: 4.1 cm / 5.4 x 1.6"

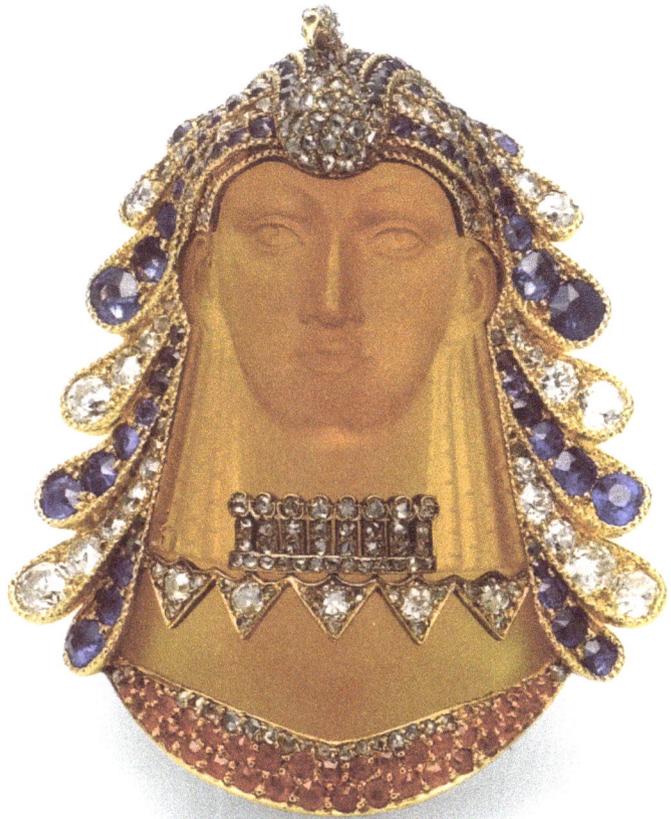

"Cleopatra" Brooch
Tiffany & Co.
New York, c.1890–1895
Topaz, diamond, sapphire, and gold
H: 4.8 x W: 4.1 cm / 1.9 x 1.6"

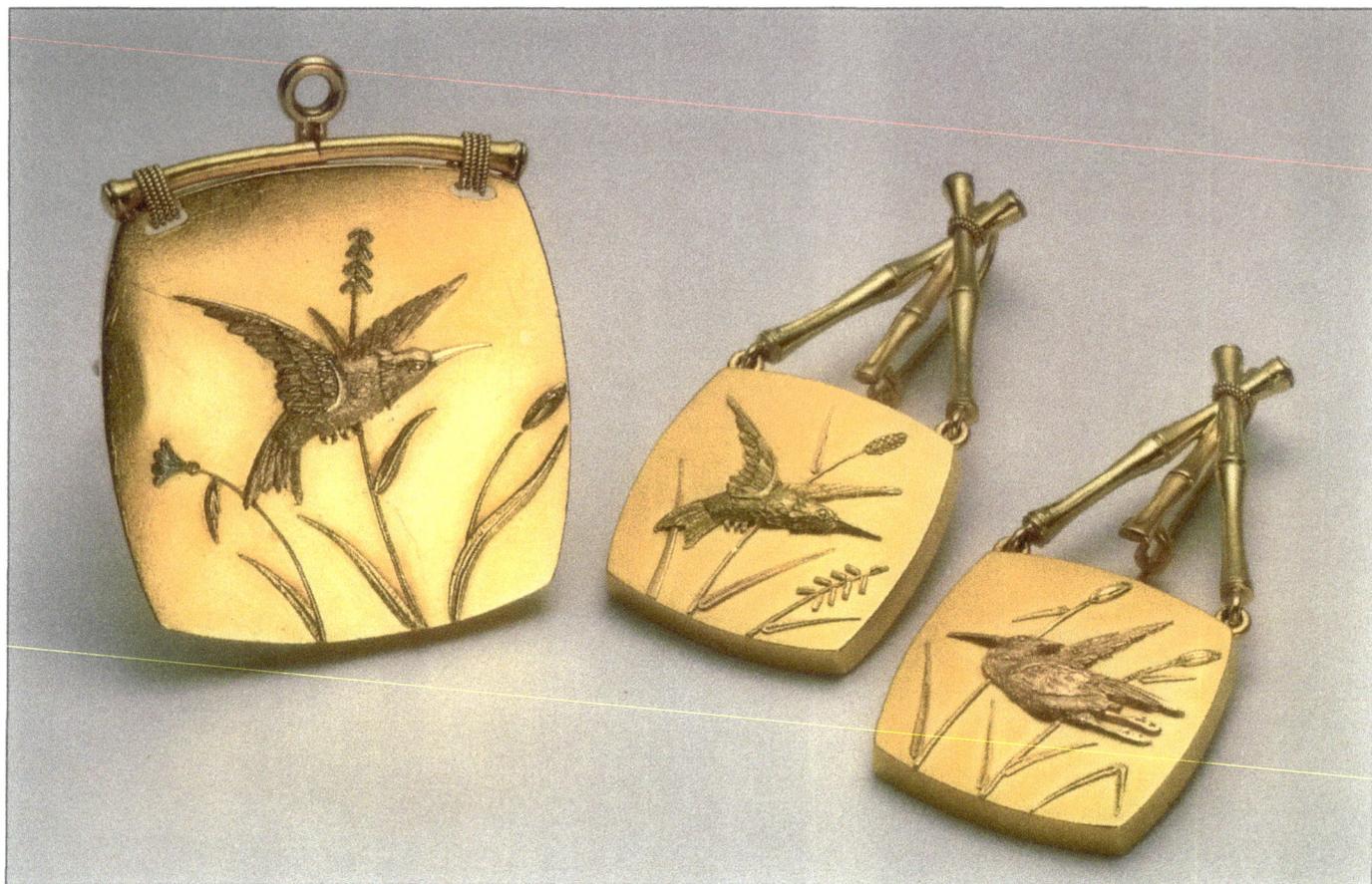

Japanese Bamboo Suite
Tiffany & Co.
New York, 1878
Brooch: H: 3.6 x W: 3.5 cm / 1.4 x 1.4"
Earrings: 4.9 x 3.9 cm / 1.9 x 1.5"

flowers looks like Japanese lacquerware (above). The Japanese bangle bracelets on page 21 evoke the calm of Kyoto with the boldness of the American interpreted design. And even the necklaces of Mogul India got into the act, with the quintessential example designed by Louis Comfort Tiffany in 1905, but without the gold and enamel work (pictured on page 23). This

piece is more American, in that the necklace is lighter and more lyrical.

At the beginning of the new century, art became new art or Art Nouveau, with its sensuous lines, naturalistic designs, and great use of color. This movement is depicted in the lockets on page 28: one has the Medusa motif, and the other is a mythological, winged

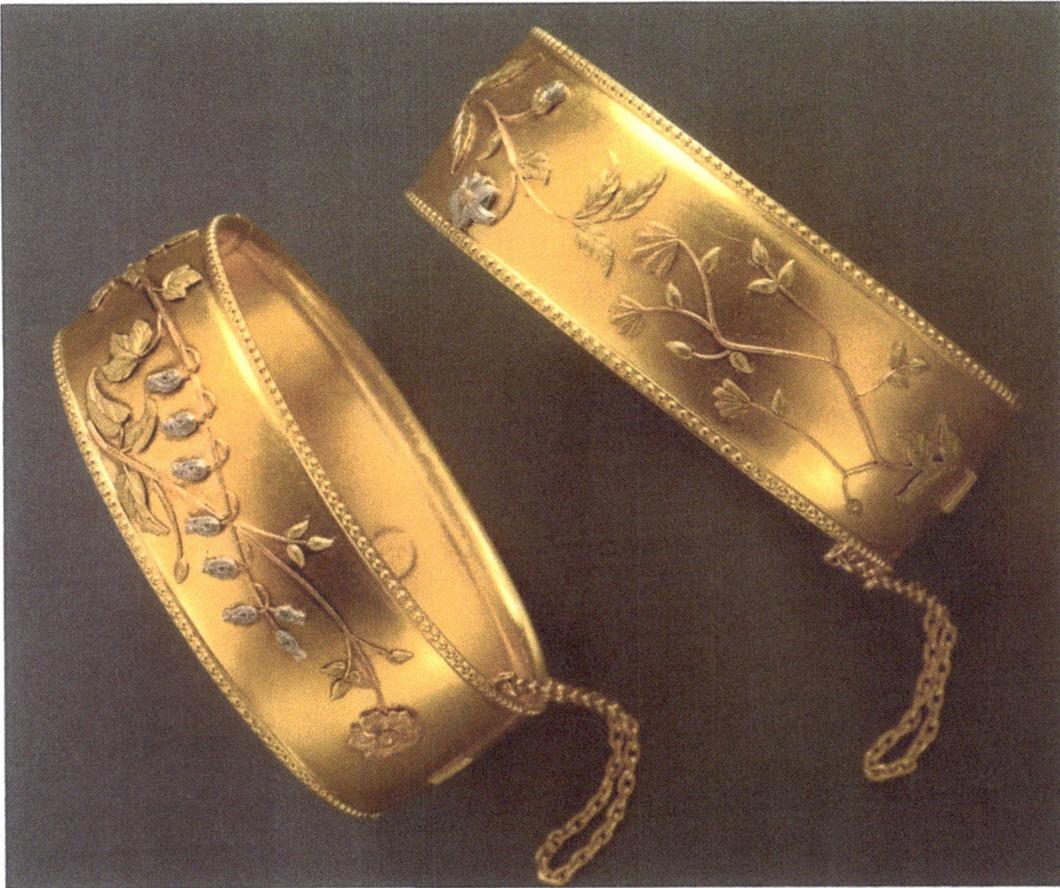

Japanese Bangle Bracelets
Tiffany & Co.
New York, 1900
H: 4.8 x W: 5.7 cm / 1.9 x 2.25"

flute player. Both of these lockets were created for a rising middle class by the so-named Newark Jewelers.

From 1880 to about 1950, there was a proliferation of manufacturers who served the desire of the newly emerging middle class. Newark, New Jersey was an important site for these commercial jewelry companies. Their concept was to mass produce 14k gold jewelry for both men and women. Most of these pieces were enameled. These designs could have been mass produced and finished by hand. Today the names are not familiar to us: Hedges, Riker, Alling & Co., Carter Gough, and Krementz, among others.

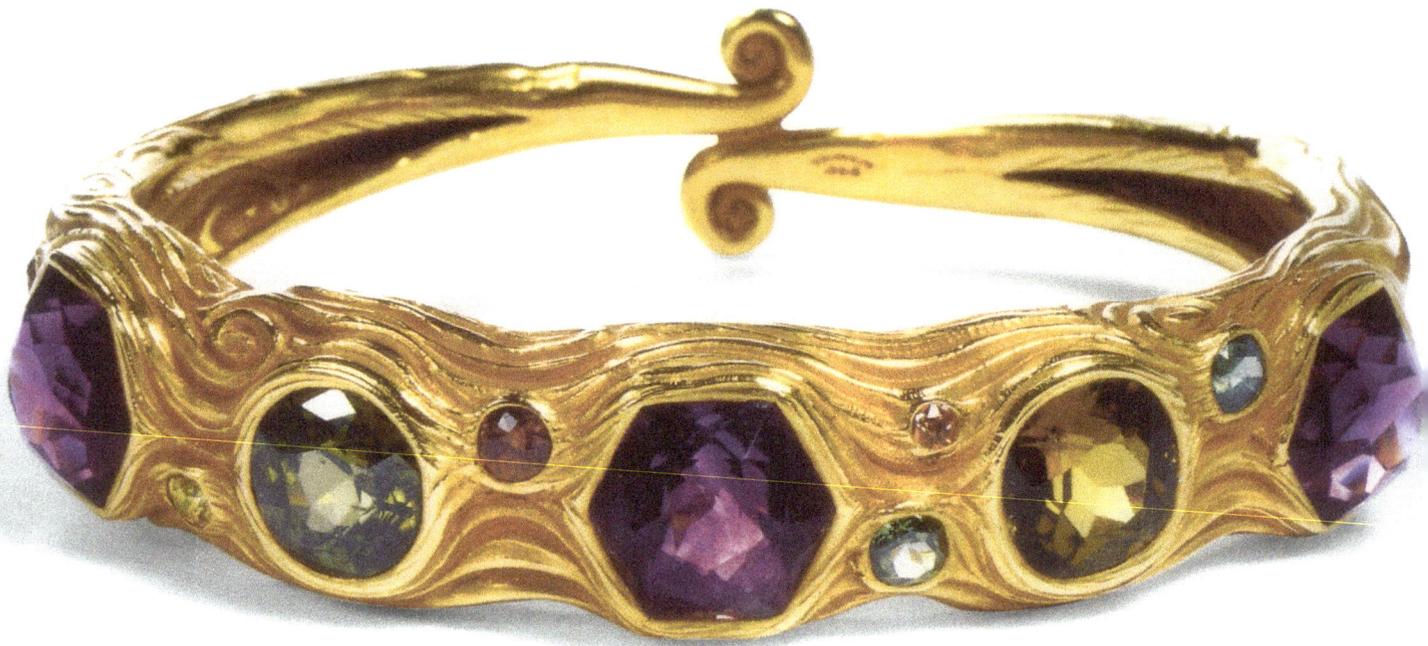

(Above) The gold bracelet is set with amethyst, garnet, aquamarine, pink tourmaline, and sinhalite. The Art Nouveau bangle bracelet's strong design is echoed by the variety of colors in the stones.

Art Nouveau Bangle
Paulding Farnham, Tiffany & Co.
New York, 1900
L: 7.6 x W: 7.6 cm / 3 x 3"

(Right) Moghul India was a great influence in early twentieth century American jewelry design. Louis Comfort Tiffany made this piece in 14k gold with jade leaves and amethyst grapes and drops.

Louis Comfort Tiffany "Grapevine" Bib necklace
Tiffany & Co.
New York, 1905
L: 38 x W: 7.5 cm / 15 x 3"

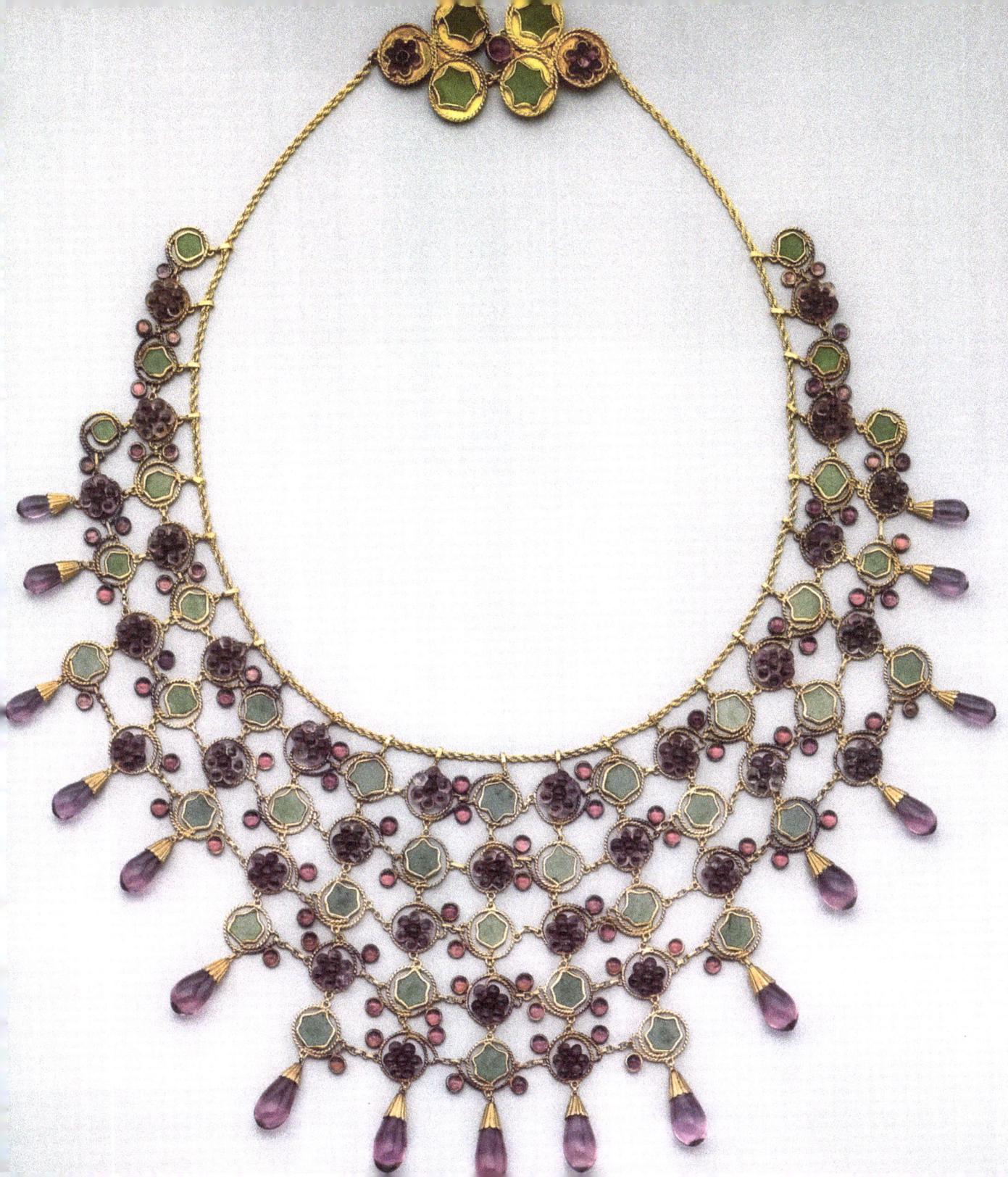

Mary Pickford

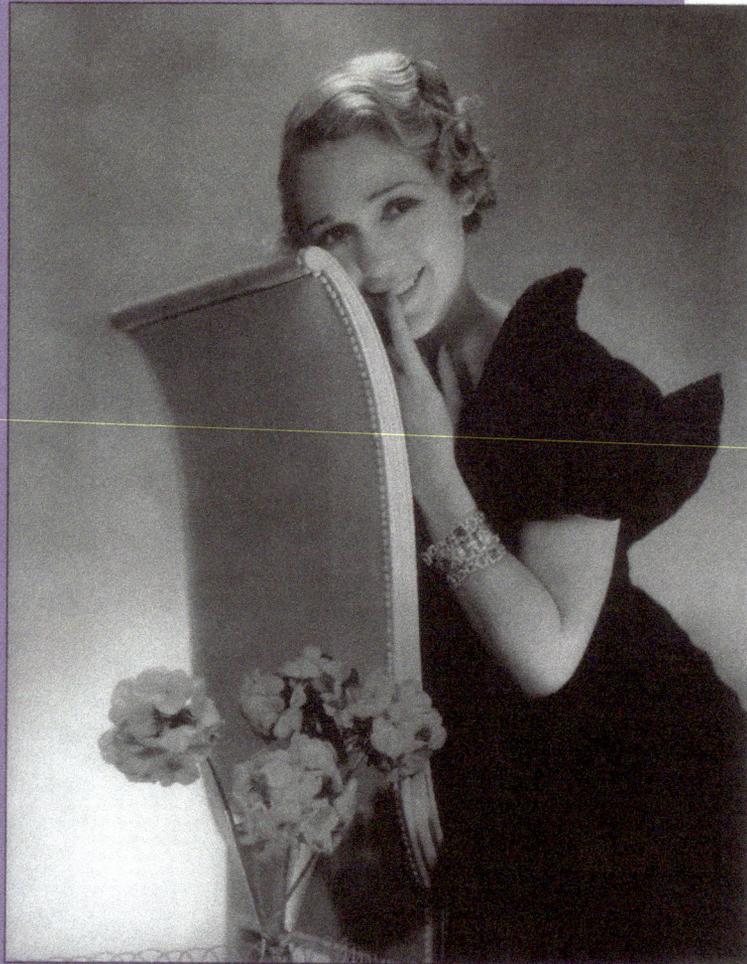

Persona

She was known as "America's Sweetheart." No woman in the history of movies enjoyed the power and adulation that Mary Pickford did. When she was thirty-six, she won the Oscar® for Best Actress in *Coquette*, her first sound film. To the audience, Mary was delicate, sweet, and looked like a fragile lily. In reality, she was as tough as the biggest movie mogul. However, she maintained her innocent image throughout her career, never letting the public see that side of her.

Roots

Born Gladys Louise Smith in May, 1892 in Toronto, she was the eldest of three children. Her father died when she was only five. The family moved to New York, where Mary and her family lived from hand-to-mouth. In 1907, she appeared in a play directed by the famous David Belasco. Two years later, when she met the famous director and producer D.W. Griffith, she had the confidence to tell him: "You must realize I'm an actress and an artist. I've had important parts on the real stage. I must have twenty-five a week guaranteed and extra when I work extra."

Lucre

She was one of the first actor millionaires. At all stages of her career, she demanded the pay that men in the business received. By the time she was twenty-nine, she was earning over half a million dollars for her movie work, and this was in 1917!

Taste

During the First World War, she traveled throughout America, encouraging people to buy War Bonds. This not only helped with the war effort, but the public became even more in love with her patriotism. With her second husband, Douglas Fairbanks, (they were dubbed "Hollywood's Royal Couple") she bought a property in Benedict Canyon in Beverly Hills. She hired well-known Wallace Neff to redesign the mansion and named it "Pickfair." This house provided the setting for Hollywood's most glamorous parties.

Style

She was known for being independent. In fact, at the young age of twenty-seven she created United Artists, forming it with her husband-to-be Douglas Fairbanks, Charlie Chaplin, and D.W. Griffith. She wanted to be the star, producer, and studio owner of all her pictures and master of her life. However, her life never quite kept up with the perfect roles she played. Although she had won a Best Actress Oscar® in 1929 for her first speaking role, her personal life began to unravel. She and Fairbanks divorced in 1936, and the following year she married the actor and band leader Buddy Rodgers, with whom she had starred in her last silent movie, *My Best Girl*. During her final years, she became quite private. One of her more notable quotes describes it all: "One of the great penalties those of us who live our lives in full view of the public must pay is the loss of that most cherished birthright of man's privacy."

Gems

In 1965 Mary Pickford owned the largest private jewelry collection in the world. Mary had started by collecting personal charm bracelets made by Cartier that were set with diamonds and sapphires. Mary preferred very large rubies and sapphires. She owned both the 200-karat Star of India and the 60-karat Star of Bombay. Often she wore both at the same time. Her favorite jewelers, in addition to Cartier, included Trabert & Hoeffer, Inc. Mauboussin.

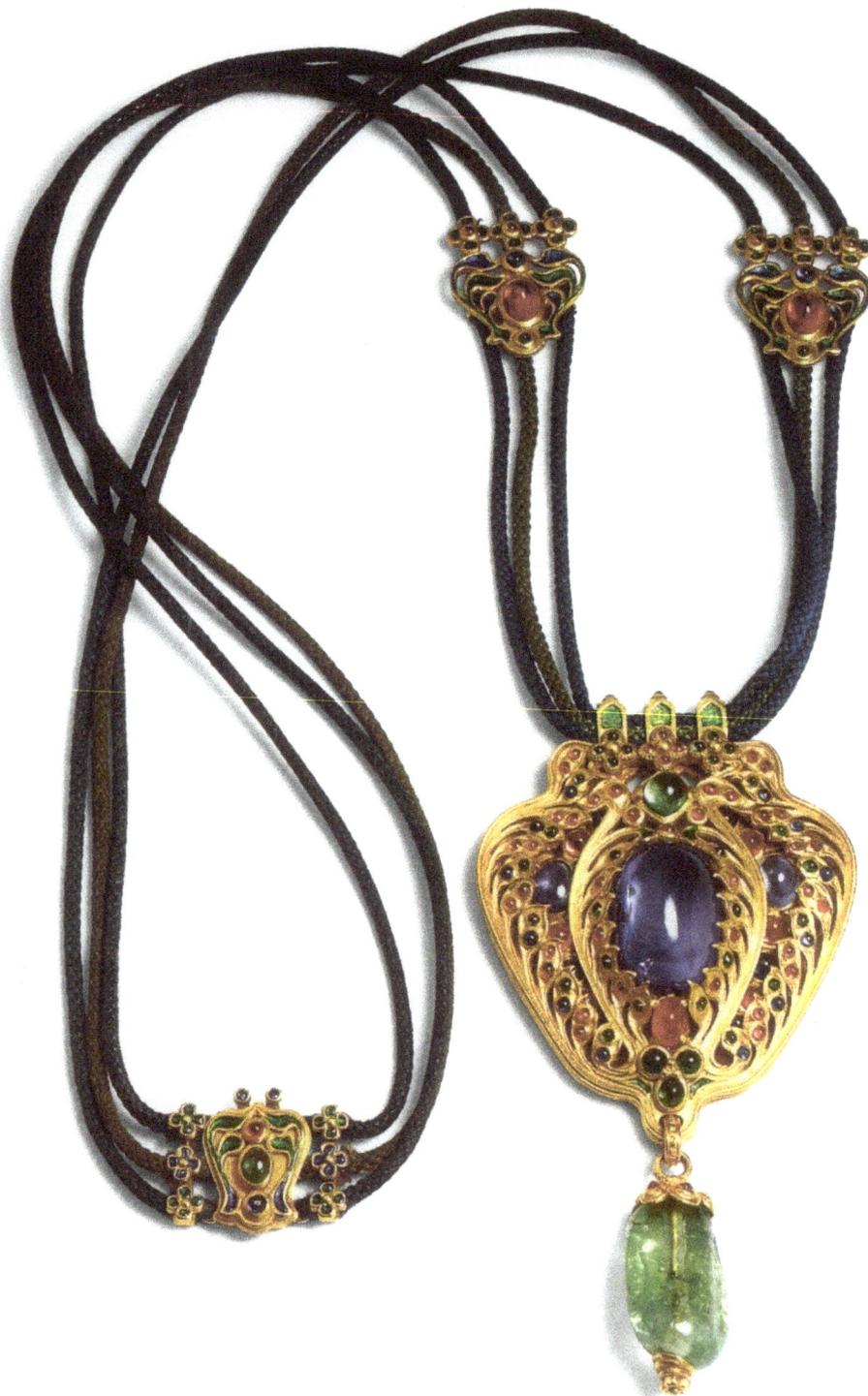

The American firm that played the biggest role in the "new art" style, and at the World's Fair, was Tiffany & Co. As mentioned previously, Charles Tiffany opened his shop in 1837. He and his partner John B. Young wanted to sell objects for the home, specifically to affluent homes.

No one reading the history of Tiffany & Co. could predict the dramatic turn the business took only a decade after its doors had opened. Specifically, eleven years after Tiffany began manufacturing gold jewelry, one of the partners, John Young, traveled to Paris.

The Moghul Indian style continued to influence the American jewelers. Louis Comfort Tiffany created this necklace with an Indian-style gold and green enamel pendant with sapphires, rubies, and emeralds. The sapphire is a 35-karat oval, and the drop is a 25-karat cabochon emerald. The use of a silk cord also evokes the Indian spirit.

Necklace
Louis Comfort Tiffany, Tiffany & Co.
New York, 1918
L: 71 x 9.5 cm / 28 x 3³/₄"

He found that because of disease in the potato crops, and the French King Louis Phillipe's subsequent exile to England, the value of diamonds had dropped 50 percent. Even though Charles Tiffany and John Young were just starting out, Young made the incredibly strategic decision to divert nearly all the company's funds and invest in diamonds.

While he purchased many diamonds in the next decade, the deal that sent all the tongues wagging was the purchase in 1878 of an important share of the French Crown jewels. Napoleon III, Empress Eugenie, as well as Marie Antoinette, were definitely not held in high esteem. Ironically, the French did not consider any of their jewels of historic value, especially since Empress Eugenie had had these diamond ornaments completely redone by her own jewelers. Tiffany bought over one-third of the collection for half a million dollars, an incredible sum at the time. In hindsight, it was obviously the right move.

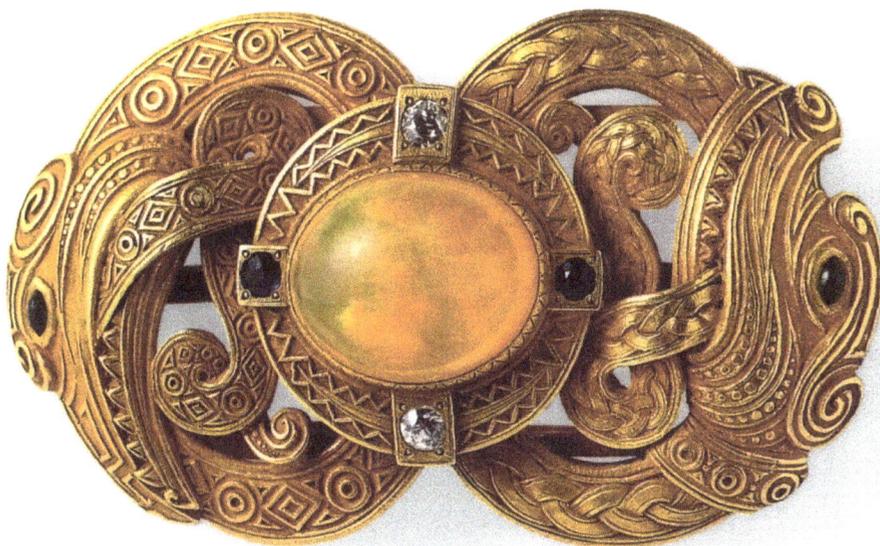

Again, we see the influence of the major archeological discoveries in American jewelry. This "Celtic"-style buckle was made with yellow gold, emeralds, sapphires, diamonds, and a Mexican fire opal. Unlike most European jewelers, who considered opal a sign of bad luck, Americans were not afraid to use opals in their jewelry.

Celtic Buckle
Theodore B. Starr
New York, 1910
H: 6 x W: 3.5 cm / 2½ x 1¾"

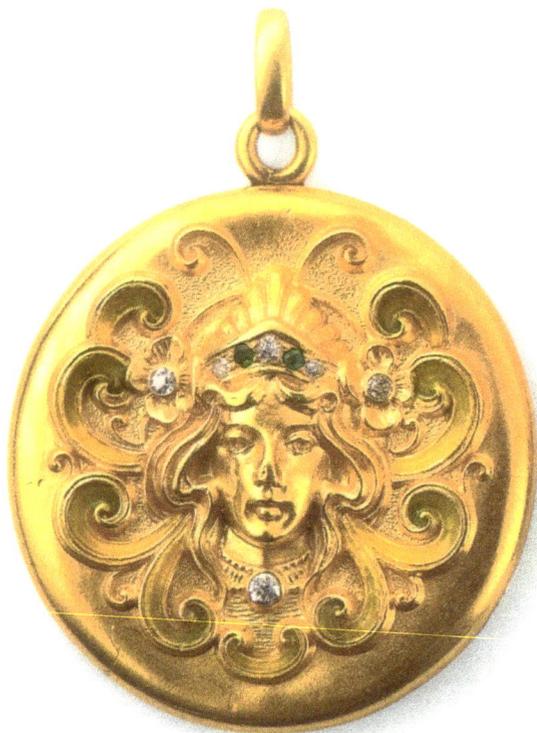

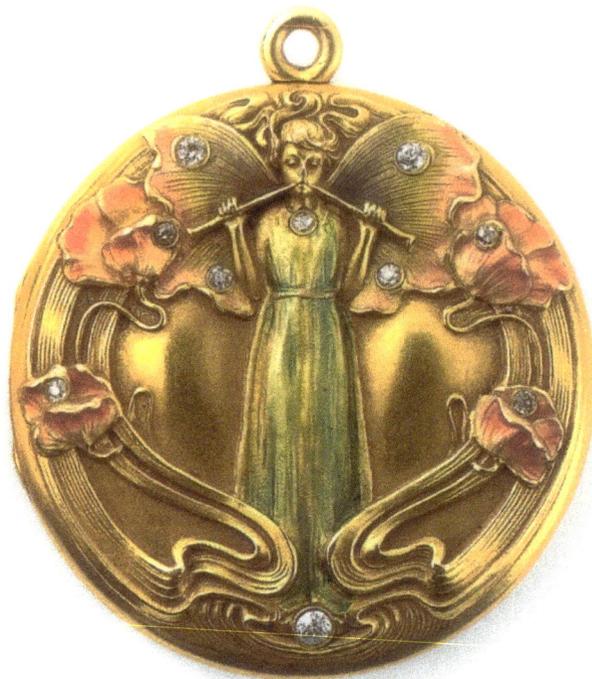

In 1878, Tiffany acquired a 287.42-karat rough diamond in South Africa and had it cut in Paris. At the time, the traditional way of setting diamonds was to use bezel mounting, which encased the lower part of the stone. Nearly seven years later, they introduced the "Tiffany setting," which lifted the diamond away from the shank with supporting prongs.

This way, light could come in from below and enhance the stone.

Now with extreme self-confidence, Tiffany began to introduce color in jewelry. According to the *Jewelers' Circular* (April 1889), "Tiffany & Co.'s display at the forthcoming Paris Exposition . . . resides in its being of thoroughly American character."

Today it's not unusual to see Native American designs both in jewelry and in artifacts, but Tiffany was working in a different time period--this World's Fair was over 100 years ago. Tiffany chose stones never before displayed in jewelry. There were Montana sapphires, Arizona garnets, Colorado crystal, emeralds from North Carolina, and tourmalines from Maine. Tiffany's also exhibited twenty-five enameled orchids that were perfect reproductions of the plants found in Brazil and East Asia. They even went to the trouble of creating jewelry cases from woods such as California redwood, then covered them in lizard or alligator and lined them with elk or reindeer hide.

George Kunz, who had worked for Tiffany since 1879, assembled an incredible group of pieces. Financier J.P. Morgan bought nearly everything for New York's Museum of Natural History.

By the turn of the century, Louis Comfort Tiffany, the son of Charles, had a profound effect upon American and European jewelry

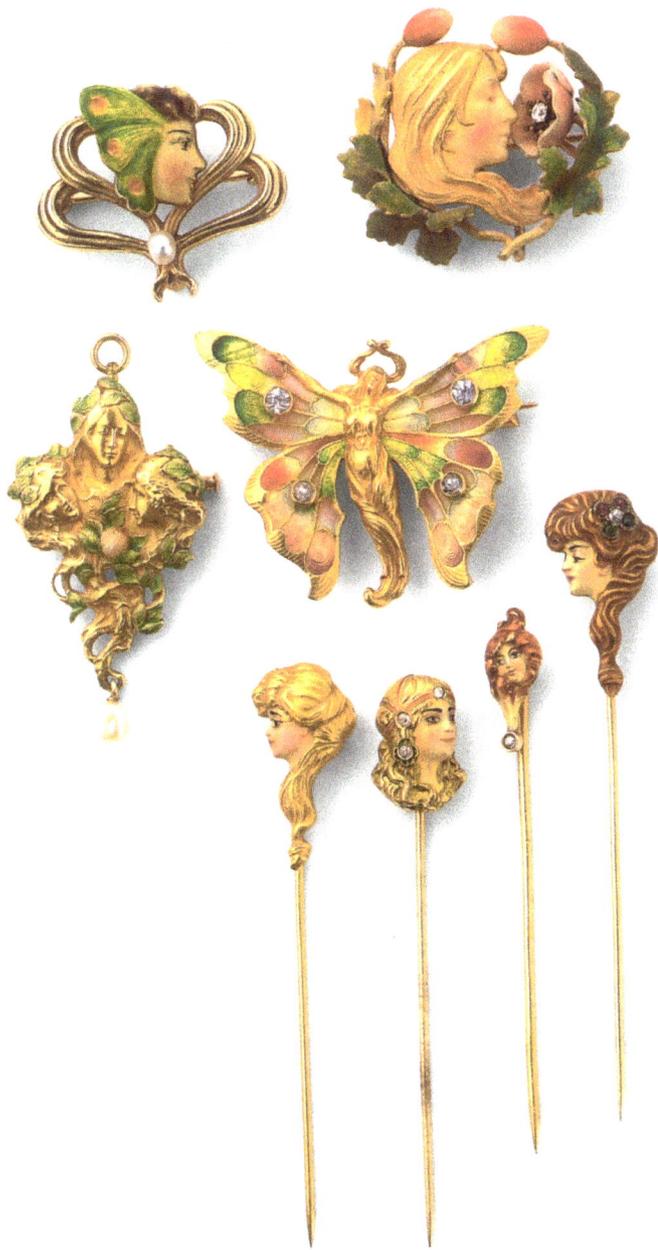

The butterfly is done by Henry Blank & Co. The stick pins are renderings of the Gibson girls, the "pin-ups" of the 1890s

Art Nouveau Pin Grouping
Newark Group
1900

design. In the 1880s René Lalique, upon seeing some of Louis Comfort Tiffany's enameled flowers, said that it totally inspired him with his own enameled jewelry.

Although brought up in a privileged household, Louis Comfort Tiffany wanted to bring art—and of course, good design—in affordable jewelry to the middle class. He focused on semi-precious stones, which became *en vogue* all over America. "Street wear" or "day" jewelry became popular. Stones such as garnets, tourmalines, or opals became even more the fashion. And often times the colors of the stones were chosen by the woman to go with the color of her dress. As early as the 1870s, color extended to the mixing of metals as well: jewelers had a choice of setting stones in yellow, pink, or green gold. An example of the use of colored gold jewelry is the photograph on page 31, of the purse, chain, earrings, and brooch.

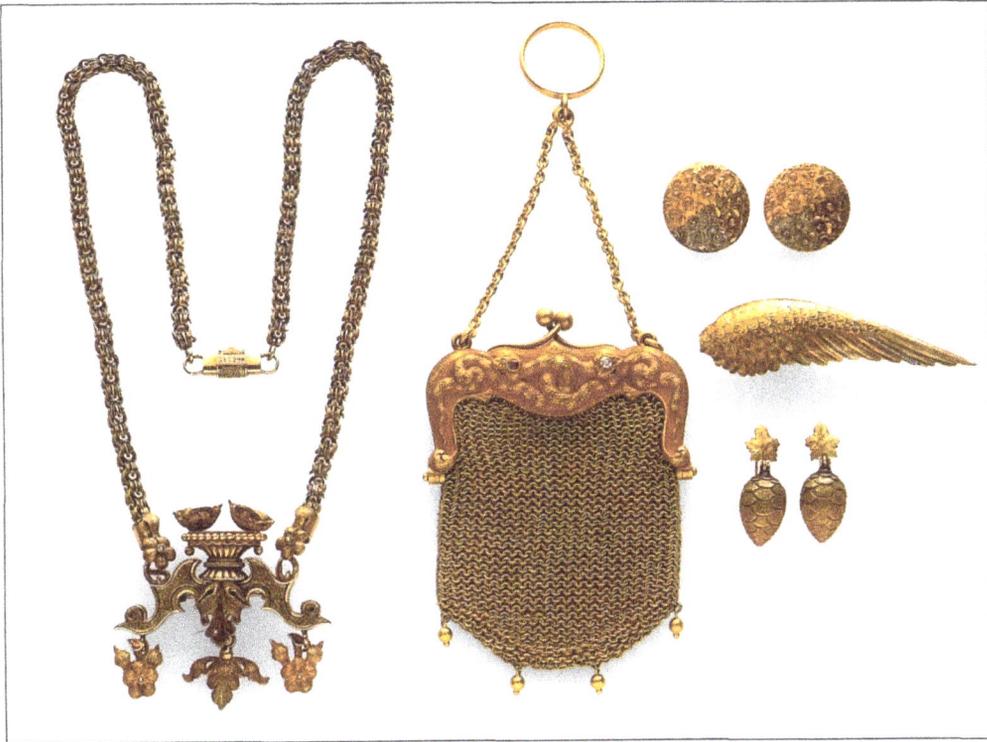

Multi-color Gold Accessories
Unsigned
Newark Group
1870–1900

Laurel Wreath Crown
Paul Gillot
New York, 1917
W: 5.1 cm / 1³/₄"

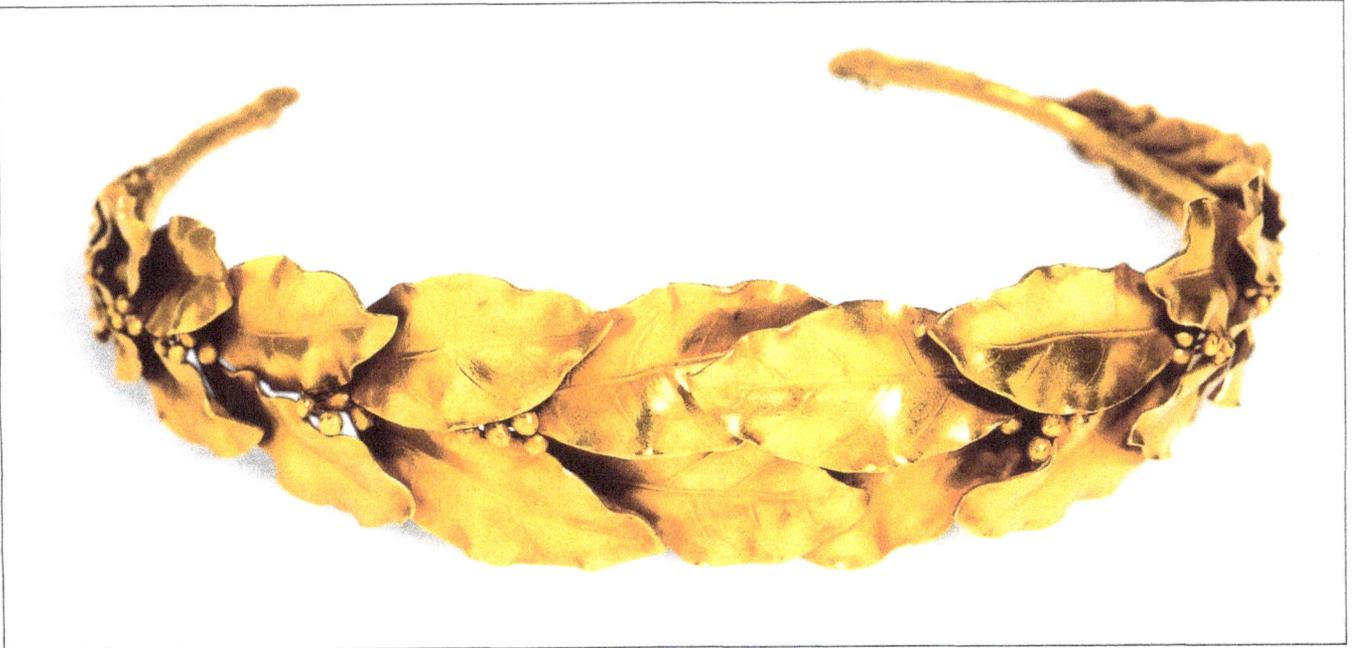

Clare Booth Luce

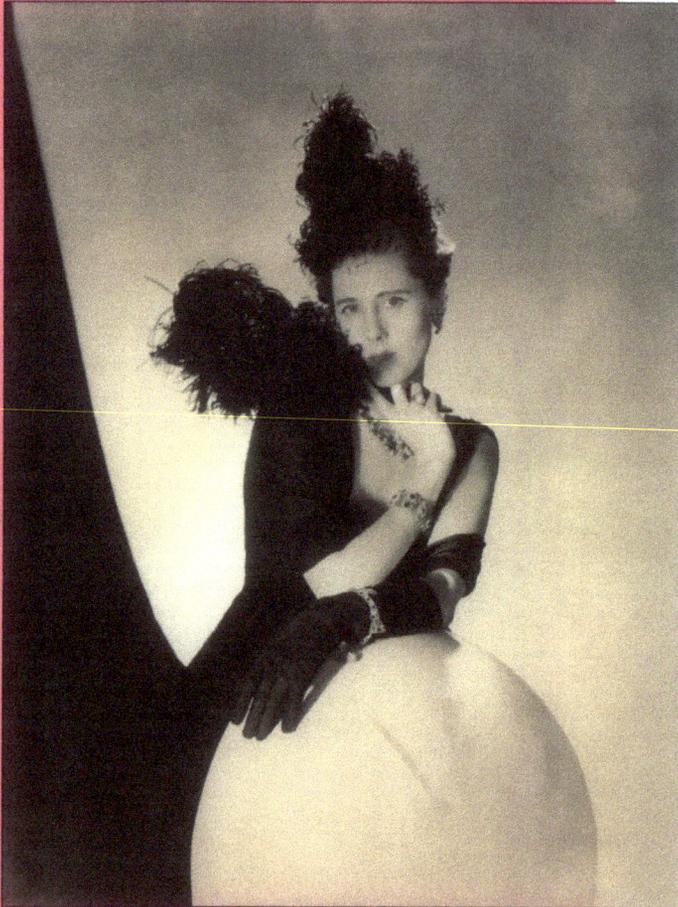

Persona

She was strong and opinionated. One of her most famous quotations says it all: "Because I am a woman, I must make unusual efforts to succeed. If I fail, no one will say, "She doesn't have what it takes." They will say, "Women don't have what it takes."

Roots

Clare was born in New York City in 1903, but following her parents' separation, she spent her childhood in France. Originally, she wanted to be an actor and understudied Mary Pickford before briefly going to Clare Tree Major's school in New York City. When she was nineteen, she met George Brokaw, who was twenty-four years older than she was. One year later she married him. Another year later, she gave birth to a daughter, but she divorced Brokaw five years later due to his excessive drinking.

She went to work at *Vogue* as an editorial assistant and in 1931 became an associate editor at *Vanity Fair*. Two years later, she was its managing editor. During this time, Clare wrote short stories that made fun of New York society, such as "Stuffed Shirts" (1933).

Clare's big year was 1935. She had recently married Henry Luce, the founder and publisher of *Time* and *Fortune* magazines, and her play, *Abide with Me,* opened on Broadway. While the reviews were not good, the play was probably a reflection on her first marriage: it is a drama about an abusive husband and his terrified wife. A year later, *The Women* opened, a comedy again containing material familiar to Mrs. Luce: it makes fun of wealthy women and divorcees.

Lucre

While not born to a wealthy family, Clare moved in the right circles. When she married Henry, she became a journalist for life (part of his empire), interviewing world leaders in Europe, Africa, and Asia. These included Chiang Kai-Shek and Jawaharlal Nehru. Access to power was much more important to her than money.

Style

During her lifetime, Clare Boothe Luce was a journalist, editor, playwright, politician, and diplomat as ambassador to Italy. She was outspoken, and it often hurt her. For example, in 1959, Clare was appointed Ambassador to Brazil by President Eisenhower. Although the appointment was narrowly approved, her biggest opponent was Oregon's democratic senator, Wayne Morse. Rather than saying nothing, she commented that Morse's actions were the result of being "kicked in the head by a horse." This outrageous remark caused such a fury that she resigned the ambassadorship a few days later. But, unapologetic throughout her life, Clare Boothe Luce memorably observed, "No good deed goes unpunished."

Taste

There is no question that Clare Boothe Luce was not a clothes diva. Although, after Henry Luce died in 1967 she built a house in Hawaii and started to become more involved with native design.

Gems

In this picture by Horst, Clare had been married to Henry for three years. She was definitely the woman to watch, not just by being Mrs. Henry Luce but by being a playwright and author on her own. Her independent will and taste directed her jewelry purchases.

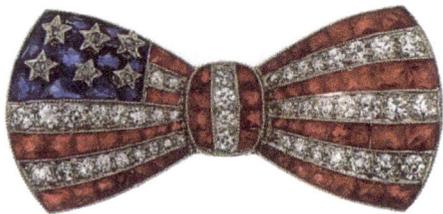

Flag brooch
Cartier
New York, 1927
H: 3 x W: 1.5 cm / 1⅛ x 1¹/₁₆"

As America grew richer, the demand for diamonds increased. Now a style emerged to enhance the whiteness of the diamonds—namely by coupling them with platinum. Platinum was first discovered in Russia, but because it is difficult to melt, its use remained impractical. Finally, in 1912 a blowtorch was developed to weld and solder platinum in ways not possible before. The result was delicate jewelry, such as dog collars and bows.

When America entered World War I, the platinum problem surfaced, and jewelers had to limit their production. When the war finally ended, jewelry sales increased dramatically. Another example of the intertwining of American history with jewelry is a beautiful, platinum Cartier flag brooch, created as a bow (pictured left).

Simultaneous with the war effort, the American suffragette movement was gathering

Yellow, pink, and white gold celebrate the new technology of flying. Black, Star, & Frost has been part of the jewelry landscape since 1810. In 1876, the company opened on Fifth Avenue. Their clientele consisted of "new" money, such as the Vanderbilts and the Carnegies.

Airplane Cigarette Case
Black, Star, & Frost
1928
18k gold
L: 8 x W: 11½ cm / 3¼ x 4½"

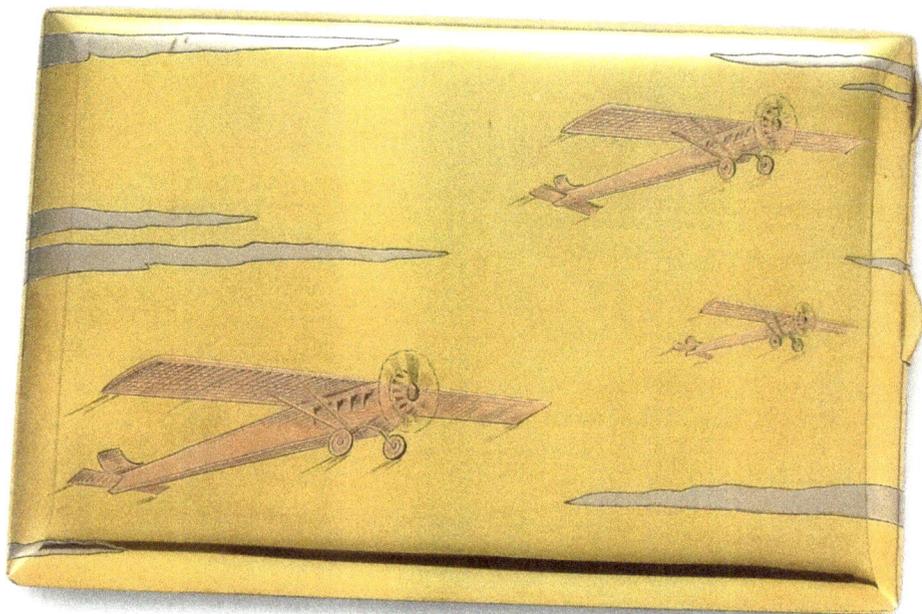

Watch celebrating Wilbur Wright's flight
over New York on September 30, 1909
Signed "LM"
1910
18k gold
L: 6 x W: 4.5 cm / 2³/₈ x 1³/₄"

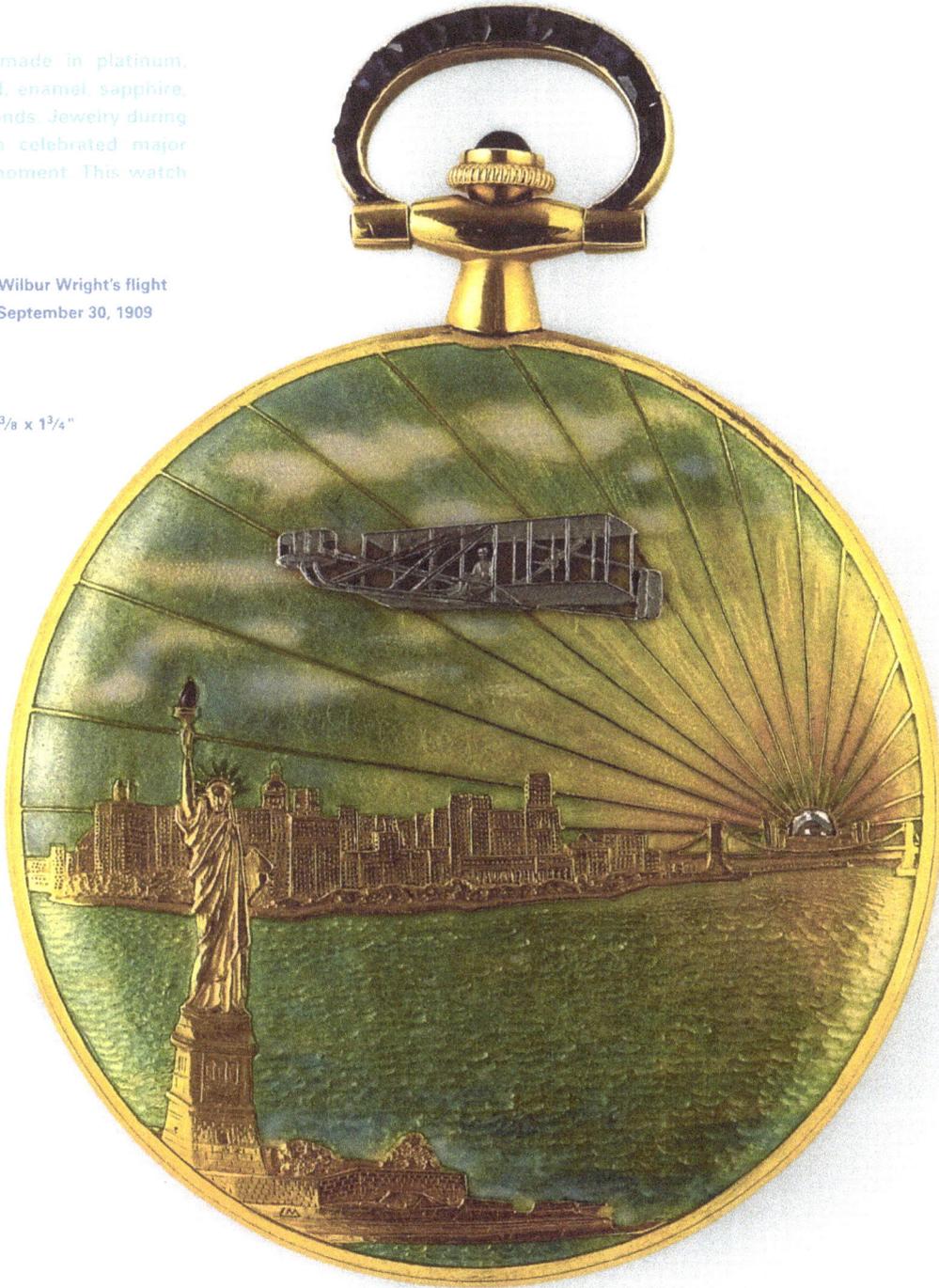

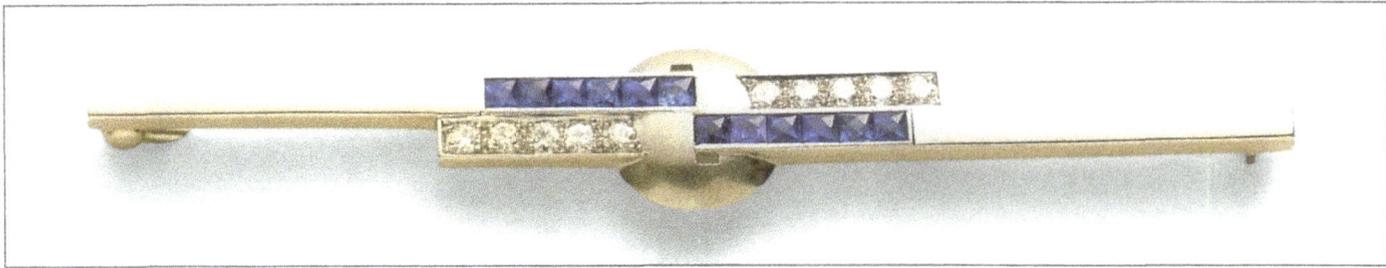

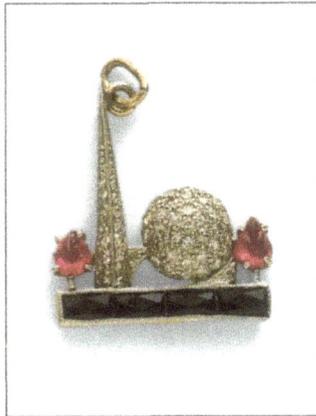

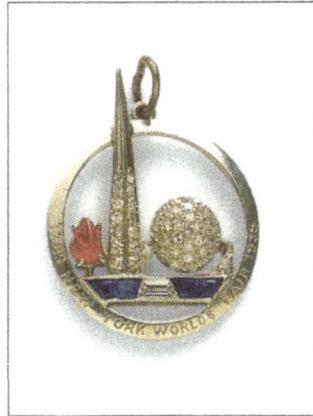

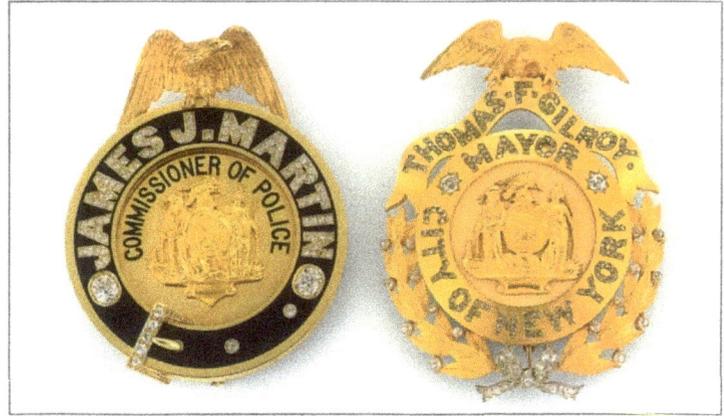

Americans liked to commemorate their big events in jewelry. The 1939 New York World's Fair was one of those moments.

(Top) Bar Pin
Abstraction of World's Fair Emblem
Sapphire, diamond, and platinum
L: 9 x W: 1½ cm / 3½ x ⁹/₁₆ "

(Bottom Row) Pendant Charms
(Left) New York World's Fair Charm
Unsigned
1939
Diamond, ruby, and black onyx
L: 2.3 x W: 1.7 cm / ⁷/₈ x ⁵/₈"

(Center) New York World's Fair Charm
Inscribed "1789 New York's World Fair 1939"
1939
Diamond, ruby, and sapphire
Diameter: 1³/₄ x 1³/₄"

Tiffany & Co. was commissioned to create a jeweled medal in gold, enamel, and diamond for James J. Martin, police commissioner in 1889.

(Bottom Row Right)
Jeweled Medal
Tiffany & Co.
New York, 1889
Diameter: 2¹/₄ x 1³/₄"

A ceremonial medal made in gold and diamonds commemorating the Mayor of New York, Thomas F. Gilroy, was created by the upstairs retailer Thomas Kirkpatrick.

(Bottom Row Extreme Right)
Ceremonial Medal
Kirkpatrick
c. 1890
Diameter: 2¹/₂ x 1³/₄"

strength. In 1917 Paul Gillot, a New York retail jeweler was commissioned by a group of women to make an 18k gold classical leaf crown. It is inscribed on the back, "To Vera Boarman Whitehouse, From the Women of New York State, Whom she led to victory Nov. 6, 1917" (pictured on page 31).

America's fascination with technology can be seen on the very patriotic watch shown on page 35. It depicts Wilbur Wright's fifty miles per hour flight around the Statue of Liberty on

September 30, 1909. It is engraved "LM" for the maker. A second example is the cigarette case on page 34. It was designed by Black, Starr & Frost in 1928 and engraved with three airplanes. Cortland Starr was in the military during the Civil War. He became a partner in the jewelry firm in 1875. While never known for innovation, Black, Starr & Frost were loved by their clients.

America's no-nonsense approach in our lifestyle is illustrated by cufflinks designed by Paul Flato in 1940 (pictured right). Americans use ordinary objects—and make them beautiful. Americans take a nuts and bolts approach to solving problems—simple, straightforward, and not too fancy. What can be more American than these approaches to jewelry?

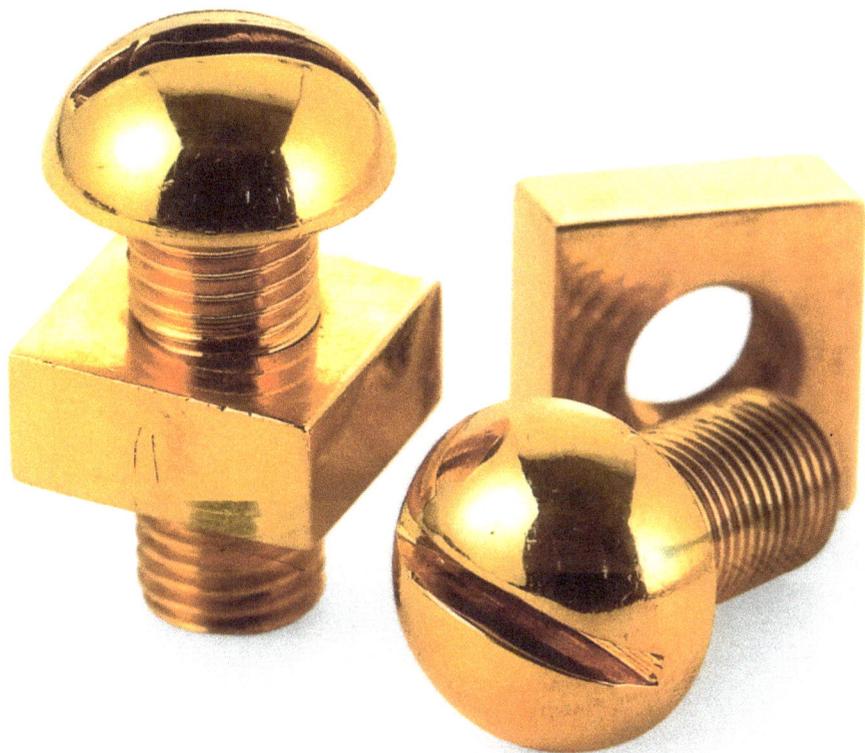

Paul Flato was the darling of the Hollywood and café society sets. What more basically American could he have designed than these simple cufflinks in the shape of nuts and bolts?

"Nuts and Bolts" Cufflinks
Paul Flato
New York, 1940
L: 2 x W: 1 cm / ³/₄ x ⁷/₁₆"

NATURE

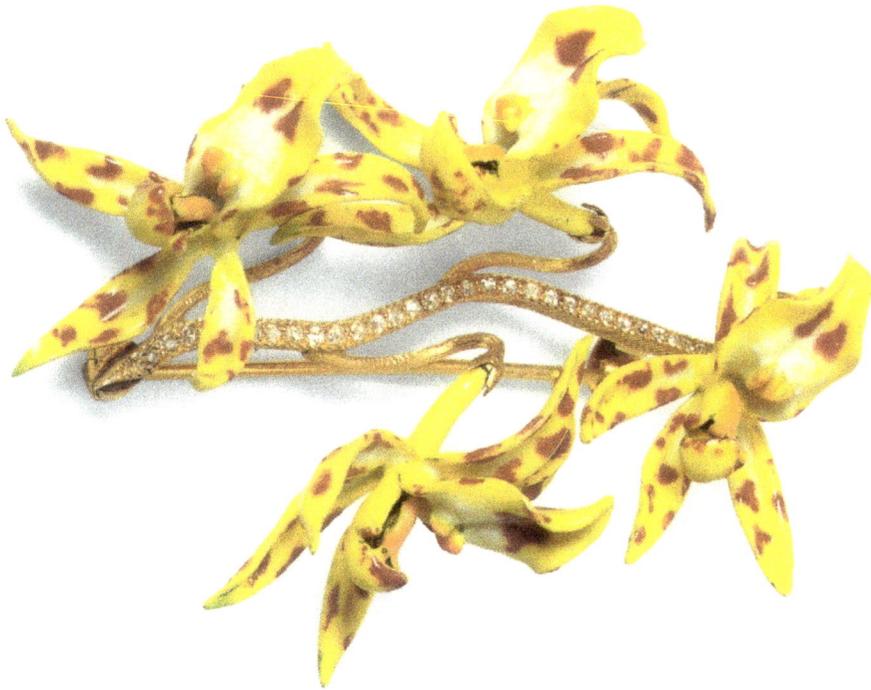

These orchids were made out of diamonds, enamel, and set in gold.
They were extremely delicate, yet very wearable.

If there is a single, major theme in jewelry, it is nature. The beginnings of America are intrinsically tied to nature. Establishing new frontiers and confronting the wilderness were sources of pride and identity. In fact, in American literature, as in the visual arts, nature is often regarded as the spirit behind the American character.

America's fascination with flowers dates back to the Jeffersonian era. At this time,

Odontoglossum contsrictum Orchid Brooch
Paulding Farnham
Tiffany & Co.
New York, 1889
H: 7 x W: 6.4 cm / 2.75 x 2.5"

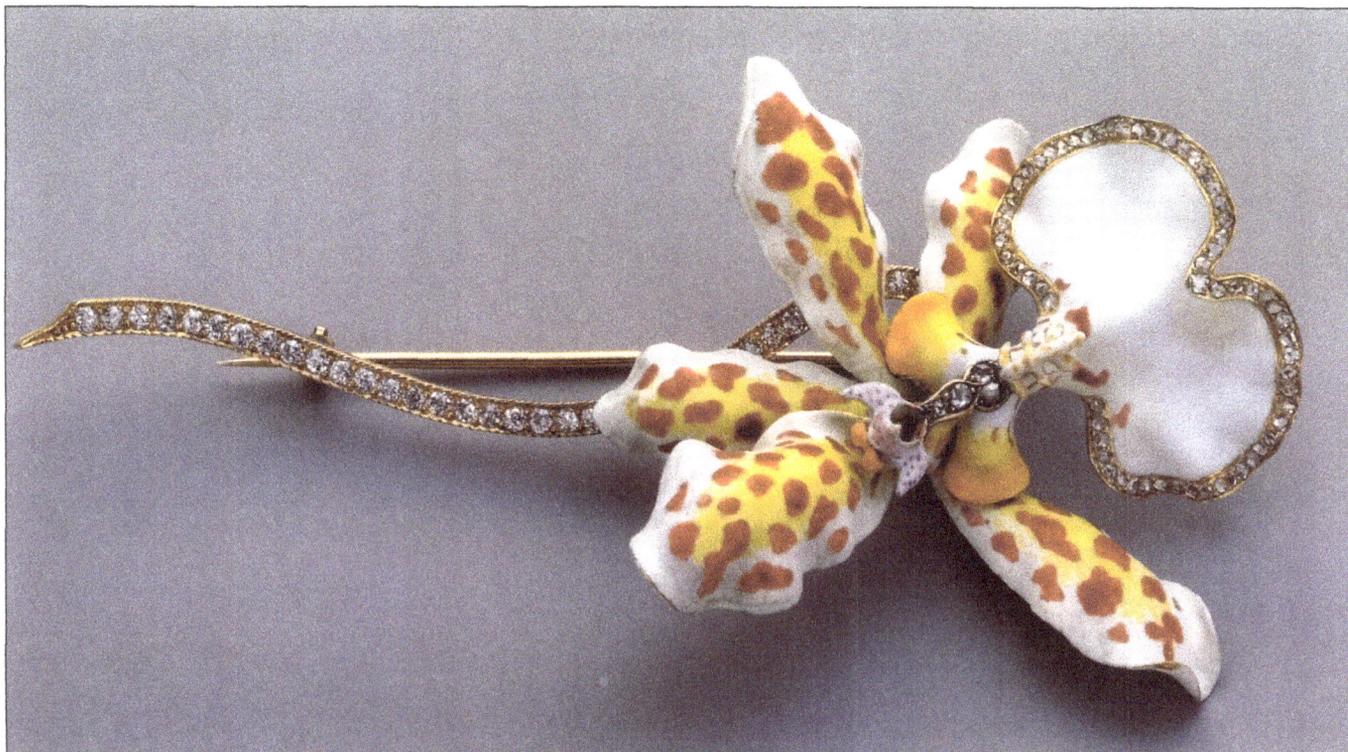

scientific expeditions were initiated to investigate the American continent. People like chemist Joseph Priestley, anthropologist Charles Peale, and botanist Benjamin Rush compared notes and shared results of their experiments. Reporting these excursions in the popular press awakened the American public to the glories of nature, and public awareness stimulated an interest in jewelry images.

In the 1850s and 1860s the writings of Ralph Waldo Emerson and Henry David Thoreau characterized an American renaissance. They believed that nature possessed true beauty, independence, and universal truth. Artists in this period, such as Albert Bierstadt, Frederick Church, and Thomas Moran painted America's landscapes and wilderness. Jewelry and art intermingled when Tiffany & Co.'s gem expert, George Kunz, invited Moran to go with him on his expeditions and paint what he saw.

In 1889, Tiffany displayed twenty-five orchid brooches designed by Paulding Farnham for the Paris World's Fair. As the price of these brooches was by no means such as to put it within the reach of the multitude, many were purchased by Jay Gould, the railroad baron who was a great orchid lover. According to the Syracuse (NY) Herald of April 7, 1989, "Every one was bought up before it had been on view two days." Particularly enthusiastic over these imperishable reproductions of his favorite flower, Gould purchased them not for female adornment, but kept them in a cabinet for his own personal delectation.

Oncidium Jonesianum Orchid Brooch
Tiffany & Co.
New York, 1889
H: 10.5 x W: 5 cm / 4.1 x 2"

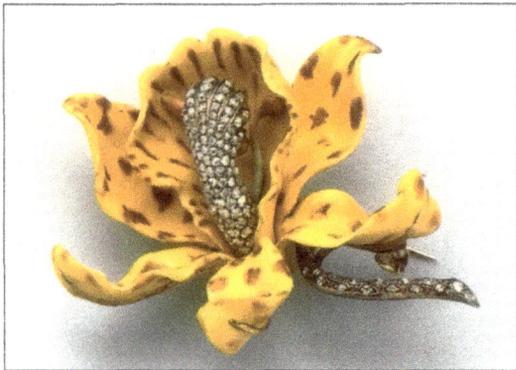

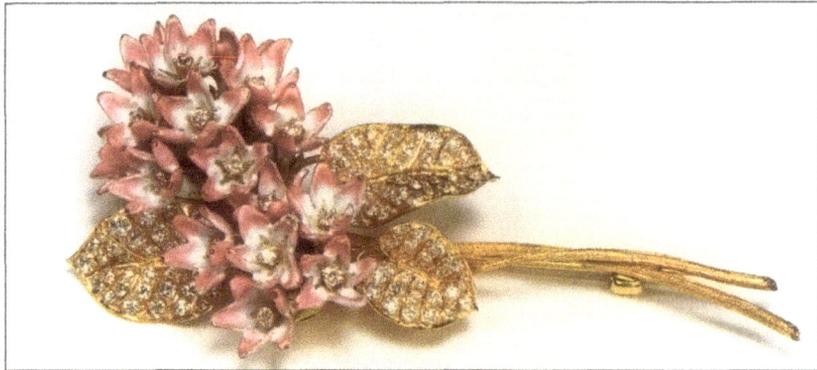

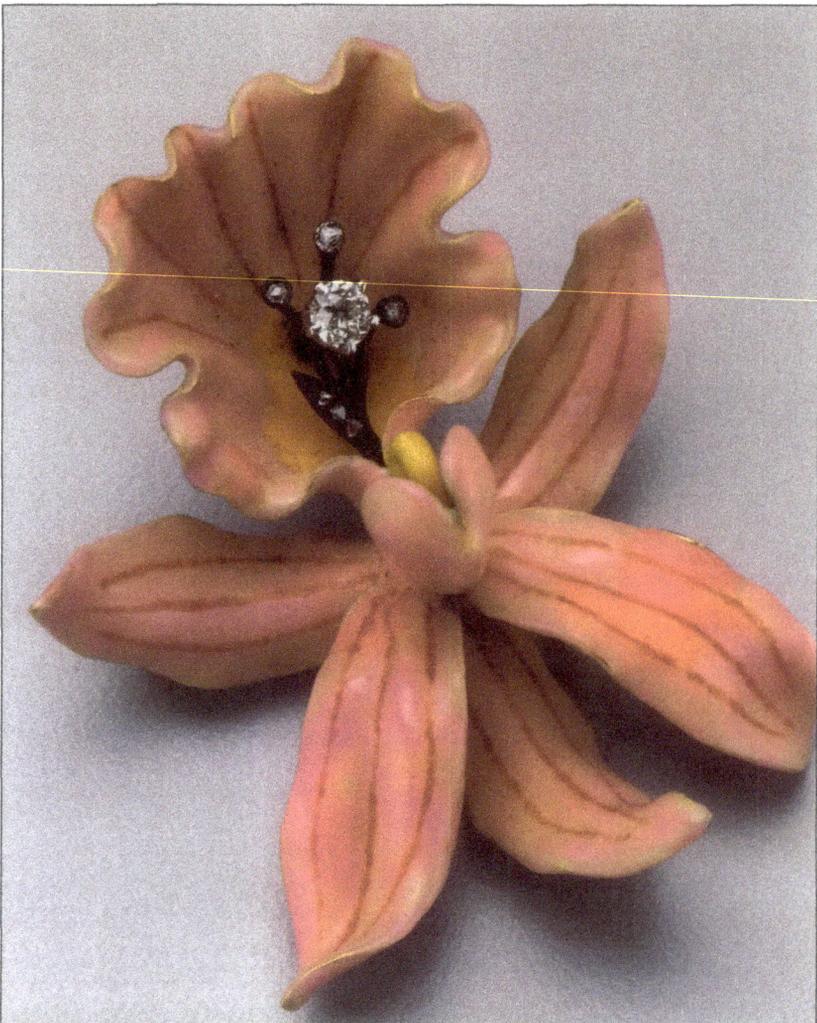

(Above) This extraordinary brooch is made with diamonds, ruby, enamel, gold, and sterling silver. Paulding Farnham was the lead designer of jewelry for Tiffany & Co. in the late nineteenth and early twentieth centuries. He had an appreciation for the exotic in nature, as well as the exotic in ancient cultures.

Vandopis parishii Orchid Brooch
Paulding Farnham
Tiffany & Co.
New York, 1889
H: 6.7 x W: 5 cm / 2.6 x 2"

(Top Right) Made out of pink enamel, diamonds, and gold. This also was exhibited at the Paris World's Fair.

Pink Nosegay Brooch
Paulding Farnham
Tiffany & Co.
New York, 1889
H: 9 x W: 4 cm / 3.55 x 1.5"

(Bottom Right) The brooch is a tropical Asian orchid, made with enamel, diamonds, and set in gold. It is said that René Lalique, upon seeing Tiffany's orchids at the World's Fair, claimed that they were a source of inspiration for his (Lalique's) creations.

Calanthe veitchii
Paulding Farnham
Tiffany & Co.
New York, 1889
H: 4.5 x W: 3.8 cm / 1.75 x 1.5"

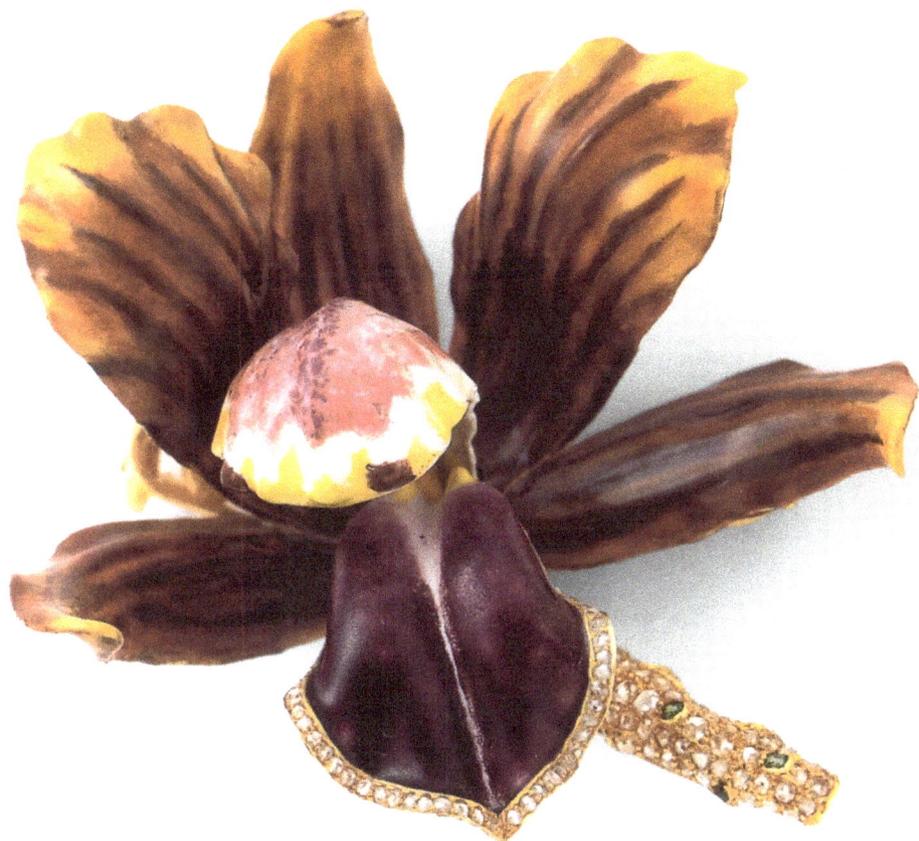

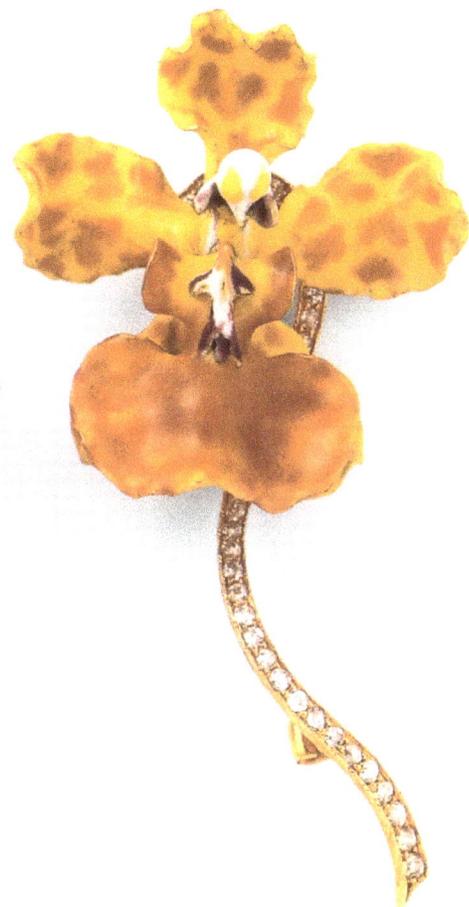

One result of this fascination with nature is the Tiffany & Co. orchids: a collection of twenty-five enameled jewels shown in Paris in 1889. These orchids are created in gold and enamel. Some of the orchids featured are highlighted with diamonds, as seen on page 39 and 40. It is said that before they came to Paris, Tiffany showed the orchids in New York. One customer, philanthropist Jay Gould, bought several jewels to add to his natural orchid collection.

Early examples of pieces representing nature in this book include two perfume bottles signed by Tiffany & Co., seen on page 42. What is particularly interesting about these pieces is the rattlesnake and bird

The orchids are made out of enamel, diamond and gold. The larger one (on the left) was shown at the Paris World's Fair in 1898. The one on the right, although more modest in creation, illustrates another variety of orchid.

Two Orchids
Paulding Farnham
Tiffany & Co.
New York, 1889 and 1900
(Left) L: 7 x W: 6 x H: 3 cm / 2³⁄₄ x 2¹⁄₂ x 1¹⁄₄"
(Right) H: 2¹⁄₂ x W: 1¹⁄₂"

What is unusual about these perfume bottles is that they are decorated with snakes, lizards and flies, yet they were bought and used by women! All these bottles were created not to be carried, but rather to add an aesthetic vision to a lady's dressing table.

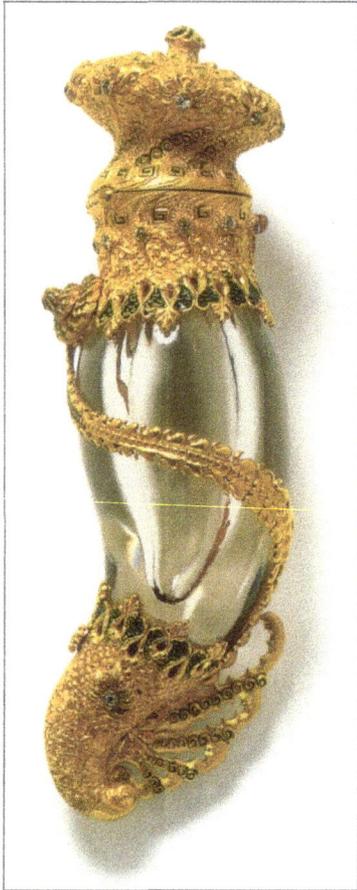

Tiffany made a number of perfume bottles—this one shows the inspiration of the sea.

Nautilus Perfume Bottle
Tiffany & Co.
New York, 1890–1910
Rock crystal quartz, diamonds, enamel, and 18k gold
H: 11.4 x W: 3.8 cm / 4.5 x 1.5"

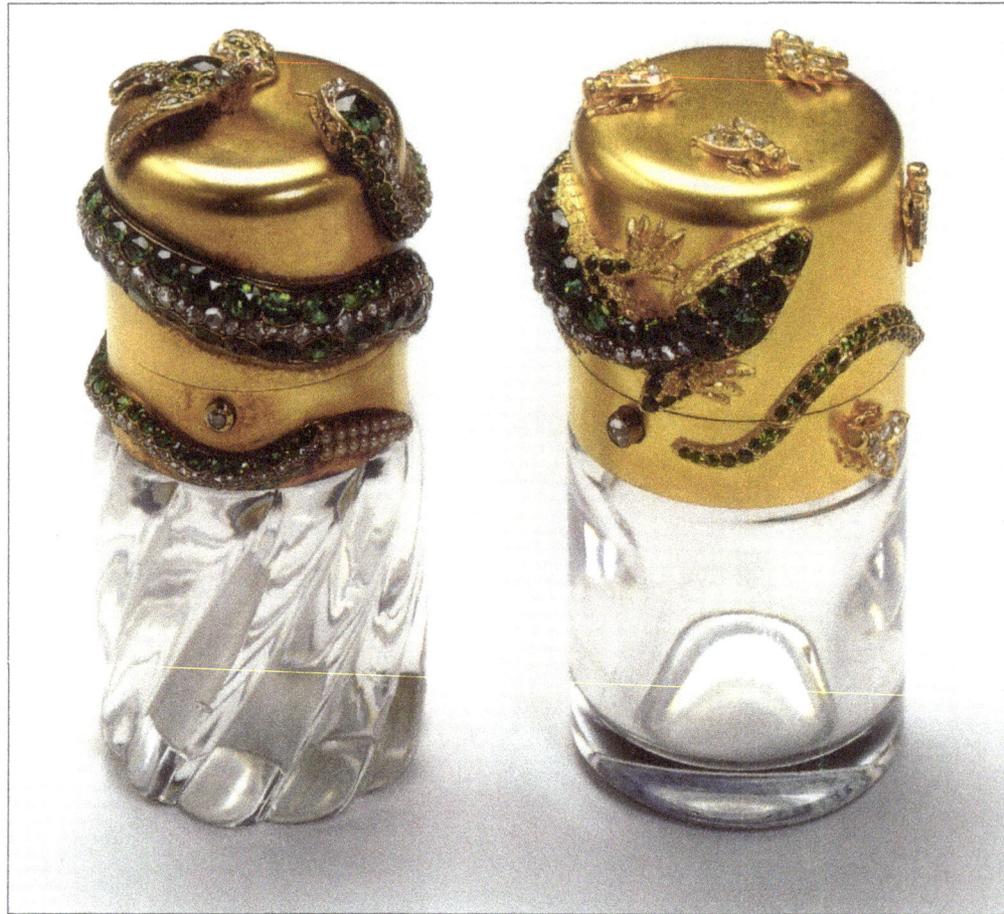

Two Perfume Bottles
Paulding Farnham
Tiffany & Co.
New York, 1890
Crystal, yellow gold, demantoid garnets, diamonds, rubies, and pearls
Lizard Bottle: H: 6.5 x W: 3.8 cm / 2.6 x 1.5" diameter
Snake Bottle: H: 6.7 x W: 3.5 cm / 2.6 x 1.4" diameter

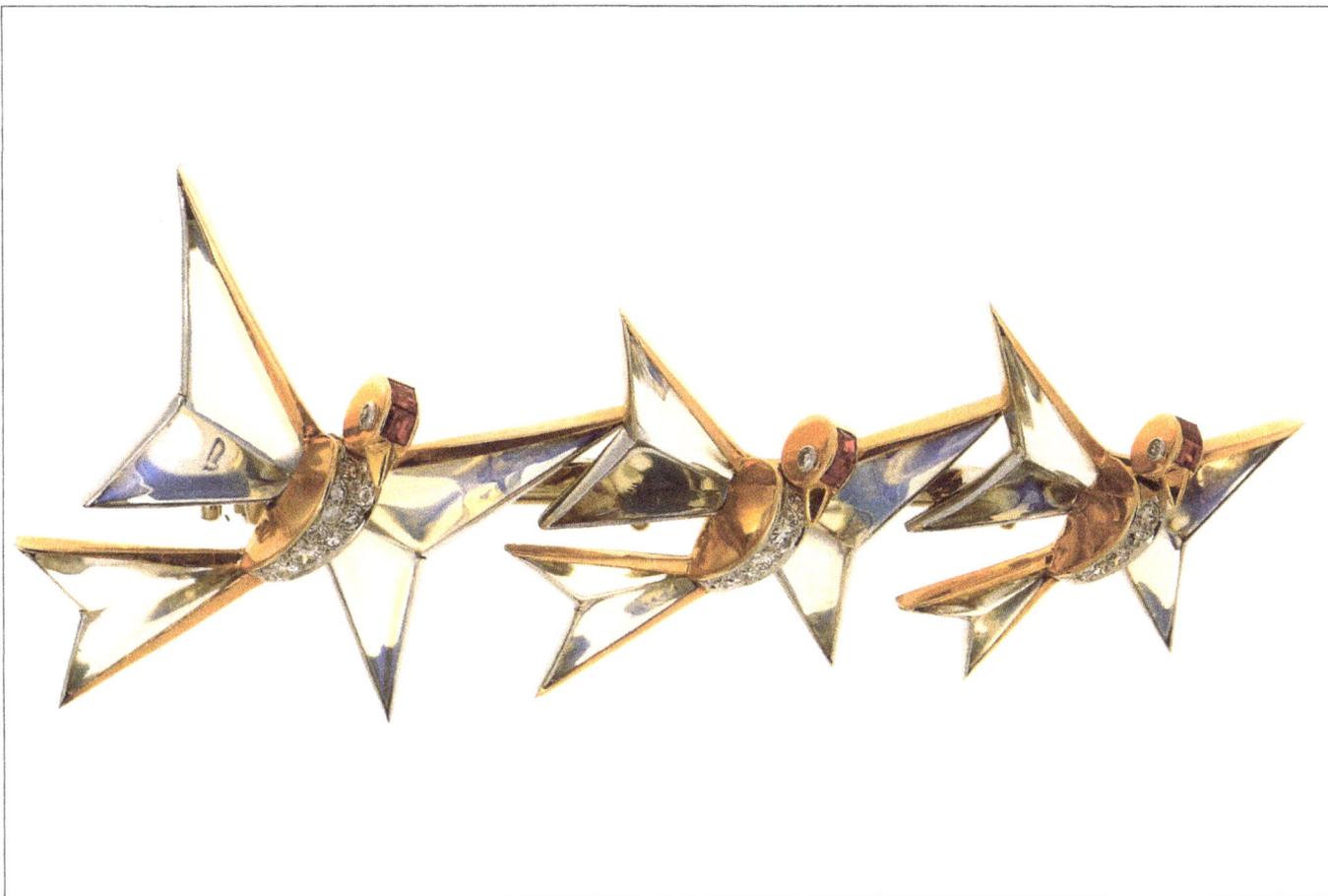

decoration having been designed with crystal, diamonds, pearls, rubies and demantoid garnets. What is so unusual about these perfume bottles are the snake and insect designs, despite the femininity connoted by the intended user.

At the turn of the century, the jewelry designers who were influenced by the Art Nouveau period produced jewelry based on nature, which was often reflected in their choice of stones. Moonstones and opals were now the gems of choice. Also, scientific papers were published about newly discovered exotic plants. This brought a new awareness to the jewelers who started to use these new flowers in their works. During this time, other firms,

Birds in Flight Brooch
Marcus & Co.
New York, 1940
L: 5 x W:11.4 cm / 2 x 4½"
Moonstones, rubies, diamonds, rose gold, and platinum

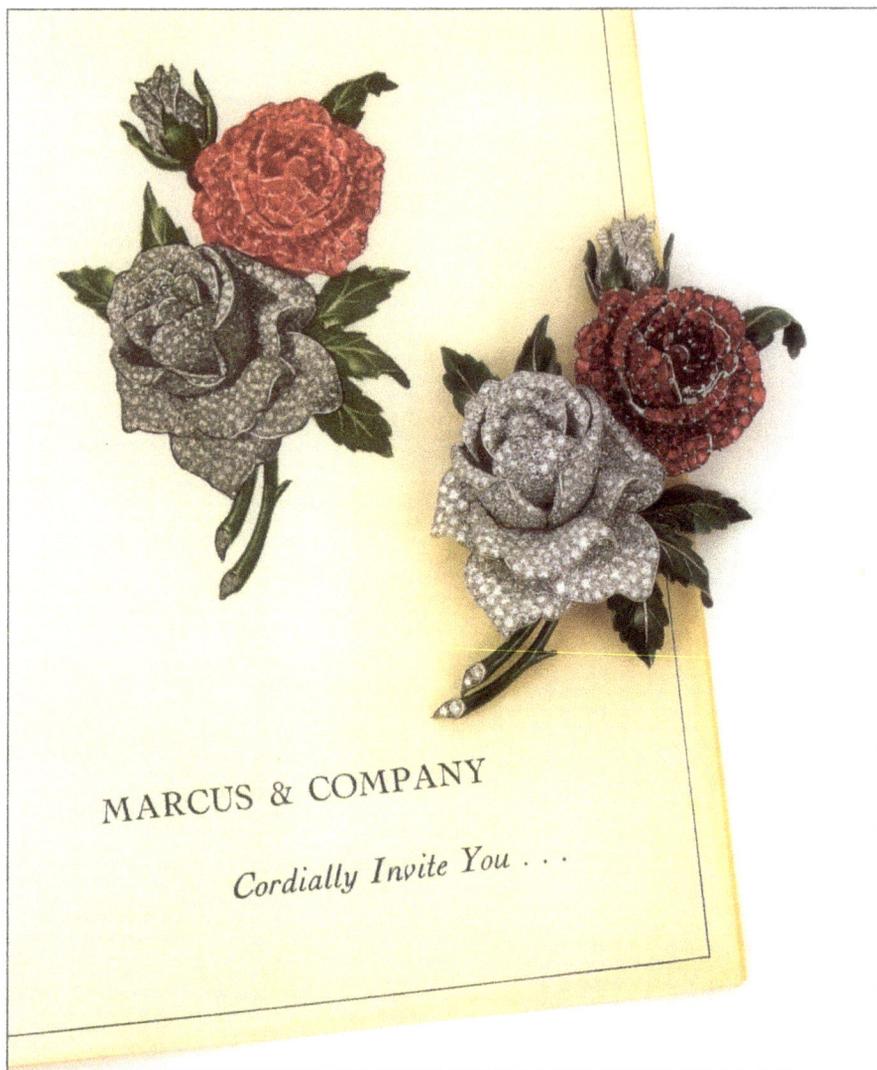

Photographed for a Marcus & Co. catalogue are the actual diamond and ruby rose pins. In this piece, enamel has given way to diamonds and rubies. However, the leaves are still enameled green. This brooch was part of a series of ruby and diamond flower brooches that Marcus created in the 1920s and 1930s.

Diamond and Ruby Rose Brooch
Marcus & Co.
New York, c. 1937
H: 3$\frac{1}{2}$ x W: 2$\frac{3}{8}$"

(Page 45, Top) Moonstones had reached their greatest popularity in jewelry in the 1940s. The large scale of this brooch stands out among Tiffany's production in that period.

Pussy Willow Brooch
Tiffany & Co.
New York, 1950
Moonstones, diamonds, and platinum
H:15.7 x W: 4.8 cm / 6.2 x 1.9"

(Page 45, Bottom) The interest in this piece is in the cut of the stones and the sophisticated enameling.

Jeweled Platinum Swan Brooch
Unknown Artist
1905
Sapphire, peridot, diamonds, and enamel
L: 3.8 x W: 5.9 cm / 1$\frac{1}{2}$ x 2$\frac{5}{16}$"

such as Marcus & Company and J.E. Caldwell were also recognized for their extraordinary jewels representing nature. For a fifty-year period until 1940, Marcus & Company created remarkable bird and flower brooches. The jewels were also in keeping with the fashions and styles of the times. Another amazing bird and flower brooch by Marcus & Company is the brooch on page 43, designed in 1940 with moonstones, rubies, and diamonds.

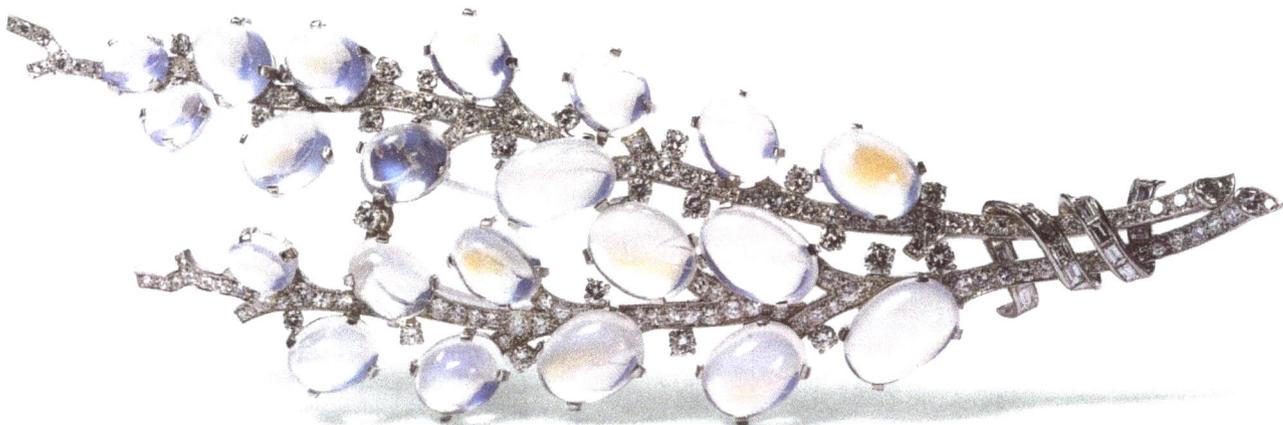

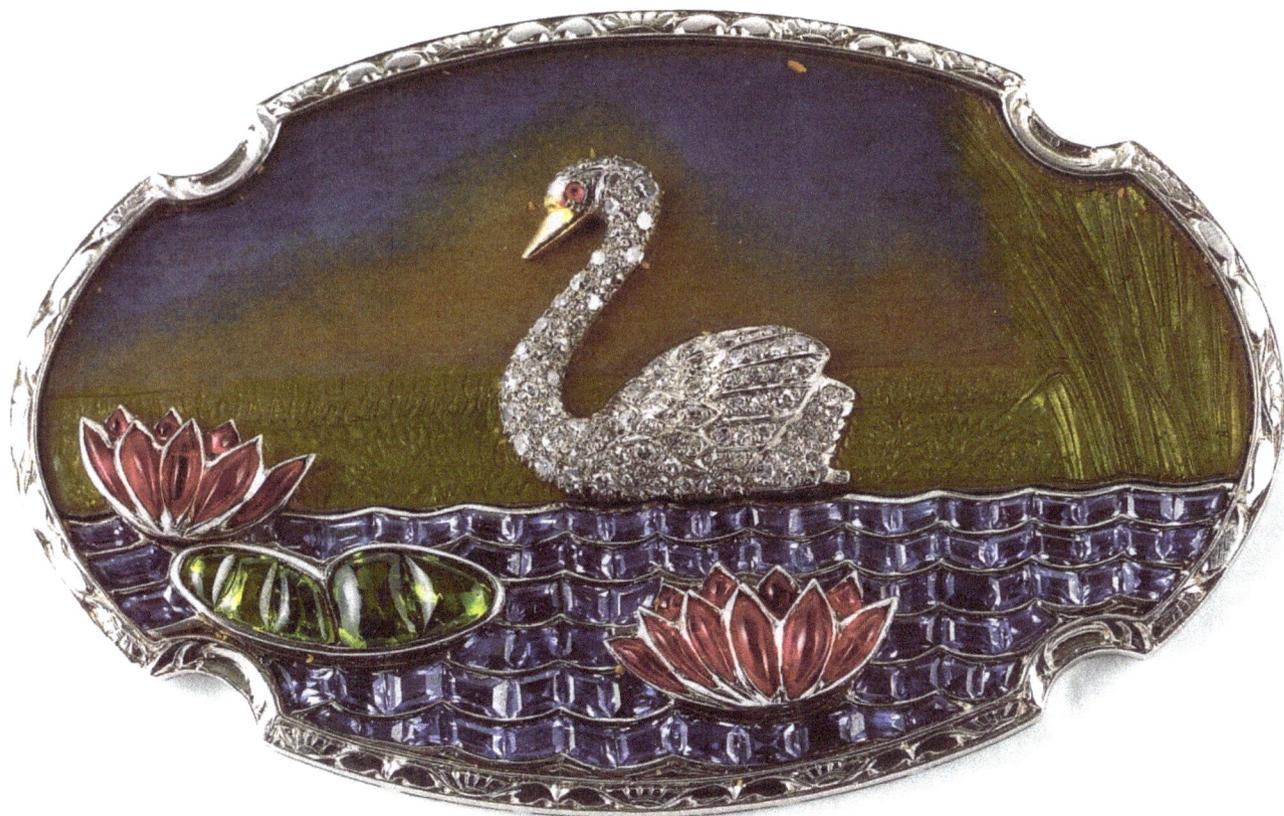

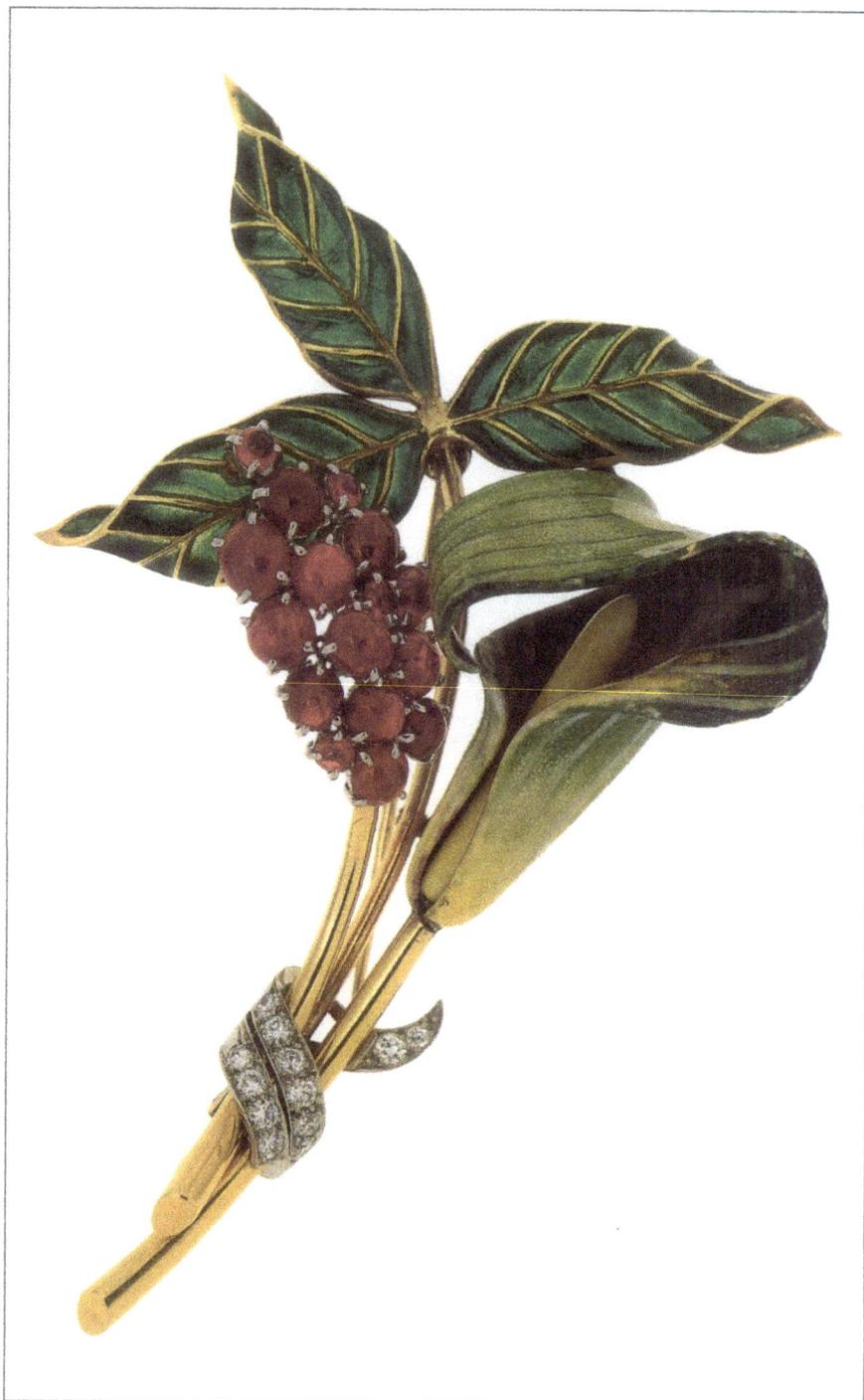

At the turn of the century, jewelers were attempting to copy nature. As the century progressed, there was greater courage among designers to abstract nature.

Jeweled Lily Flower Brooch
Marcus & Co.
New York, 1930
Rubies, diamonds, gold, and enamel
L: 8 x W: 5.5 cm / 3³/₁₆ x 2¹/₂"

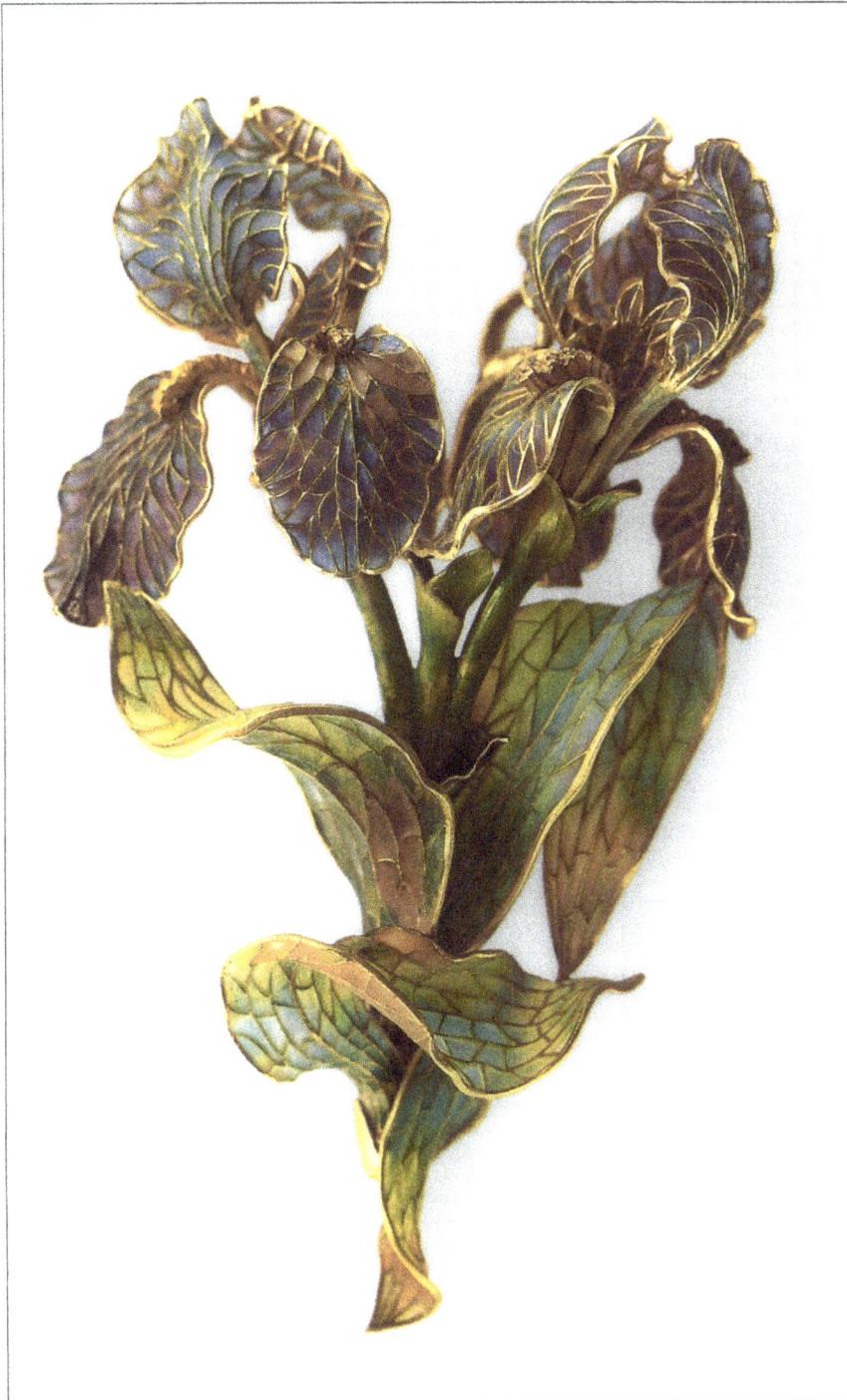

When held up to the light, the leaves and flowers of this extraordinary brooch appear translucent. The naturalistically depicted iris looks as if it just came from a garden.

Iris Brooch with Enamel and Yellow Gold
Marcus & Co.
New York, 1900
H: 10.5 x W: 6.5 cm / 4 x 2.5"

Millicent Rogers

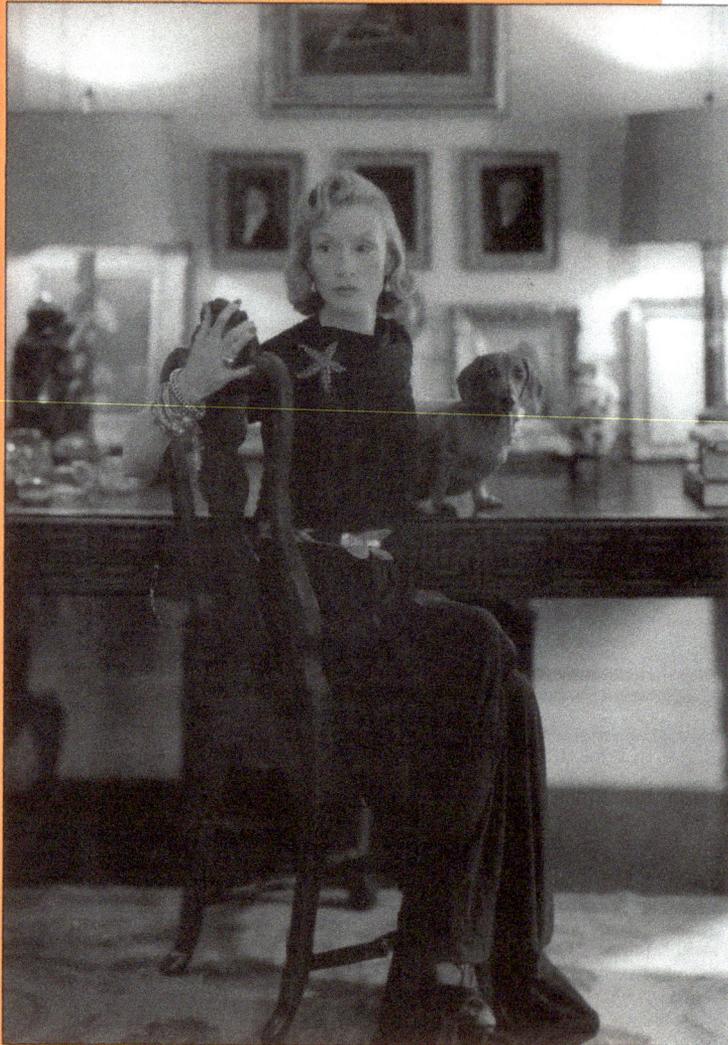

Although Millicent Rogers passed away in 1953, her contribution to art, and the establishment of the Millicent Rogers Museum in Taos, New Mexico, has kept her name very much alive in the world of decorative art. She was a formidable woman, though whether this was derived from her great wealth is unclear. One thing *is* clear—no one ever called Millicent Rogers a shrinking violet.

Roots

Millicent Rogers was the granddaughter of Henry Huttleston Rogers, one of the original founders of Standard Oil. In 1880, her paternal grandfather was nicknamed "The Hellhound of Wall Street," and Millicent Rogers was known as "The Standard Oil Heiress." She spent much of her early life in Europe, then moved to New Mexico. In the 1920s, she modeled for *Harper's Bazaar*, *Vogue*, and *Town & Country*. She married a Native American and had two sons, Paul & Arturo Ramos, who started the museum that showcases her extraordinary collection of decorative art.

Lucre

She was enormously rich, and lived in a totally different world than most people. She loved the arts, including painting, sculpture, and theatre, but she had a specific passion for American jewelry.

Taste

From the mid 1920s until the late 1940s she had over 500 couture gowns created for her by designers Alix Gres, Elsa Schiaparelli, Jeannie Lanvin, Mainbocher and Charles James. Later in life she invented the hybrid Southwest style, incorporating Southwestern materials into her notions of taste.

Style

While sometimes looking very patrician, Rogers had the chameleon's ability to change her clothes, her hair style, and its color. In the late 1930s, for example, she became platinum blonde, after being a dark brunette.

Gems

Millicent Rogers loved jewelry that mimicked nature. Her favorite jewelers were Verdura and Jean Schlumberger, seen in the photograph on page 48 by John Rawlings. She sits at her writing desk with her pet dachshund eyeing the camera, wearing heavy silver bracelets on her left wrist.

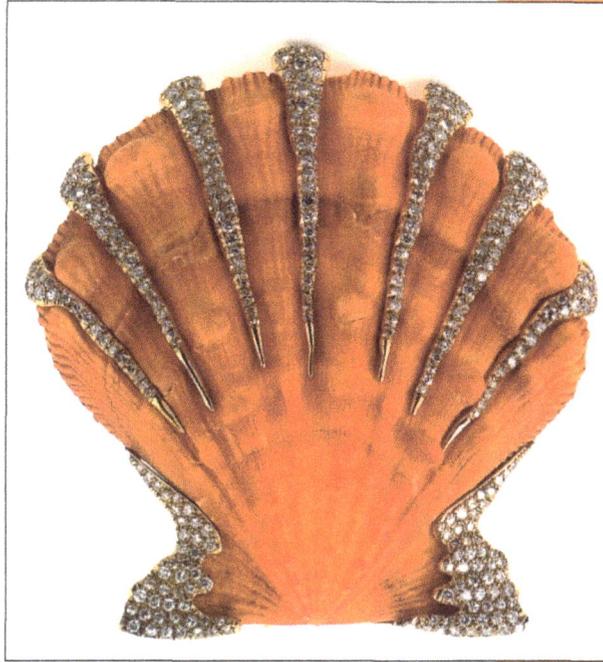

Verdura had worked for Coco Chanel in Paris and moved to New York in 1934. He worked for a few years for jewelry designer Paul Flato before opening his own business in 1939. Verdura was witty and had great style. The brooch pictured here was designed for Millicent Rogers. It is simple and elegant. Verdura's use of diamonds on a shell is uniquely American, as the American designers took "found" materials like seashells and made works of art from them.

Lion's Paw Shell Brooch
Verdura
New York, 1940
Shell, diamonds, and 18k gold
L: 8.25 x W: 8.25 cm / $3^{1}/_{4}$ x $3^{1}/_{4}$"

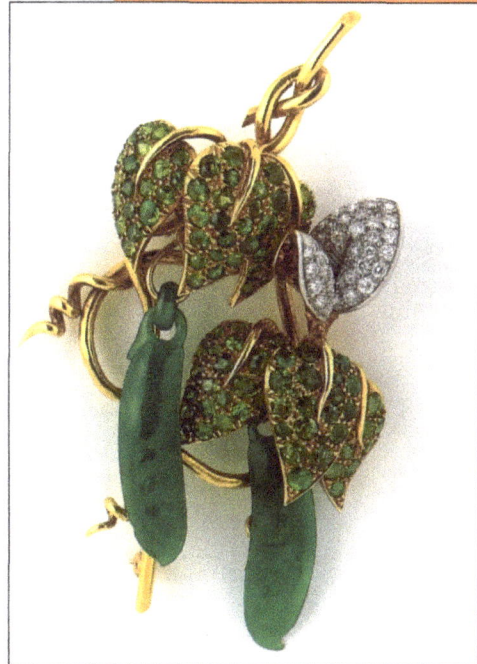

Schlumberger came to New York and opened his own business in 1947. He became a good friend of Editor Diana Vreeland, who publicized him in *Harper's Bazaar* and then *Vogue*. He began working for Tiffany in 1956, and showed an early love of nature in his work. He loved mixing colors in stones.

Jeweled String Bean Brooch
Jean Schlumberger
New York, 1951
Diamonds, jade, demantoid garnets, and 18k gold
L: 7.1 cm / $2^{3}/_{4}$"

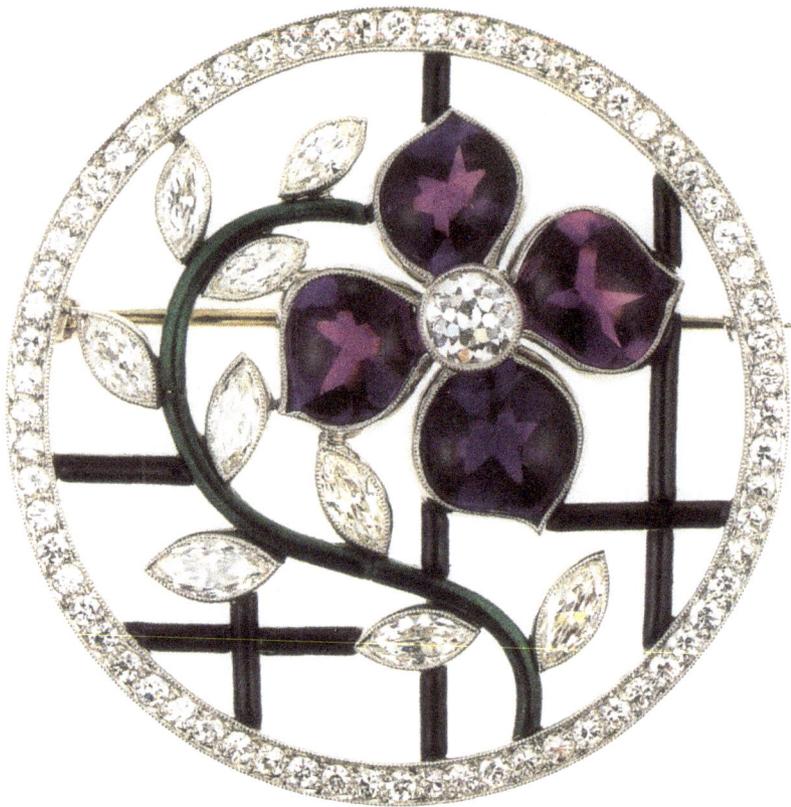

J.E. Caldwell & Co. was "the" jeweler for the Philadelphia Mainline establishment. This pin reflects the socio-economic status of Caldwell's clientele, who consisted primarily of married and conservative people.

Geometric Flower Brooch
J.E. Caldwell & Co.
Philadelphia, 1920
Diamonds, amethysts, enamel, and platinum

(Page 51, Left) While this series was not part of the Newark Group, it was aimed at the same clientele, i.e., the newly emerging middle class. The emphasis on multi-colored gold makes this group unusual.

Flowers and Birds
Unsigned
Newark, 1879

(Page 51, Top Right) This flower was designed and made by a Baltimore retailer, Oscar Caplan. It was created in 14k gold with a topaz in the center, and was possibly enameled in Newark.

Purple Flower
Oscar Caplan
Baltimore, 1938
L: 8.7 x W: 8.4 cm / 3³⁄₈ x 3¹⁄₆"

(Page 51, Bottom Right) Although mass produced, each of these Newark pieces still had to be individually enameled by hand.

Enameled flowers, with pearls and diamonds by Hedges
Newark Group
Newark, c. 1910–1940

Another designer of American jewels known for floral styles was J.E. Caldwell, known as "The Watch Jeweler" to the Philadelphia establishment. J.E. Caldwell began designing jeweled floral pins using semi-precious stones. A later pin, from about 1920 (above), is quite simple. It is set with diamonds and amethysts and is enameled.

Matching the production of the high-end jewelry retailers were the Newark manufacturers, who appealed to the newly emerging middle class. The results of their varied production of flowers, animals, and birds can be seen on pages 51 to 60. Newark was able to create beautiful jewelry with colorful enamel and simple design. Without the Newark firms' ability

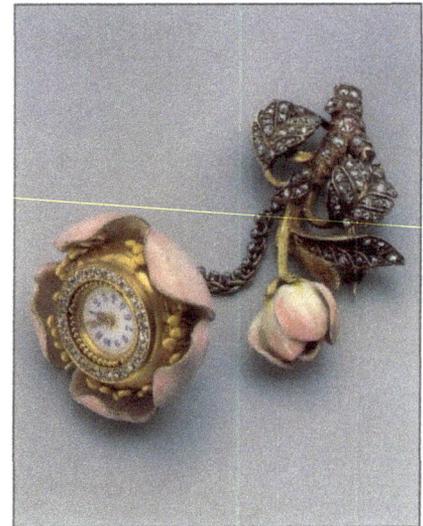

Lapel watch is made out of enamel, crystal and diamonds, and set in gold. Of interest in this piece is the use of a Native American flower.

The American Wild Rose
Paulding Farnham
Tiffany & Co.
New York, 1889
H: 8.25 x W: 3.8 cm / 3.25 x 1.25"

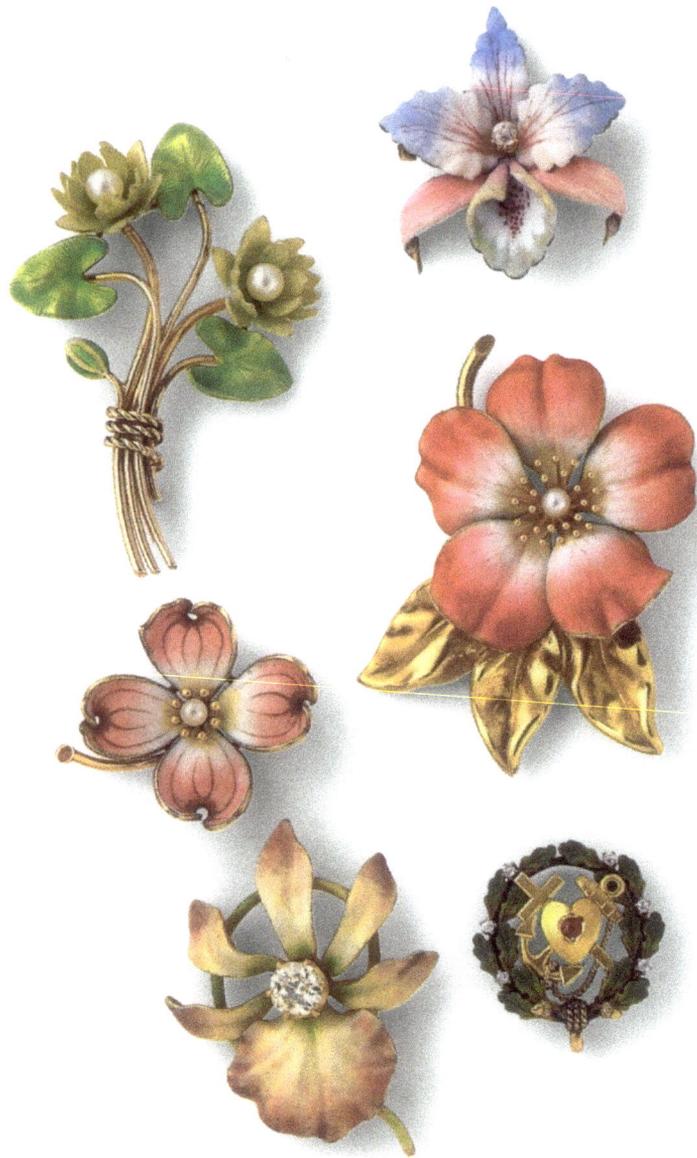

What is interesting in these flowers is their enamel coloring. These flowers could be mass produced in editions of up to 500. This is quite a contrast from the mass production of today, where numbers get into the tens of thousands.

Flower Brooches
Newark Group
c. 1915–1930

to mass produce, there is no way that Verdura's beautifully crafted natural seashell (on page 49) or the David Webb natural tortoise shell box could ever have been produced (page 61).

At the end of World War I, one force of social change profoundly affected the jewelry industry. Women were becoming more liberated in terms of their dress, their accepted

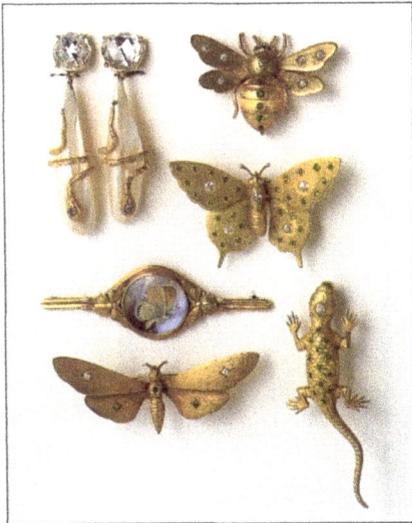

What makes this group interesting are the rose-cut diamond earrings and pearls, as well as the body of a butterfly encased in the gold bar pin. The gold animals are all set with diamonds and demantoid garnets. These pieces were made by Hedges, the Newark jeweler.

Salamanders and Bees
Newark Group
Hedges
Unsigned
c. 1880–1900

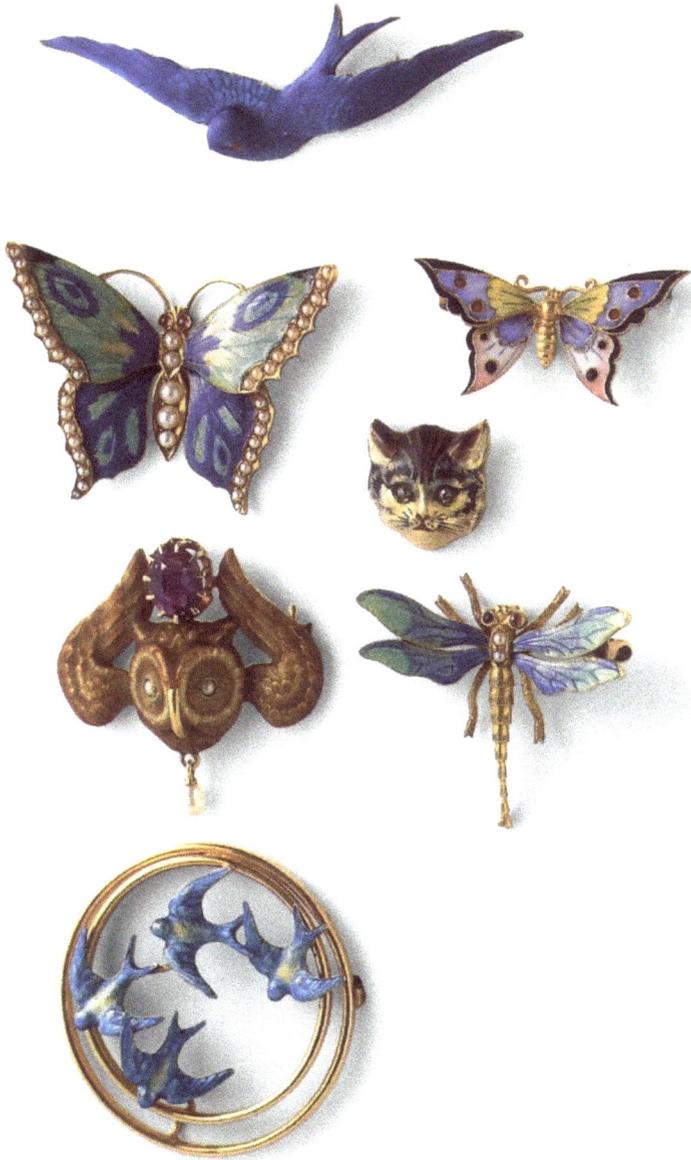

The birds are by Krementz and the butterflies by Riker Bros.
The enameling on the butterflies shows a more sophisticated design.

Birds and Butterflies
Newark Group
c. 1910–1940

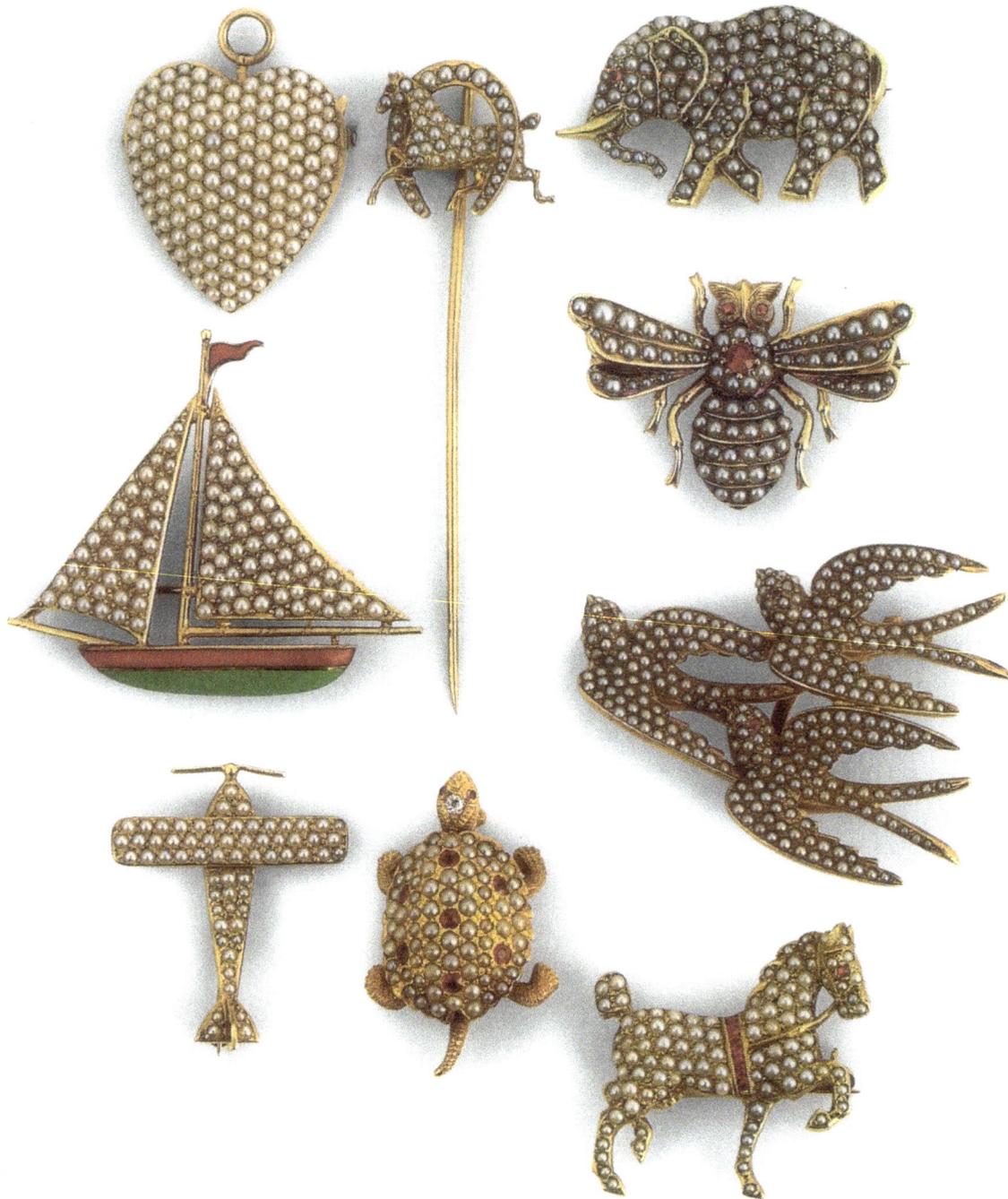

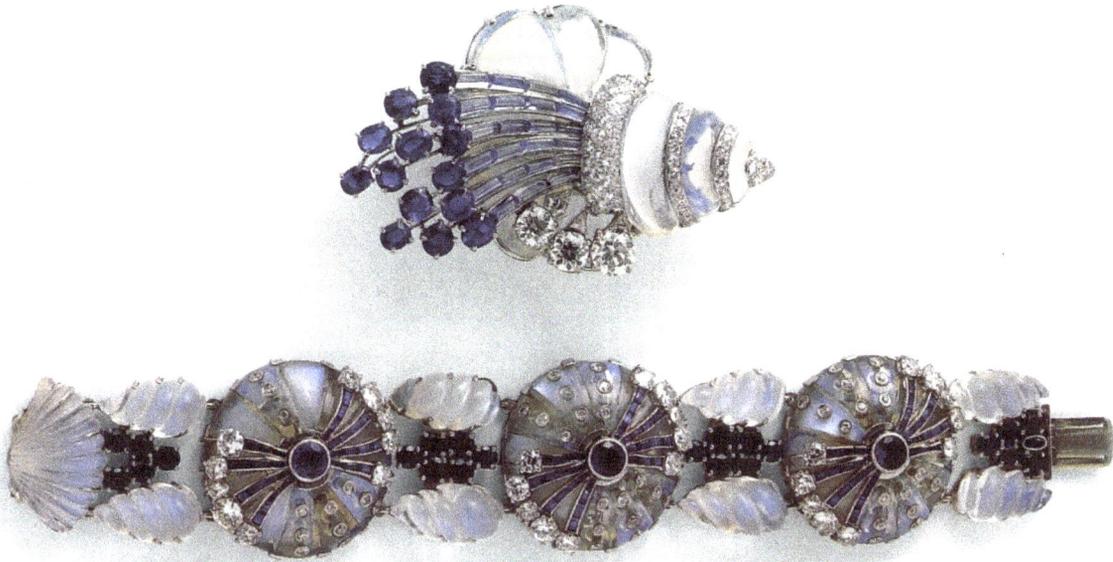

behavior (like smoking in public) and their new economic empowerment. Condé Nast realized that women could be persuaded to buy jewelry. In the pages of *Vogue*, he took advertising from the jewelers and showed their wonderful jewelry on highly fashionable women. What better way to experience the dream than to buy something that was on these pages? As a result, jewelry advertising has become memorable with headlines such as "Diamonds are Forever." More recently, advertising has taken the next step of encouraging women with headlines like, "The left hand declares your commitment, your right hand is a declaration of independence."

Marcus & Co. was inspired by the sea to create this set. The boldness of the design interacts with the blue water coloring of moonstone and sapphire.

Bracelet and Brooch
Marcus & Co.
c. 1935
Carved moonstone, sapphires, and diamonds set in platinum
Brooch: L: 7 x W: 4 cm / 2^1/$_2$ x 1^1/$_2$"
Bracelet: L: 16 x W: 2.8 cm / 6^1/$_2$ x 1^1/$_8$"

(Page 54) This Newark group made by Krementz, Riker Bros., and Sloane & Co. shows the variety of seed pearl jewelry being produced in Newark.

Seed Pearl Jewelry
Newark Group
c. 1920

Dutchess of Windsor

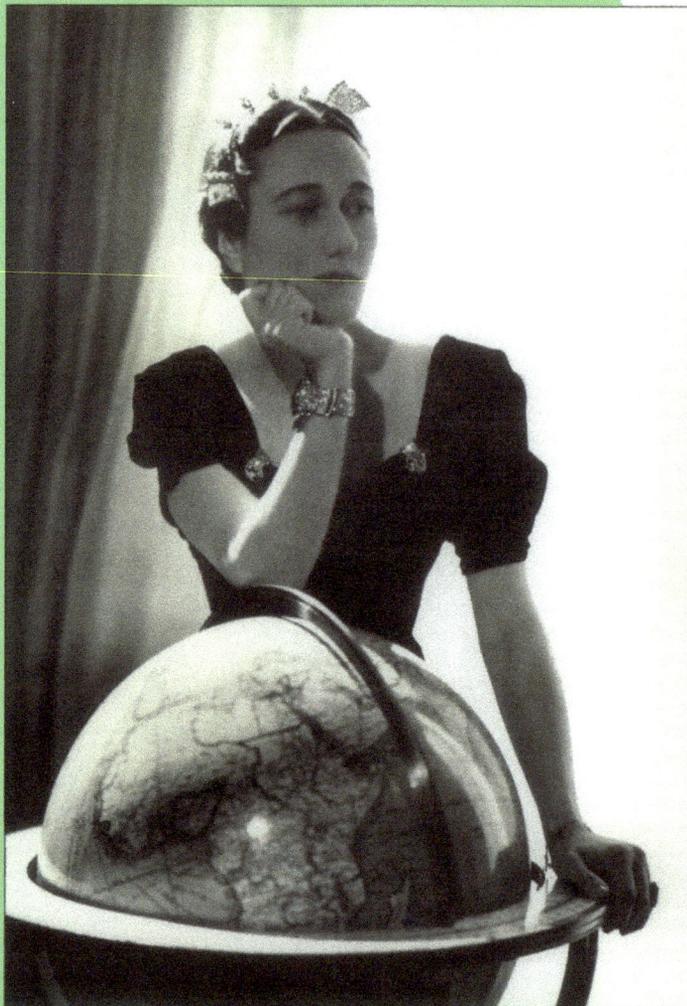

Persona

In *A King's Story*, the Duke of Windsor writes: "In character, Wallis was, and still remains, complex and elusive; and from the first, I looked upon her as the most independent woman I had ever met."

Roots

She was born Bessie Wallis Warfield in Baltimore, Maryland in June of 1896. Her father died when she was less than a year old. Her mother was forced to approach wealthy relatives for help. According to historical reports, Bessie dropped her first name because "So many cows are called Bessie." She married quickly to escape from Baltimore, soon divorced, and then married a wealthy shipping industrialist. She was still married when she met the Prince of Wales.

Lucre

She had a terrible fear of being poor. In 1930, she wrote to her mother: "I really feel so tired of fighting the world alone and with no money." Another of the more famous quotations attributed to Wallis sums up her outlook perfectly: "A woman can never be too thin or too rich."

Style

She was known to say that clothes should be simple, however she cared very much about what she wore: "I'm not a beautiful woman. I'm nothing to look at, so the only thing I can do is dress better than anyone else."

Taste

In 1937, Wallis Simpson married the Duke of Windsor in France. Although he could never become King, because of his marriage, the Duke gave Wallis the life of a Queen. She furnished a thirty-room mansion in Paris, and all of the international café society was at her feet. She hobnobbed with the Rothschilds, Woolworths, Donahues, and Estée Lauder in Palm Beach.

Gems

The Duke lavished fantastic jewels upon her. According to *Famous Jewelry Collections*, by Stefano Papi and Alexandra Rhodes: "The Windsors patronized such designers as Suzanne Belperron, Verdura, Seaman Schepps and David Webb. She was a major client of Cartier and Van Cleef & Arpels."

The McLean Diamond was probably Harry Winston's best contribution to the Windsor's collection. It was a cushion-shaped stone weighing 31.26 karats and of the finest "D" color from the old Golconda mines in India. It had been owned previously by Evelyn Walsh McLean, the celebrated Washington hostess and avid jewelry collector.

When she died in 1986, the jewels were sold at Sotheby's in Geneva. Their value totaled more than $31 million. Papi and Rhodes report that Sotheby's auctioneer Nicholas Raynor said: "The three elements of history, quality, and design make the collection altogether unique."

Seaman Schepps is best known for his large jewels, set with precious and semi-precious stones. When Schepps visited Hong Kong, he was inspired to create an "Oriental" series. This buddha is in perfect sync with nature and is representative of that style.

Oriental Brooch
Seaman Schepps
Late 1930s
Tourmaline, emeralds, rubies, diamonds, yellow gold, and platinum
H: 5.5 x L: 2 x W: 1.8 cm / 2¼ x 1¾ x ¹¹⁄₁₆"

(Page 59) The Duchess of Windsor had a great effect on jewelry design. When she wore a flower, everyone wanted one. This flower designed by Cartier is crafted with a carved emerald and is enhanced by diamonds. Many firms at this time were focusing on semi-precious stones. Cartier went the other way and focused on precious stones.

Flower Brooch
Cartier
New York, 1939
Carved emerald, rubies, diamonds, yellow gold, and black enamel
H: 5.5 x W: 5 cm / 2⅛ x 2"

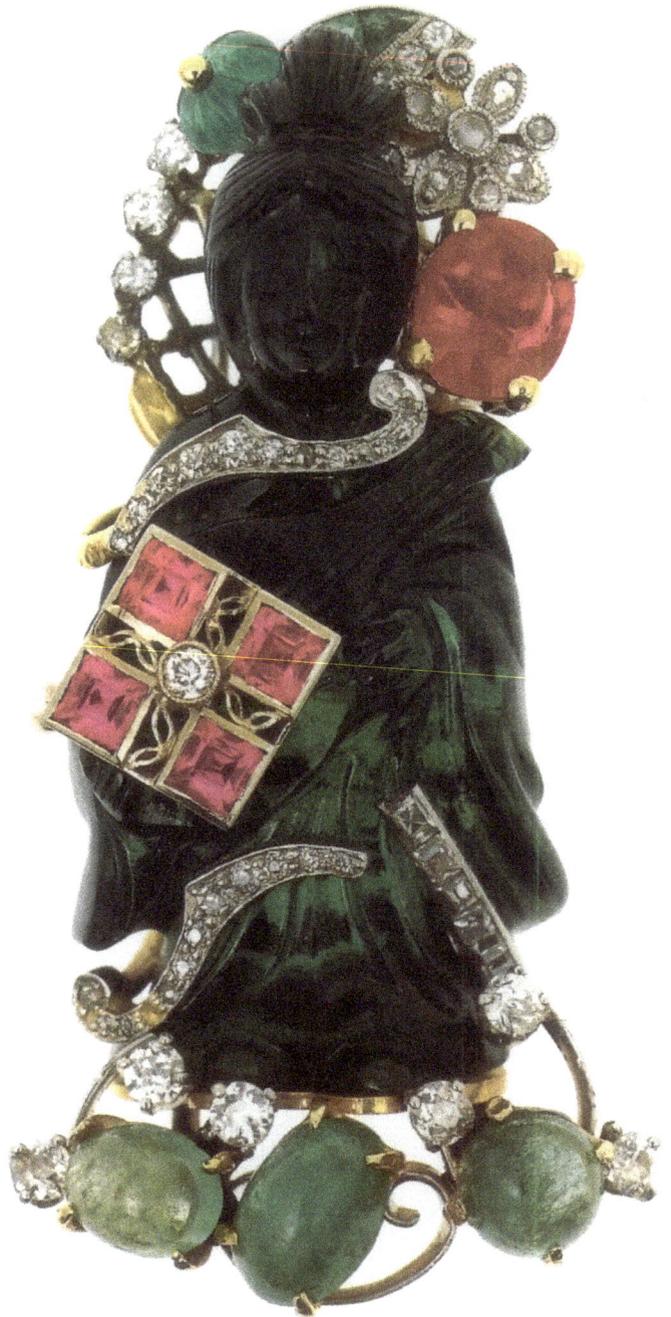

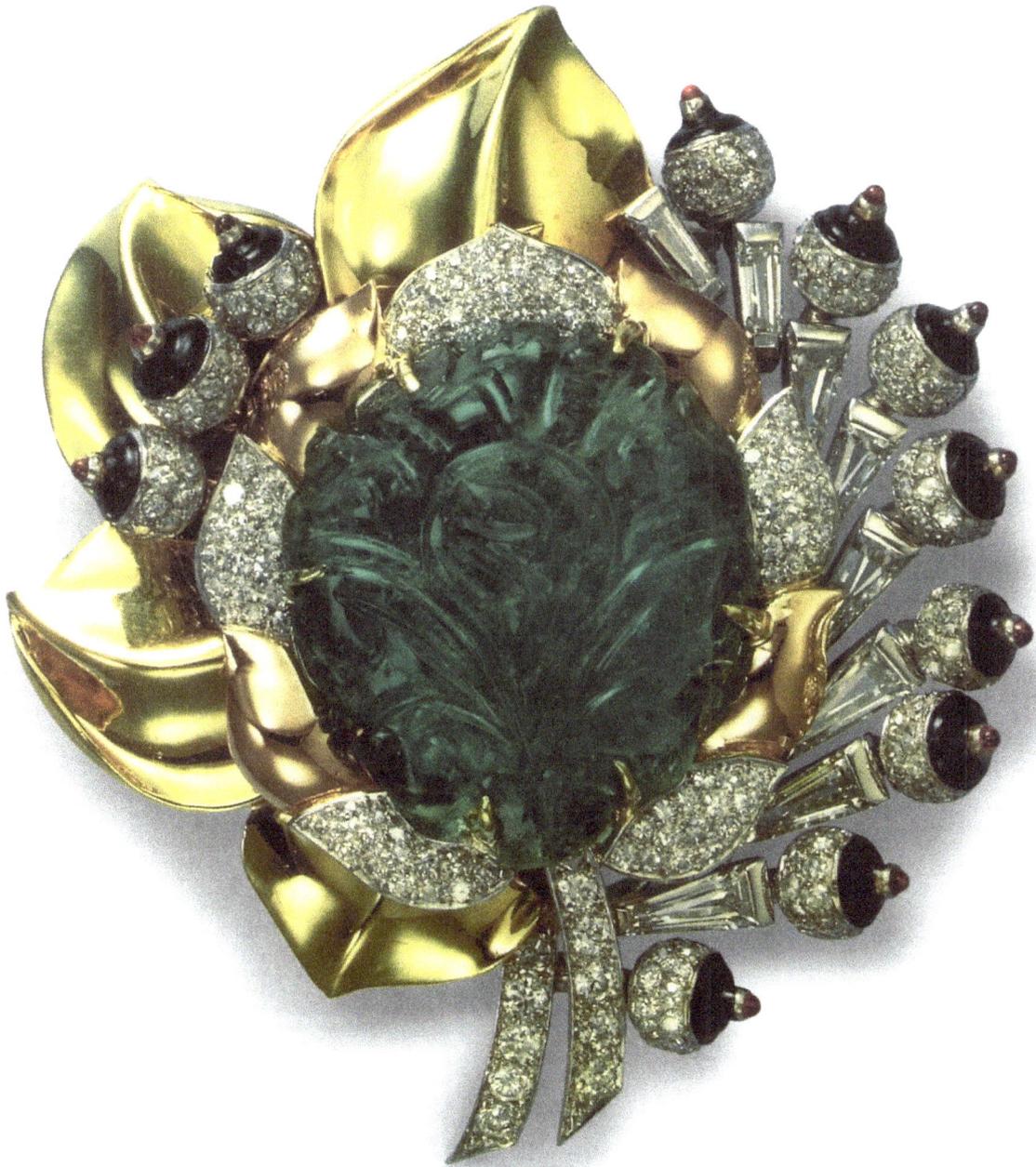

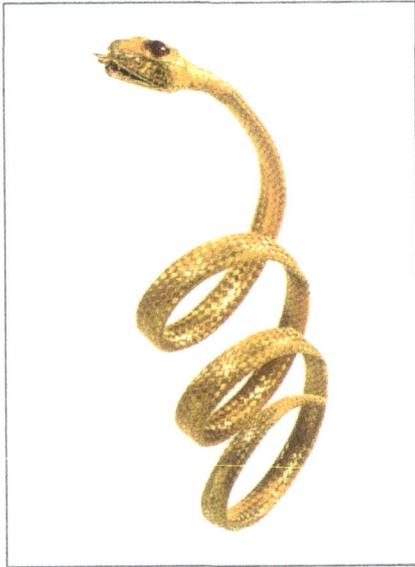

(Above) This piece could be worn as a bracelet or upper armband. Krementz was a leading Newark manufacturer of jewelry and a supplier of precious stones to the jewelry market.

Gold snake with topaz in head and coiled body
Krementz
Newark Group
1915
L: 72.5 x W: 1.2 cm / 28½ x ½"

(Right) In their nature-derived themes, the Newark Group also included the domestic cat, foxes, owls and spiders. Note the unusual delicacy of the comb with the two butterflies.

Variety of Animal-themed jewelry
Newark Group
c. 1910–1940

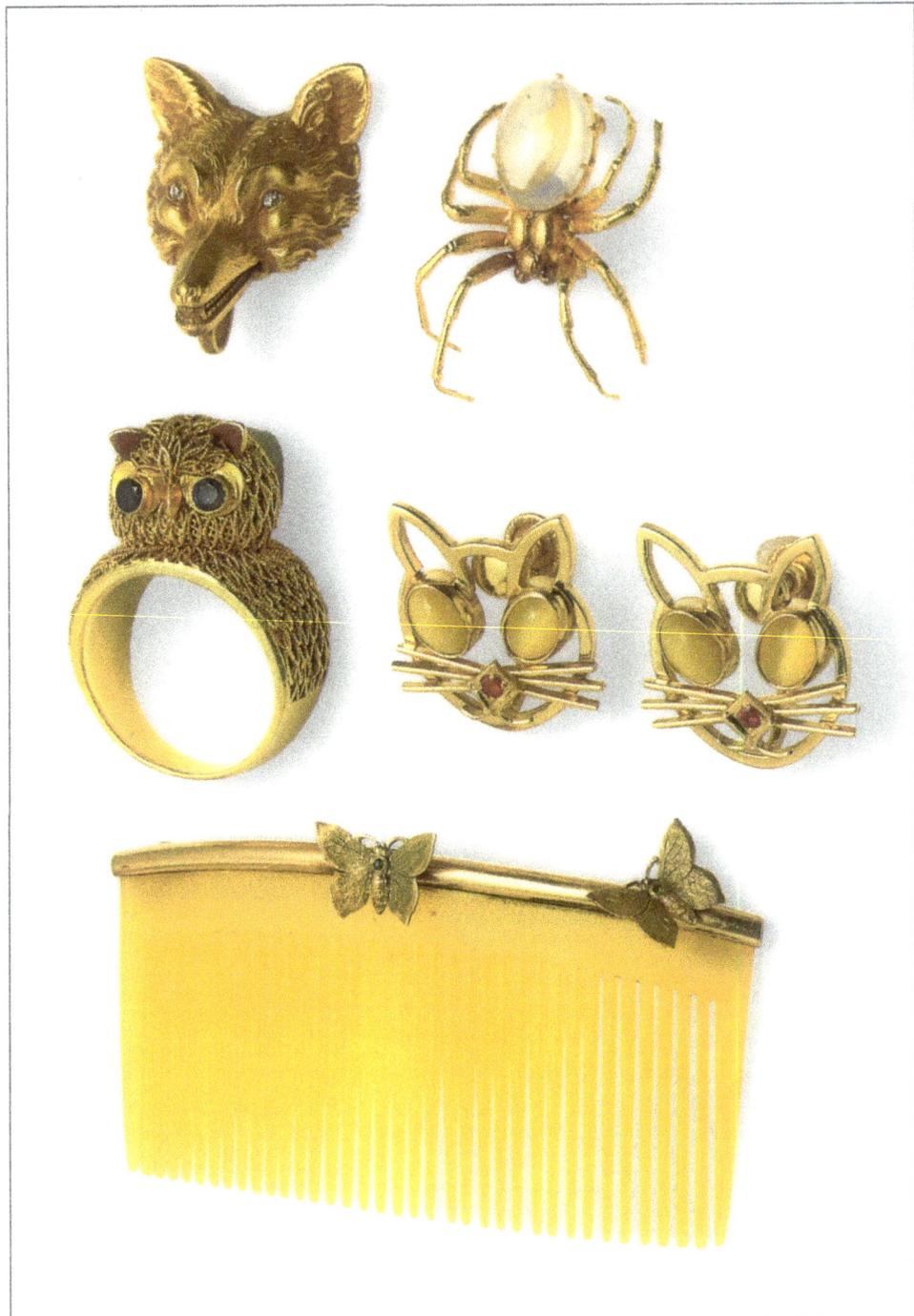

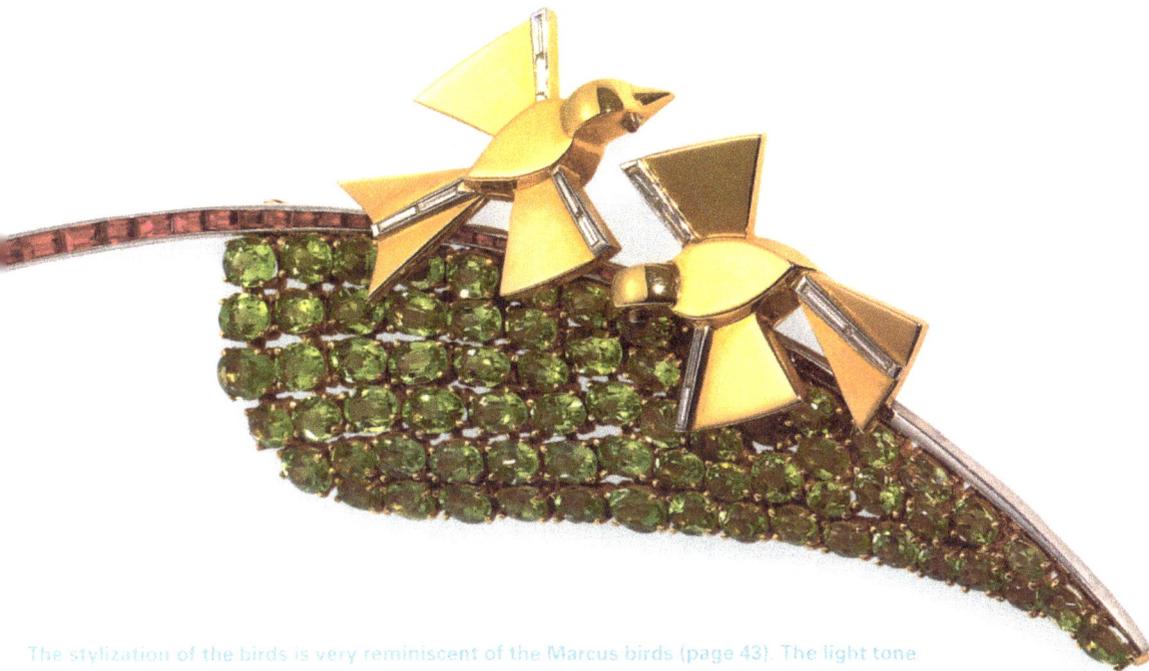

The stylization of the birds is very reminiscent of the Marcus birds (page 43). The light tone of these peridots indicates they are from Norway and creates a more balanced piece of jewelry with the boldness of the gold birds.

Birds on Leaf Brooch
Unsigned
c. 1940
Rubies, diamonds, peridots, gold, and platinum
L: 4.8 x W: 11.8 cm / 1³/₄ x 4⁵/₈ "

One important, flower-style jewel represented in the book is the leaf brooch with invisibly-set rubies, signed by Van Cleef & Arpels in the high style section page 110. There were three of these made; one was purchased by the Duchess of Windsor.

From the Art Nouveau designs to the linear Deco creations to the modernist visions of today, nature jewelry has ultimately been a reflection of the American spirit and an expression of our endless possibilities.

Our pioneer culture and the aspirations of immigrants seeking a better life manifest themselves in dreamlike images of celebrating nature and the vast landscapes of America.

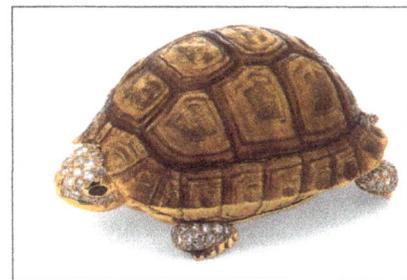

David Webb moved to New York from Ashville, North Carolina. In 1946, he began a business with Nina Silberstein. Like Verdura, Webb used "found" materials and turned them into art objects. This is an actual tortoise shell that Webb turned into an elegant 18k box.

Tortoise Vanity
David Webb
Tortoise shell, diamonds, gold, and emeralds
c. 1960
L: 8.25 x W: 5.5 cm / 3¹/₂ x 2¹/₃ "

(Above) Montana sapphires were discovered at the turn of the twentieth century. Because of their brilliant coloring and small dimension, they were sought by European and American designers.

Flower watch bracelet
Van Cleef & Arpels
New York, 1950s
Montana sapphires, diamonds, 18k gold, and platinum
L:18.3 x W: 2.5 cm / 7 x 1"

(Page 63) The Montana sapphire is habitually cut as a round stone, which adds to its natural luster.

Montana Sapphire Flower Brooch
Van Cleef & Arpels
New York, c. 1950
L: 9.5 x W: 6.3 cm / 3³/₄ x 2³/₈"

PASTIMES

It's hard to prove, but the sporting life may be in the DNA of Americans. In Europe, only the upper class hunted, fished, or sailed. In America, hunting and fishing were the pastimes of nearly every man. And even if some Americans were not active participants, they all enjoyed the great American pastime of baseball.

One of the earliest pieces depicting America's love of leisure, signed by Marcus and Company from 1900, is an enchanting brooch depicting a fantasy ship of yesteryear. The piece is a commission for a family who loved the leisure activity of sailing. We can see

their ideal "fantasy ship" portrayed in the brooch pictured on page 65.

By the 1920s, industrialization had taken over life in America. The automobile changed everything. The passengers and the driver of a car even required different clothes—so "sport" jewelry was born. One of the most important American firms manufacturing sport jewelry was William Scheer in New York.

During the roaring twenties before the 1929 crash, the work of William Scheer reflected America at play. We see some of his work on page 66 encrusted in pavé diamonds,

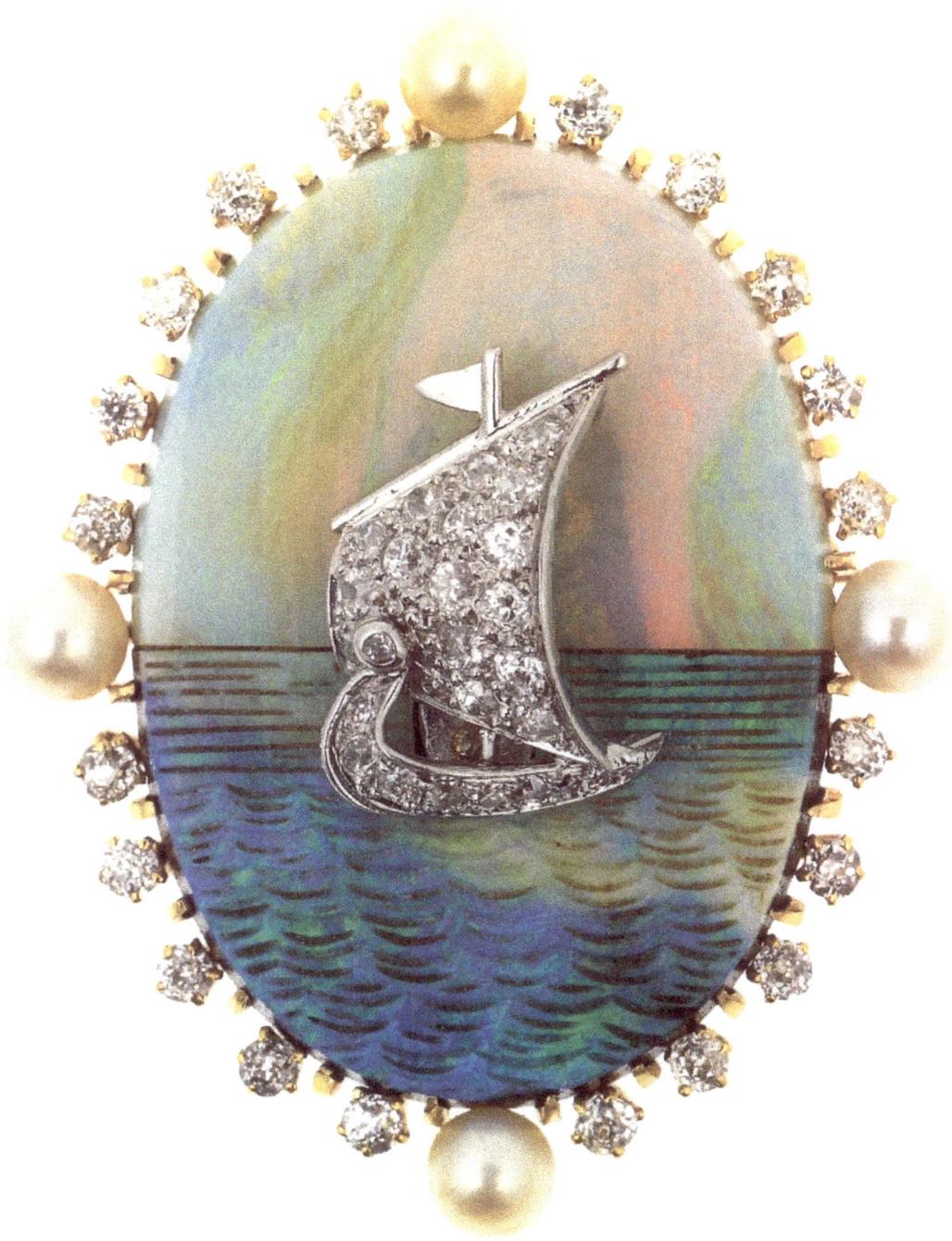

This piece was created for a family who loved the sea, as evidenced by the delicate work of the pin. Marcus & Co. was established in 1892 when Herman Marcus came to New York from Germany. Having worked in the jewelry business, Herman was joined by his brother, George, and his son, Herman. Herman had worked for Charles Tiffany and Theodore B. Starr, establishing Starr & Marcus. In the 1920s, Marcus & Co. opened branches in London, Paris, and Palm Beach. Raymond C. Yard worked as a door boy for Marcus & Co. before achieving recognition on his own.

Sailing Ship
Marcus & Co.
New York, 1900
Platinum, yellow gold, opals,
diamonds, and pearls
L: 4.3 x W: 3.5 cm / 1.7 x 1.3"

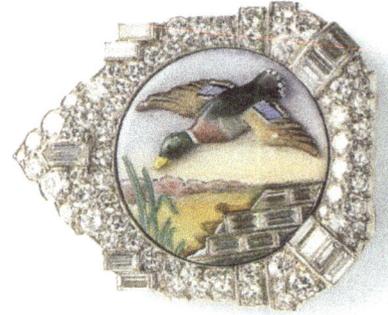

Fox Hunt Brooch
Alling & Co.
Newark, c. 1940–1950
Diamond, 14k gold, and enamel
L: 3.5 x W: 2.5 cm / 1¼ x 1"

Fish and Harpoon Brooch
William Scheer
New York, c. 1940–1950
Pearl, 14k gold, and enamel
L: 4 x W: 1 cm / 1⅝ x ⅝"

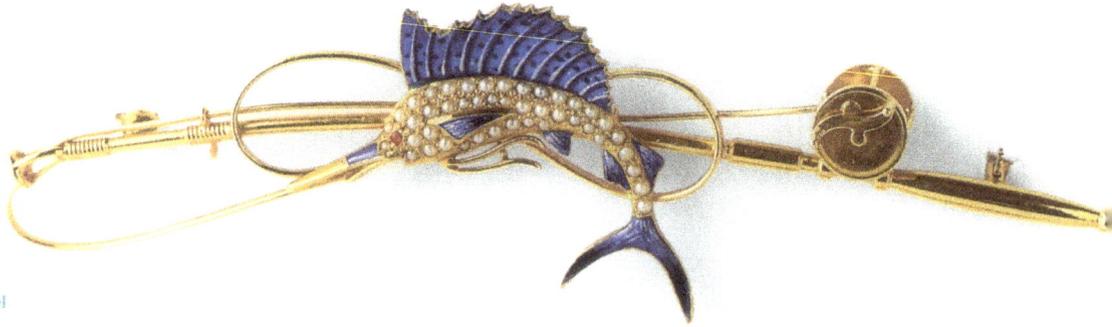

Fish and Rod Brooch
Sloan and Co.
Newark, c. 1940–1950
Pearls, ruby, 14k gold, and enamel
L: 10 x W: 2.5 cm / 3¾ x 1¼"

Racehorse Pencil Case
Battin & Co.
Newark, c 1940–1950
Demantoid garnets, and 14k gold
L: 8.2 x W: 1 cm / 3¼ x ¾"

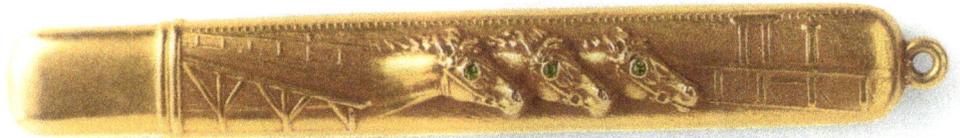

Flying Duck Clip
William Scheer
New York, c. 1940–1950
Diamonds, enamel, and platinum
L: 3.2 x W: 2.5 cm / 1¼ x 1"

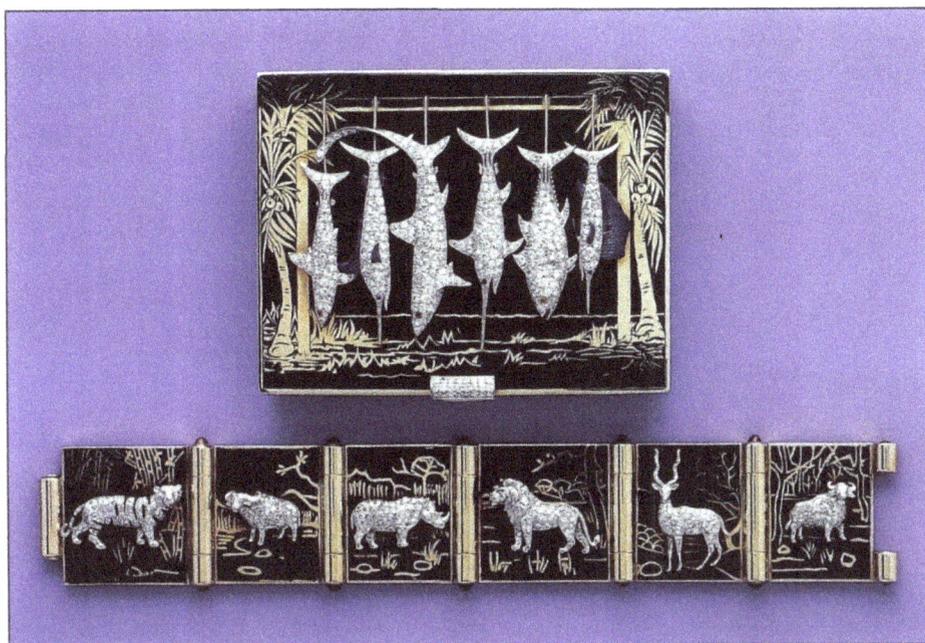

pearls, and enamel. The greater part of his work was unsigned since he manufactured jewelry for major American and European retailers.

Another important firm established at about the same time was Charlton & Co. Their store was located at Fifty-first and Fifth Avenue, opposite St. Patrick's Cathedral, and they had a second branch in Paris. Pictured above is a 1937 cigarette case and bracelet made by Charlton & Co. that commemorates fishing and safari expeditions.

The pastime of baseball dates back to the late 1830s. According to a commission formed in 1905 to determine baseball's origin (called the Mills Commission, after Colonel A.G. Mills of New York, the fourth president of the National League), Abner Doubleday was the pioneer. Doubleday, who graduated from West Point, used a stick to mark out a diamond-shaped field in the dirt, limited the number of players, added a pitcher and a catcher, and added bases—hence the name "baseball."

(Page 66) In the 1920s Americans expressed their passion for fishing and hunting in jewels. We see William Scheer's work in the fish pin and the mallard diamond brooch. The other objects are made by Newark manufacturers.

Wildlife Articles
William Scheer and Newark School
L: 17 x W: 3 cm / 6½ x 1⅛"

(Above) Cigarette case and bracelet with applied game—fish and animal charms are made with platinum, 18k yellow gold, enamel, diamonds, and rubies.

Fishing Case and Safari Bracelet
Charlton & Co.
1937
18k gold, diamonds, rubies, and black enamel
L: 8 x W: 6.3 cm / 3³⁄₁₆ x 2⁷⁄₁₆"

Countess Mona Bismarck

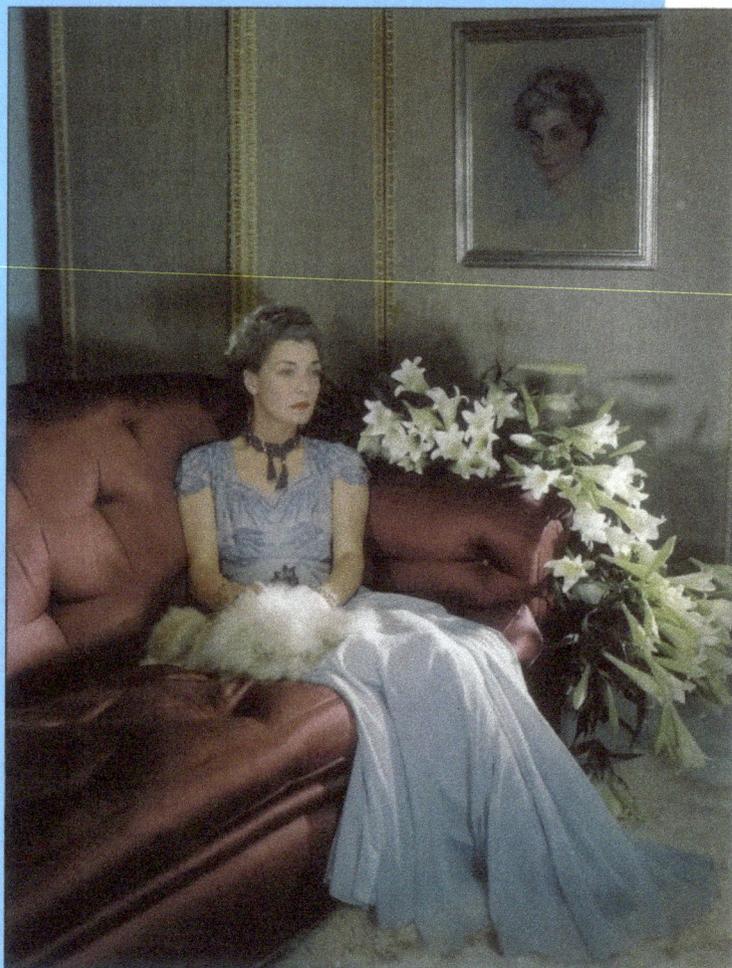

Persona

Mona's good looks and wonderful style made her a fashion icon in the 1920s. According to writer Gary Alston, "Every Christmas she held a Christmas night party in New York. One year . . . she had Fabergé flowers carved from pots in jade and lapis. How chic is that!" But perhaps her persona can be summed up by her friend and confidante, photographer Cecil Beaton: "She was a Rock-crystal goddess."

Roots

She was born Mona Travis Strader in 1897, in Louisville, Kentucky. When she was five, her parents separated, leaving her father to bring her up on his own. By the time she was twenty-seven, she had been married and divorced twice. She then set out to become part of New York café society.

Two years later, she married the extremely rich, and much older, Harrison Williams, who was said to have been one of the richest men in America.

Lucre

With Williams' money, Mona had the ability to buy only the best. She now had mansions from New York to Italy. Goyas and Bouchers were on her walls, and money was no object.

Style

In 1933, Mona was voted on The Best-Dressed List. All of the photographers wanted to take her portrait, including Horst and Cecil Beaton. She always entertained lavishly and with great style.

Taste

Mona had her own individual sense of style. According to *Vogue*, "She never orders the 'successes' in a collection, but instead the costume that is noticeable only on a second glance." She always wanted to show that she was fashion forward, and she constantly had her jewels remounted or recreated.

Gems

Mona preferred period pieces, especially created by Cartier and Jean Schlumberger for Tiffany. *Vogue*'s editor, Diana Vreeland, once wrote: "By day, I never saw her without her enormous pearls gleaming on her immaculate skin." In this photo taken by Horst, Mona is wearing sapphire beads with pearls. She has taken a 70" single length chain, with two sapphire beads and tassels on each end, and twisted it around her neck.

When Harrison Williams died, Mona married her long-time friend, Count Edward Bismarck, realizing her dream of ascending to Europe's aristocracy. She died in 1983.

Finally, in 1934, three miles from Cooperstown, New York, an old baseball was found, home-made, signed, and cloth striped. Stephen Clark, the Singer Sewing Machine philanthropist, bought the baseball for five dollars. With this baseball, known as the "Doubleday baseball," and support from the Mills Commission's findings, Clark decided to establish the National Baseball Hall of Fame and Museum.

Priceless memorabilia came from all over the country—especially baseball jewelry.

Baseball is deeply connected to the American value system: democracy, opportunity, and the desire to be best. The baseball jewels displayed at Cooperstown are either personal mementos, or stand for team achievements. For instance, players on the victorious World Series team are traditionally given a diamond ring to commemorate their victory.

With more than twenty-five World Series titles, the Yankees have won more championships than any other professional sports franchise. Shown below is the New York Yankees' World Championship watch, presented in 1928 to baseball commissioner Kenesaw Mountain Landis. The watch was made by Hamilton Watch Company and is

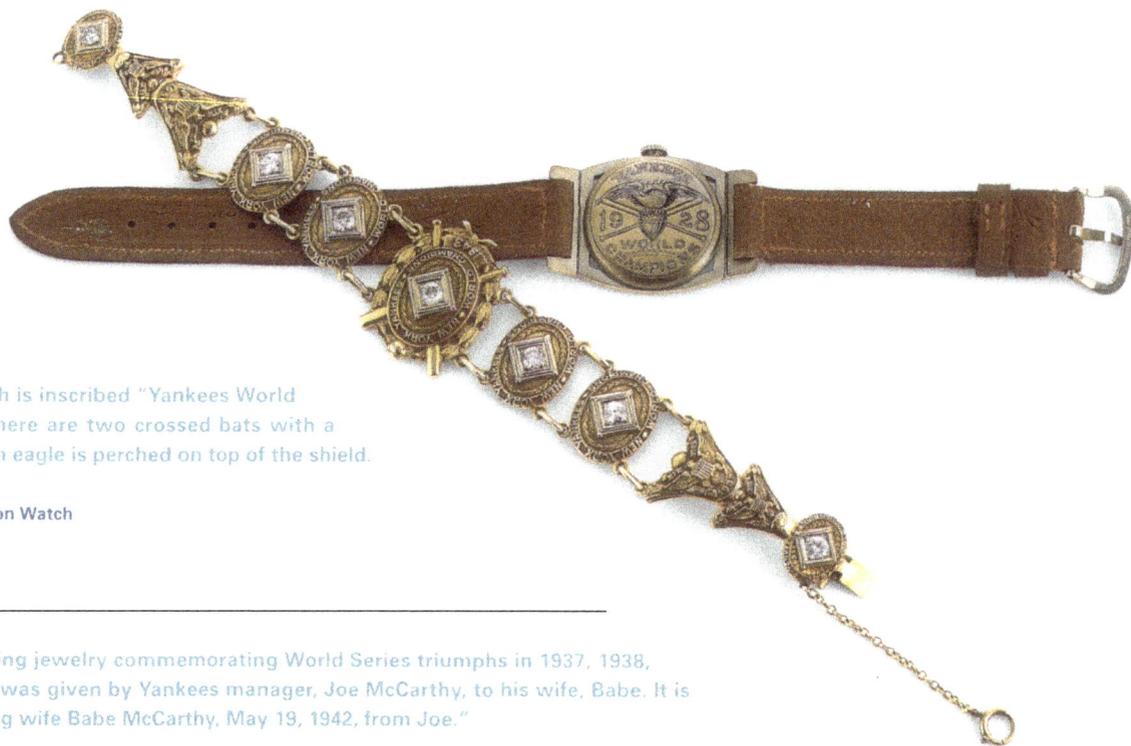

The back of this watch is inscribed "Yankees World Champions, 1928." There are two crossed bats with a shield in the center. An eagle is perched on top of the shield.

New York Yankees Hamilton Watch
1928
L: 9 x W: 1^3/$_8$"

This bracelet, containing jewelry commemorating World Series triumphs in 1937, 1938, 1939, 1941, and 1943, was given by Yankees manager, Joe McCarthy, to his wife, Babe. It is inscribed "To my loving wife Babe McCarthy, May 19, 1942, from Joe."

New York Yankees World Series Bracelet
1943
L: 8 x W: 1^1/$_4$"

engraved on the back. It is interesting to note that in 1941, weeks before Pearl Harbor, Commissioner Landis went to President Franklin Delano Roosevelt and asked him, "What do you want [baseball] to do?" Landis continued, "If you believe we ought to close down for the duration of the war, we are ready to do so immediately. If you feel we ought to continue, we would be delighted to do so. We await your order." Within two days, President Roosevelt declared that baseball was "thoroughly worthwhile." In fact, he encouraged Landis to schedule many more night baseball games, so day workers could see a game.

Baseball gives Americans pride, and one individual who symbolized this was Yankees' Manager, Joe McCarthy. Pictured on page 70 is the New York Yankees World Series Bracelet from 1943 that McCarthy gave to his loving wife, Babe. It contains jewelry commemorating World Series triumphs in 1937, 1938, 1939, 1941, and 1943. Under McCarthy's leadership the Yankees won seven world titles (an all-time record he shares with Casey Stengel) and eight pennants in sixteen seasons. McCarthy was elected to the Hall of Fame in 1957.

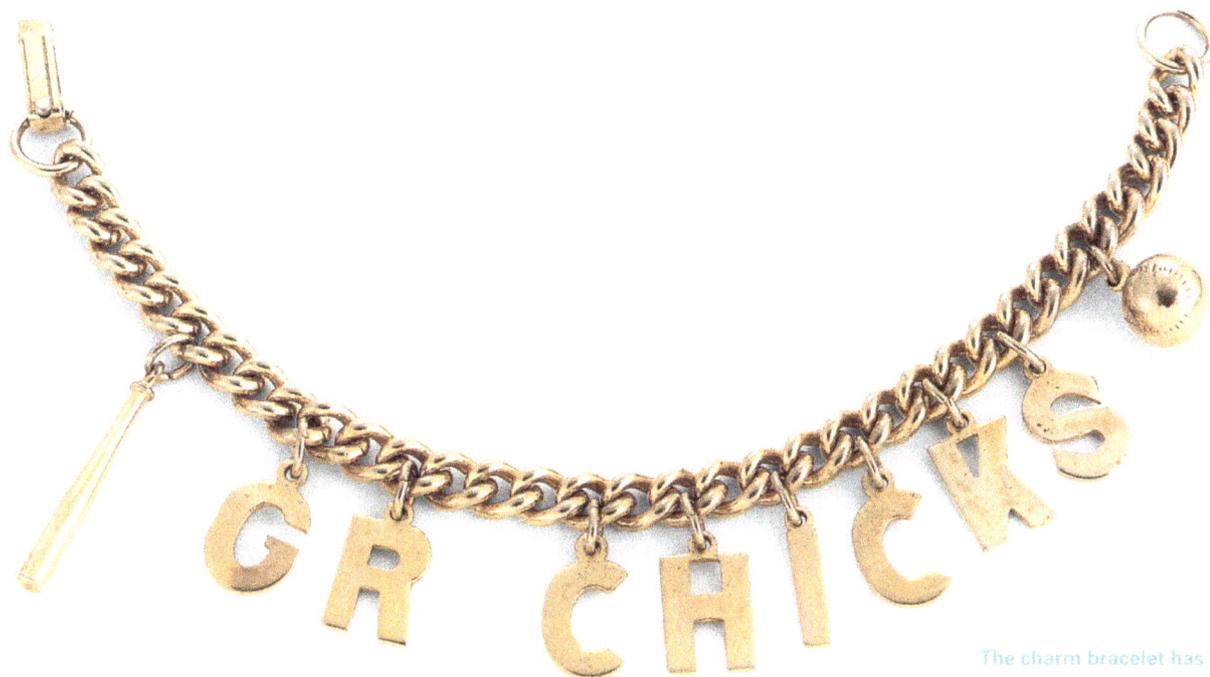

The charm bracelet has the letters "GR CHICKS" with a bat on one end and a ball on the other.

Grand Rapids Chicks bracelet
1952
14k gold
L: 7"

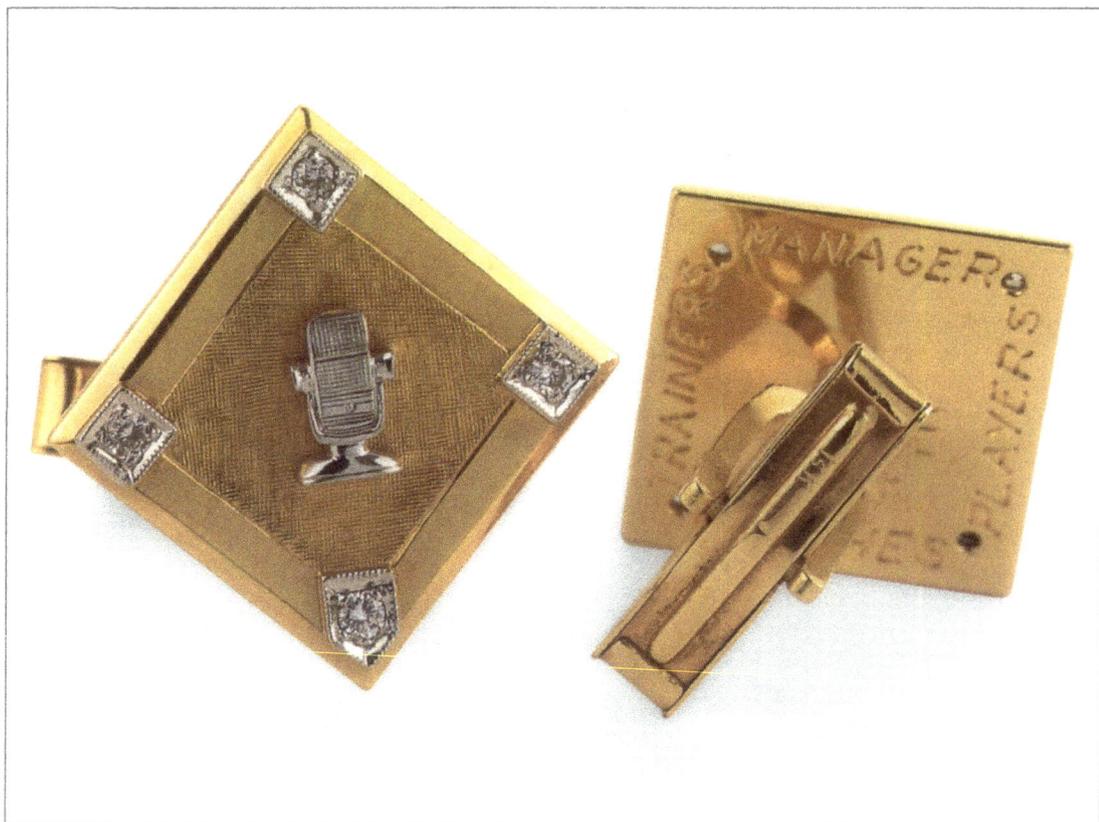

These cufflinks were made for Waite Hoyt, the radio broadcaster for the Cincinnati Reds. There is a diamond on each corner and a microphone in the center. The inscription on the back reads "Best of Luck Waite 1965 Reds." The other cufflink reads "Coaches Trainer Manager Players."

Waite Hoyt cufflinks
1965
5/8" square

The next baseball jewel is unmistakably American--a charm bracelet. The bracelet stands for the Grand Rapids Chicks, 1952. The All-American Girls Professional Baseball League played as a part of the war effort. The league was formed during the Second World War, with sixty women from around the country. In order to boost morale, they visited service hospitals, promoted war bonds, and of course, played baseball. In 1948, over one million fans attended their games. Finally, in 1954 the league disbanded.

The last baseball jewel is a pair of cufflinks, 1965, made for pitcher Waite Hoyt, who was then the radio broadcaster for the Cincinnati Reds. The engraving on the back states: "Coaches Players Mangers Trainers," and "Best of Luck Waite 1965 Reds." For those who are not up to date on their baseball history, Waite was known as the "Schoolboy Wonder," after being signed professionally at the age of fifteen and went on to become a mainstay for the Yankees in the 1920s. In the press he was nicknamed "the merry mortician" because during off-season he worked as an undertaker. He became a broadcaster for the Cincinnati Reds upon his retirement from baseball.

For those whose pastimes extended into the arts, jewelers created special objects for their clients to commemorate their artistic works. Edna Woolman Chase, *Vogue*'s editor in 1942, created a commemorative, lacquered gold box with diamonds for her daughter, Ilka. The box was the exact duplicate of the cover of Ilka's first book, *Past Imperfect*. The box was manufactured by Louis Tamis & Sons and designed by Paul Flato. The inscription reads, "To my daughter Ilka with unfailing love, Edna Woolman Chase, April 8, 1942."

Another personal touch is pictured bottom left. In a gold and jeweled cigarette case commissioned by the songwriter of "Sweet Sue," the designer has created the ultimate exotic landscape, complete with the moon, stars, and a castle. It is inscribed with the date "Christmas 1945" and the initials "MHB." The case itself has diamonds, rubies, emeralds, jade, lapis lazuli, and moonstones on it. It is the ultimate gift of a songwriter commissioned for a loved one.

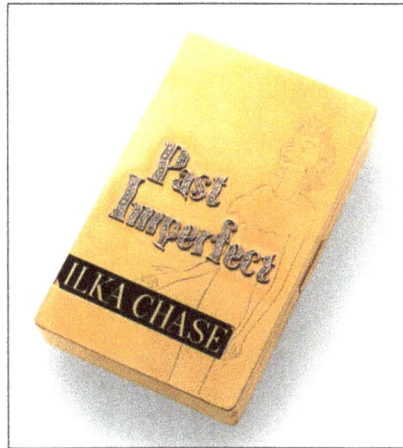

Cigarette Case
Paul Flato
New York, 1942
Yellow gold, lacquer, diamonds, and platinum
L: 12 x W: 7 x D: 1.7 cm / 4³/₄ x 3 x ⁵/₈"

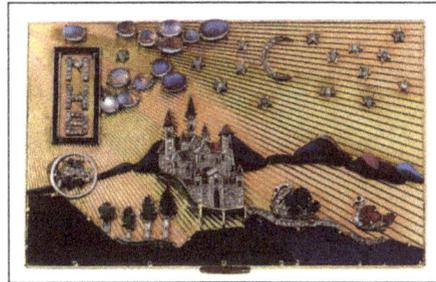

(Above Left) Engraved inside the cigarette case are bars of music for the song "Sweet Sue." The case is inscribed with the initials "MHB" and "Christmas 1945."

Cigarette Case
Unsigned
1945
L: 7.6 x W: 12.6 x D: 0.9 cm / 3 x 5 x ³/₈"
Enamel, jade, moonstones, lapis lazuli, diamonds, emeralds, sapphires, rubies, and pink, yellow, and green gold

(Above Right) This beautiful 18k gold belt buckle pays homage to the upper-class pastime of polo playing. The belt was commissioned by an important Texas family, the Waggoner family. The buckle was given to Buster Whorton, who then ran the biggest contiguous ranch in Texas, on Christmas, 1952.

Polo Belt Buckle
Unsigned
1952
Rubies, diamonds, sapphires, and 18k gold
L:11.5 x W: 8 cm / 4¹/₂ x 3¹/₄"

Barbara "Babe" Paley

Although she has been dead for over two decades, Babe Paley has remained one of the most recognizable names of American style. A high priestess of exquisite taste during her lifetime, Babe's poise, elegance, and fashion sense have made her immortal. As her friend Truman Capote once said: "Babe Paley had only one flaw: she was perfect. Other than that, she was perfect."

Roots

Barbara Cushing (Babe's real name) was born in Boston, Massachusetts, into a family of three girls and two boys on July 5, 1915. Babe was the baby of the family, hence the name. Although her father, Henry Cushing, was a successful neurosurgeon, the Cushing family was not quite considered society. As a result, Babe's mother pushed all three of her daughters to marry rich and powerful men. Babe succeeded. Her first husband, Stanley Mortimer of the Standard Oil family, was old money, which opened the door for Babe into high society. Although the marriage ended in divorce by 1946, Babe had already established herself as a fashion idol for New York and the country as a whole.

Lucre

Her finances were less than stellar after the divorce, and in 1947, Babe married the fabulously wealthy William Paley, founder of CBS. She was his entrance into New York blue blood society, and he was her ticket to the money needed to support her lavish lifestyle, as well as her two children by her first husband.

Taste

Babe was ever the symbol of highest style and impeccable taste. For the homes she shared with her husband, in New York City and Long Island, only celebrated decorator Billy Baldwin would do. Her grace, beauty, and manners made an invitation to the Paley household a very sought-after ticket. She knew how to lavishly entertain her guests, and only the best foods, servants, and surroundings were present at her events. In fact, she even planned her own memorial luncheon down to the last detail.

Style

Throughout her life, Babe was known for her refined sense of dress. Although emulated countless times, no one could quite capture the serene elegance that was Babe Paley's trademark. As if by magic, she knew how to accentuate her persona with fashion. Perhaps it was through her fashion that Babe chose to combat the low self-esteem and extreme shyness she suffered from all her life. The clothes she chose continued to emphasize the image of social perfection she strived to portray. Since she was 5'8" and only a size six, she always looked perfect. As a result, she was on the Best-Dressed List fourteen times, and she was inducted into the Fashion Hall of Fame in 1958.

Gems

Babe loved gems. According to Sally Bedell Smith's *In All His Glory*, "Babe owned more than $1 million worth of baubles from New York's finest jewelers: Cartier, Tiffany, Harry Winston, Van Cleef & Arpels, Bulgari, and Verdura." It was rumored that she hid her pearls inside a hollow monkey statue in her bathroom. In this picture by her good friend, photographer Horst, Babe is wearing gold and pearl bracelets, with her multi-strand pearl necklace around her neck.

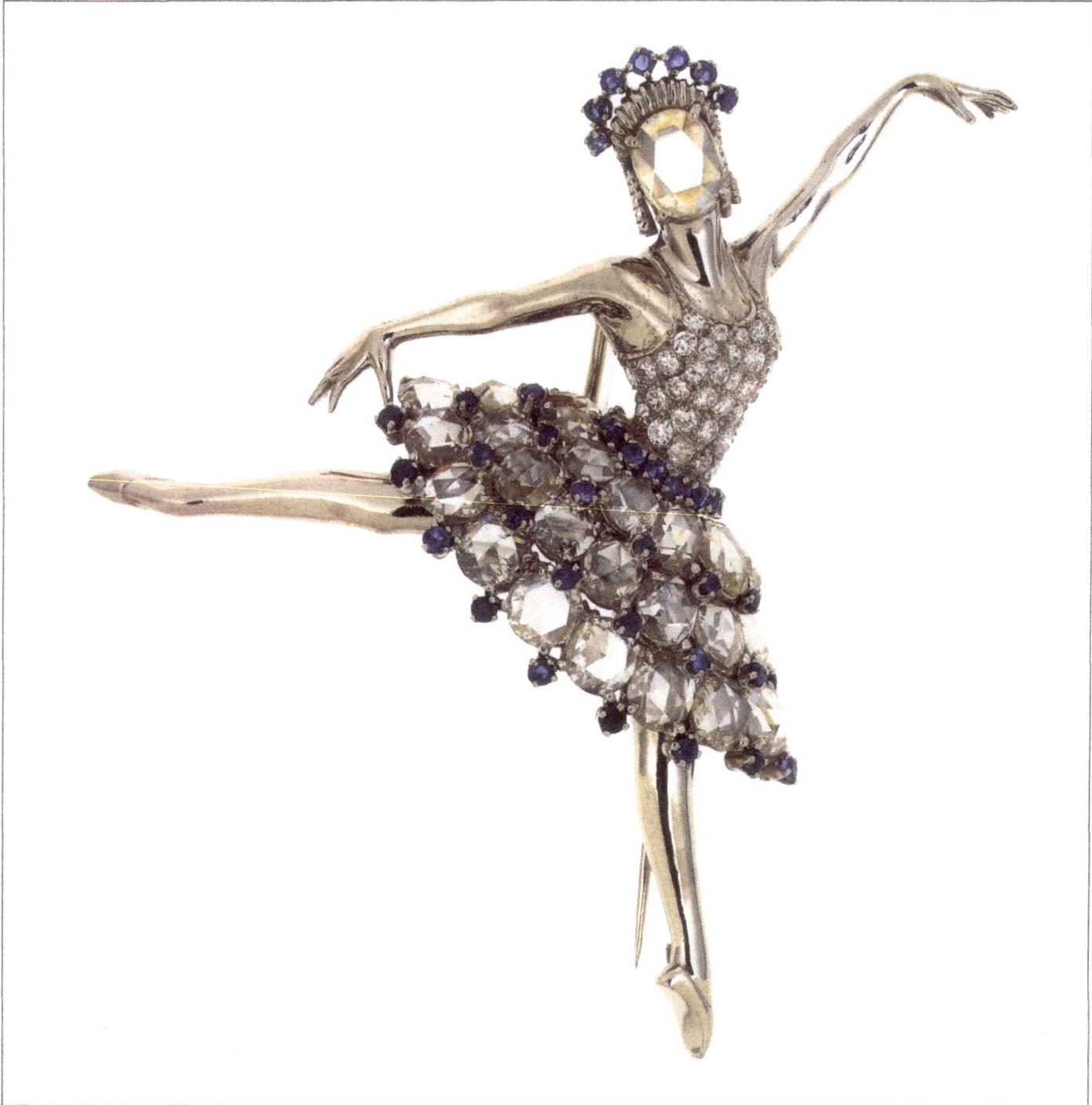

Jeweled Ballerina Brooch
Van Cleef & Arpels
New York, 1946
Sapphires, diamonds, and platinum
L: 7.2 x W: 7 cm

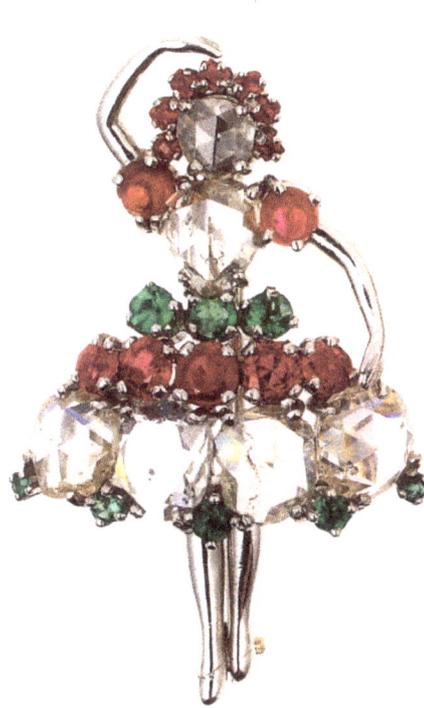

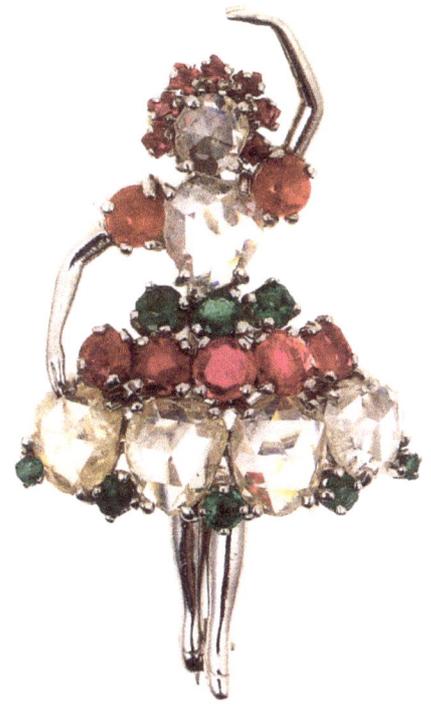

(Right) Two Ballet Brooches
Van Cleef & Arpels
New York, 1940
Rubies, rose-cut diamonds, emeralds, and platinum
L: 2.5 x W: 1.2 cm

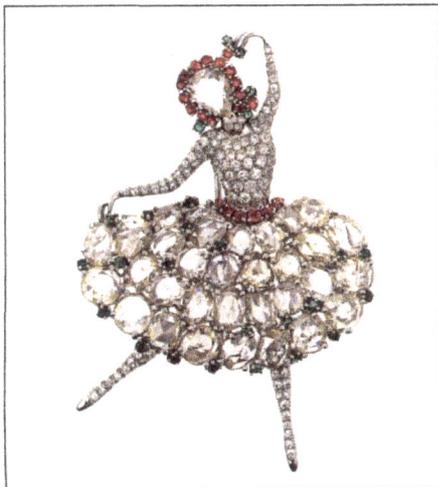

Ballerina Brooch "Maria Camargo"
Van Cleef & Arpels
New York, 1940
Rubies, rose-cut diamonds, emeralds, and platinum
L: 7 x W: 4$\frac{1}{2}$ cm / 2$^{3}/_{4}$ x 2"

Van Cleef and Arpels, synonymous with America's high style, opened its doors in New York in 1939. Because of the friendship between Claude Arpels, president of the company, and George Balanchine, the famous ballet choreographer, jeweled ballerina brooches highlighted with rose-cut diamonds were created in the early 1940s. Originally inspired by paintings of eighteenth and nineteenth cen- tury dancers, Van Cleef created a series of about fifteen jeweled, rose-cut diamond, platinum, and gold ballerinas, seen on pages 11, 76, and on this page. In 1967, George Balanchine reciprocated Arpel's gesture, and brought the jeweled ballerinas to life in "Jewels," a three-part ballet to celebrate the golden age of dance. Only in America could personal pastimes translate into personal jewelry.

HUMOR

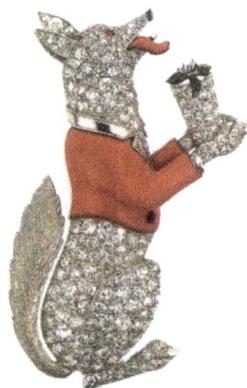

Master of Foxhounds Holding a Mint Julep
Raymond C. Yard
1933
Enamel, platinum, and diamonds
L: 4.5 x W: 3 cm / 1³/₄ x 1"

American humor and whimsy contain a spirit that is all their own. In the introduction to Mark Twain's *Library of Humor* (Harper & Bros., 1906), editor and novelist William Dean Howells writes that our humor "has always been so racy of the soil that the native flavor prevails throughout, and whether Yankee, Knickerbocker, Southern Californian, refined or broad, it was and is always American."

In *The Innocents Abroad*, which documents Twain's travels to Europe between 1867 and 1868 (*Unabridged Mark Twain*, Running Press, 1976), Twain writes: "We were troubled a little at dinner by the conduct of an American who talked very loudly and coarsely and laughed boisterously where others were so quiet and well-behaved." All the objects in this section, whether personal or whimsical, can be looked at as examples of what Mark Twain was getting at. Americans tend to be a bit louder than the rest, less conventional, and we often cherish our personal objects more than ourselves.

One of the most important influences on American whimsy was Walt Disney. He exposed our human foibles through his animal characters and cartoons, enabling us to see the humor in our lives. Disney's animation influenced Raymond C. Yard, who created the

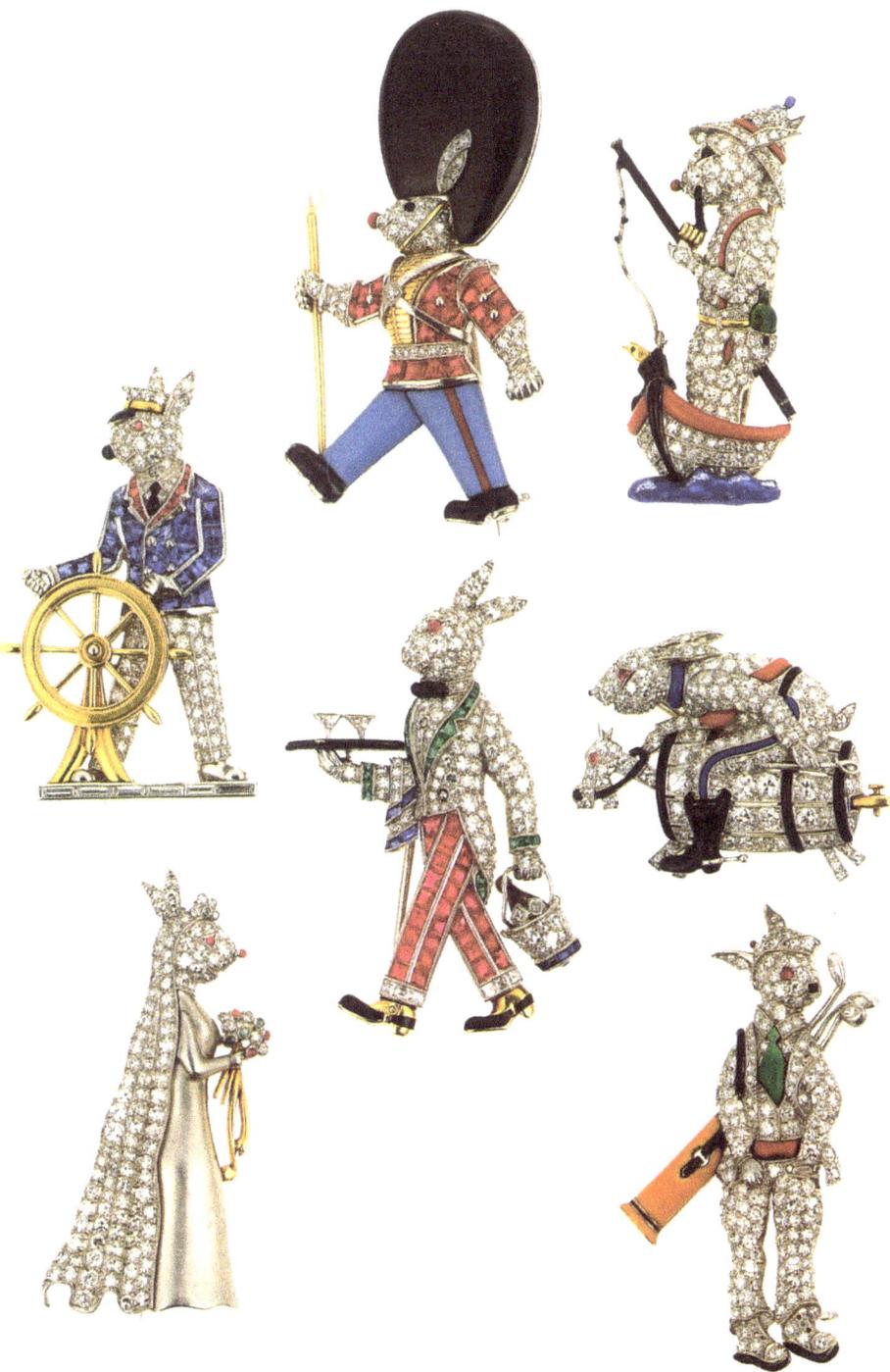

Seven Bunny Pins
Raymond C. Yard
1931–1940
Platinum, diamonds, sapphires, rubies, and emeralds
From 4 x 2 cm

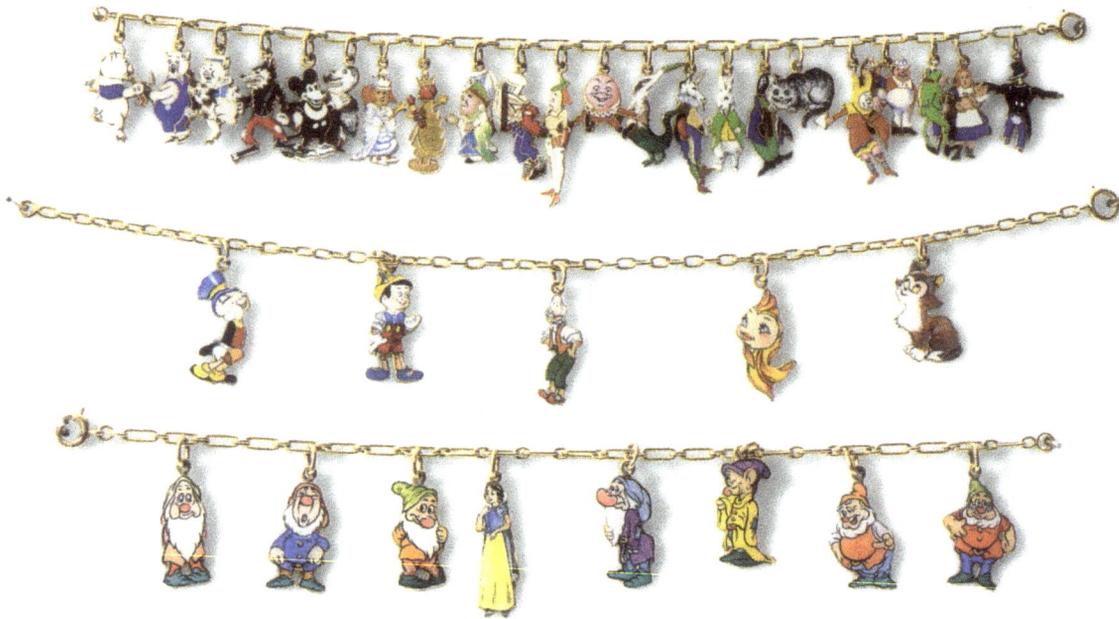

Walt Disney bracelets
Cartier
New York, 1939
Yellow gold and enamel

"Master of Foxhounds Holding a Mint Julep" (page 78), as well as a set of rabbit jewels in the 1930s, pictured on page 79. The Master of Foxhounds pin is enameled and made with diamonds and platinum. Yard's later work, the popular and amusing rabbits, are shown fishing, playing golf, getting married, and carrying a martini into the drawing room. These pieces are made with diamonds, sapphires, rubies, emeralds, and platinum.

Walt Disney himself entered into a partnership with Cartier of New York to create and retail a series of enameled charm bracelets representing his animated characters (pictured above). Disney notwithstanding, humor was otherwise incorporated by Cartier in the 1930s. To celebrate the end of prohibition, Cartier created a working clock from an Old Grand Dad whiskey bottle, shown on page 81.

Having a good time is what Americans like

to do. Whether playing baseball, relaxing on a picnic in the park, or sailing with a loved one, Americans reward their hard work with equal effort at play. An example of living the good life is seen on page 81, in the 18k enamel pin commemorating a romantic weekend or possibly a honeymoon. The couple that commissioned the piece sailed on that fantastic yacht, gambled, and then together gazed at the moon, which is beautifully depicted in this pin.

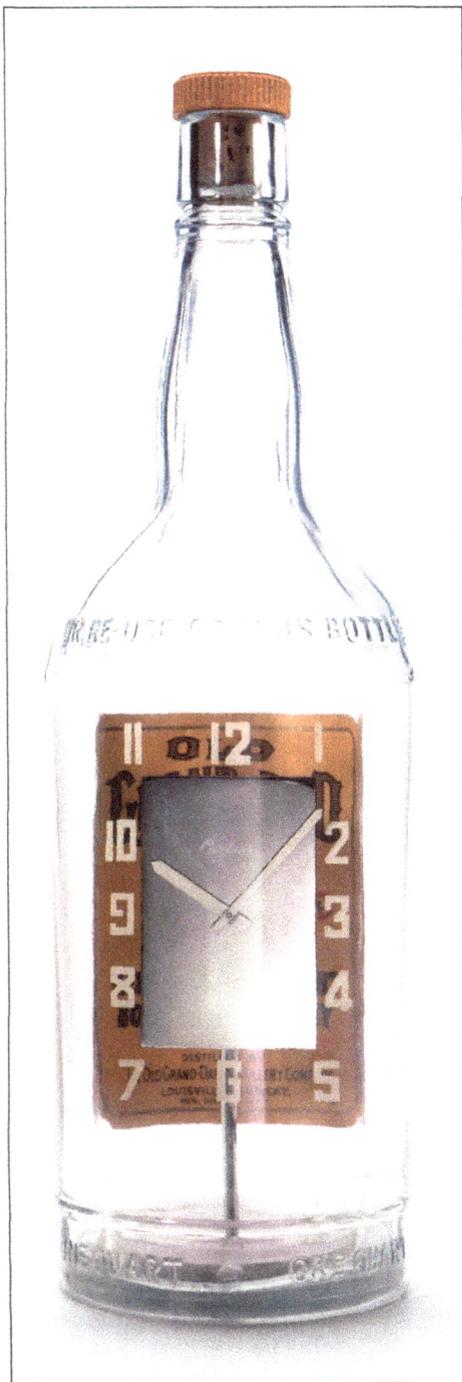

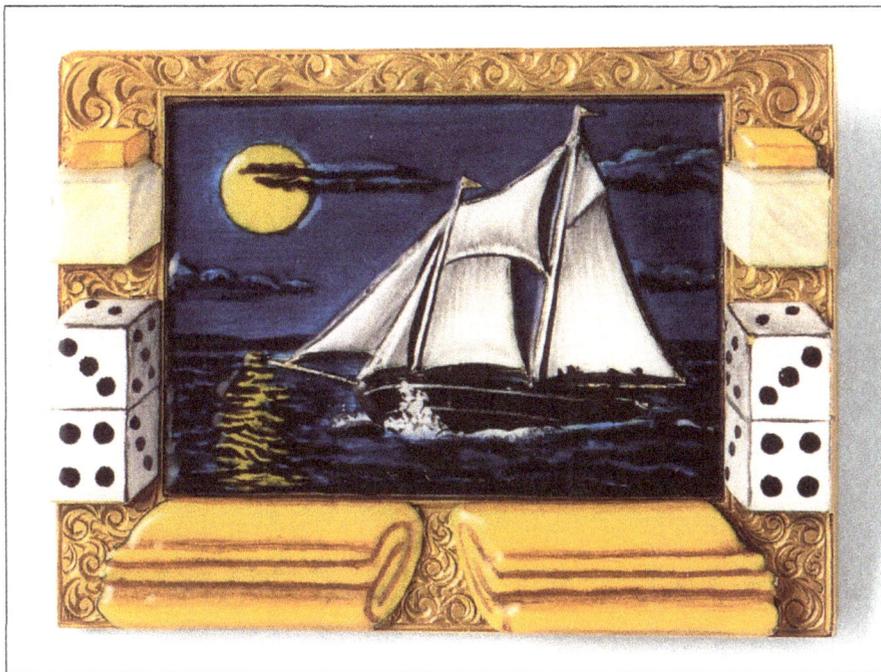

Old Grand Dad Whiskey Bottle Clock
Cartier
New York, 1930s
Paper, glass, 18k gold metal, and cork
L: 22.8 x W: 7 cm / 9 x 2 3/4"

(Above) Americans in the1930s enjoyed celebrating an experience by commissioning an important jeweler to create a brooch to commemorate a time and place. This pin portrays a fantastic yacht, and evokes memories of a romantic gambling night at sea.

Boat Pin
18k gold and enamel
L: 4.5 x W: 3.2 cm / 1 3/4 x 1 1/4"

The jeweler most associated with whimsy or humor is Paul Flato, who created the "Nuts & Bolts" cufflinks we saw in the Americana section (page 37). Based in New York, Flato loved to work on commissioned pieces for high society women and Hollywood stars. Pictured here is a set of three gold boxes imitating stamped envelopes. The stamp is enameled. and the owner's handwriting is

Again, we see whimsy in these three envelopes designed by Paul Flato. Flato himself was said to be very witty. He drew clientele from Hollywood and New York's cafe society. One of his best and most loyal customers was Cole Porter.

Cases
Paul Flato
1940
18k gold and enamel
L: 6.3 x W: 7.5 cm / 2$\frac{1}{2}$ x 3"; L: 3 x W: 4.3 cm / 1$\frac{1}{4}$ x 1$\frac{5}{8}$"; L: 3.1 x W: 11.9 cm / 1$\frac{1}{4}$ x 4$\frac{5}{8}$"

Portrait of a Man
Paul Flato
1940
18k gold, platinum, and diamonds
L: 2.5 x W: 2 cm

duplicated. Also on page 82 is an 18k gold, diamond, and platinum brooch he designed. It features a man's profile in a classical style—could it be someone's lover? We admire Paul Flato's range, from the personal to the classical. Who, but an American, would think to make a piece of jewelry using diamonds and rubies to depict their favorite pair of shoes? (Pictured right).

Another example of whimsical, personalized jewelry was commissioned by the famous art critic, Sir Kenneth Clark. Clark asked American artist Alexander Calder to design a tiara and necklace for his wife in the 1950s, which is seen on pages 84 and 85. It is interesting to note that these extraordinary pieces of jewelry are not made of precious metals, but rather of simple brass. Calder also created personalized jewelry for his friends. An example of this can be found in the "OK" pin worn by Georgia O'Keeffe pictured on page 86.

According to Mark Twain, Americans care more for inanimate objects than themselves. Who can question the truth of this statement when we see the owner of these shoes having them arranged in diamonds and rubies?

Jeweled Miniature Shoes
Paul Flato
1945
18k gold, diamonds, and rubies
L: 5½ cm / 1¾"

Sir Kenneth Clark commissioned this tiara (above) and necklace (page 85) for his wife. The famous American artist, Alexander Calder, created them. The choice of material is ironic, since tiaras are normally made in precious metals with diamonds and pearls.

Tiara (above) and Necklace (page 85)
Alexander Calder
1950s
Brass
Tiara: H: 10 cm
Necklace: L: 38 x W: 7 cm

Georgia O'Keeffe

When one thinks of American artists, Georgia O'Keeffe is one of the first names that come to mind. Indeed, she has been called the premier female artist of the twentieth century, a title she herself found distasteful due to its apparent sexism. Through her modernist and minimalist approach to art, O'Keeffe has built a somewhat controversial reputation as a truly American painter with an eye for the original. According to art historian Roxana Robinson, O'Keeffe's "struggle between the rigorous demands of love and work resulted in extraordinary accomplishment." O'Keeffe's later pieces demonstrate the American love for open spaces, particularly the Southwest.

Roots

Born in 1887, the second of seven children to a farm family in Wisconsin, Georgia O'Keeffe developed a close relationship with nature. As a teenager in Virginia, she took art lessons, where her talent was immediately recognized. Determined to become an artist, the young O'Keeffe left to study at the Art Institute of Chicago and the Art Student League in New York, where she learned to paint portraits and still life from the well-known artist,

William Merritt Chase. During this time, O'Keeffe visited 291, Alfred Stieglitz's gallery. There she became aware of the work of Rodin, Picasso, Braque, and Matisse.

Always something of a restless soul, Georgia moved around a lot, teaching art throughout the country and experimenting with her style. In 1918 she returned to New York, and she and the unhappily married Stieglitz got an apartment together. She was only thirty-one, while the pioneer photographer was fifty-four years old. They lived together for six years before marrying in 1924. He was fascinated by her independence and her natural beauty. As a photographer, he would take over 200 sensual, nude portraits of her in the first few years of their marriage.

Lucre

Her financial success began soon after she was married. She showed the first Calla Lily painting in 1925, and three years later, her paintings were selling for upwards of $25,000—she soon became enormously wealthy through her art. Nevertheless, O'Keeffe personally preferred living in two plain homes and drove a modest automobile.

Taste

Living alone in New Mexico after the death of Steiglitz, O'Keeffe found magic in the sunsets, as well as in the animal skulls she found in the desert. Through her use of color on the canvas, the objects came alive. She once said, "Nobody sees a flower, really. We haven't time, and to see it takes time." She took the time to see the magic of the world.

Style

Georgia O'Keeffe's art forms looked like colored jewels with swirls. She used intense color to express her emotions whether depicting rocks, flowers, sunsets, or shells. Despite the wide use of color in O'Keeffe's paintings, her personal appearance reflected none of the same vibrancy. O'Keeffe only wore black and white clothes, and often wore a hat.

Gems

Georgia O'Keeffe only wore one set of jewelry, created for her by the important American sculptor, Alexander Calder. This pin is carefully constructed like his sculptures, but there is an element of surprise. When you look at the pin sideways, you realize it says "OK" which stands for O'Keeffe. The pin is a reflection of the painter's style: simple, yet beautiful. It abounds with the same subtle beauty found in O'Keeffe's work, and the flowers she painted.

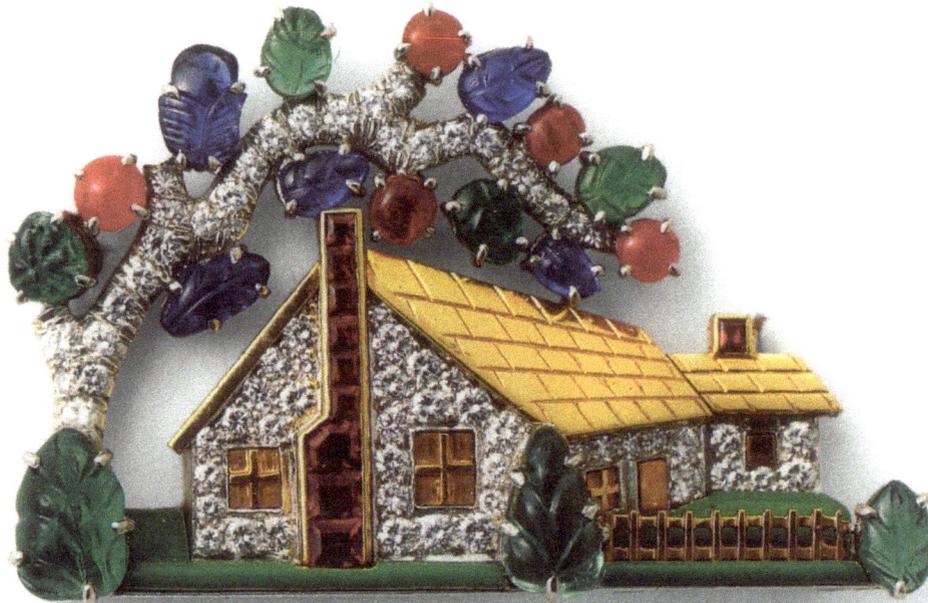

Jeweled Home Brooch
Raymond C. Yard
1961
18k gold, diamonds, platinum, citrines, rubies, emeralds, and sapphires
L: 4.5 x W: 3 cm / $1^7/_8$ x $1^1/_8$"

Part of the American dream has always been the freedom that comes with owning a place to live, from land, itself, to one's own home. These aspirations reach far beyond mere property ownership. With them are carried other important dreams of new beginnings, independence, and starting a family. Above we see an 18k gold, platinum, and bejeweled house brooch, created by Raymond C. Yard.

The "starting of your life" theme is also commemorated in 14k gold bangle bracelets such as the one seen on page 89, where

courtship, marriage, and family are highlighted within the jeweled charms.

One can't help to admire the unicorn (also pictured on page 89), created with rubies, sapphires, and gold. This mythical and mystical creature is said to be a symbol of purity. Among the many myths associated with the symbol of the unicorn is the ability of man to communicate with the heavens. What better way to stay connected to a lost love or relative than through a jeweled symbol of the unicorn?

These personally designed bracelets were very popular in the 1940s. They were created to celebrate a marriage, the birth of children, or a move to a new home.

"Starting of Your Life" Cuff Bracelet
1940s
Diamonds, rubies, sapphires, yellow gold, platinum, and enamel
W: 4 cm / 1³/₈"

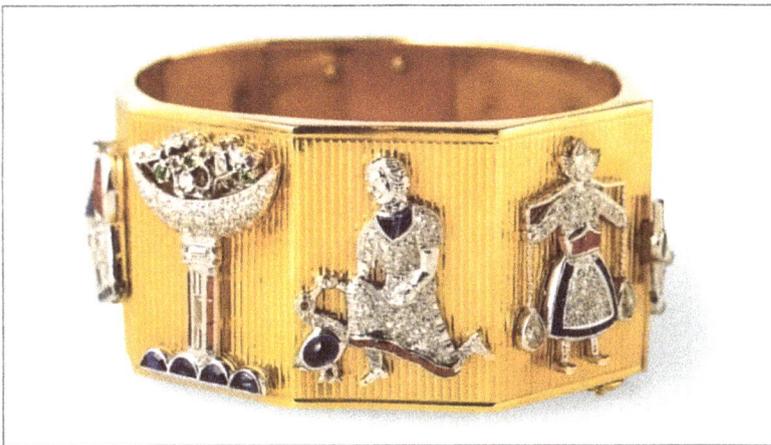

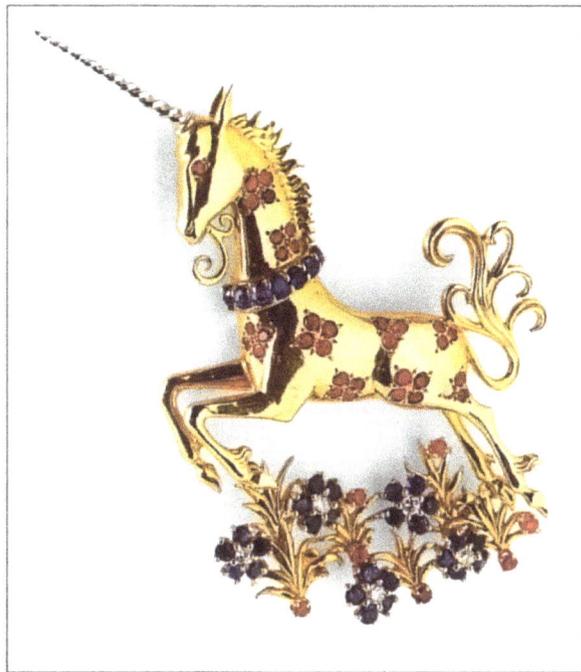

(Above) One theory is that humans can communicate with their deceased loved ones through the unicorn. Another is that the unicorn's horns are a symbol of virility. Whatever the owner intended, this piece radiates as a mystical figure.

Unicorn Brooch
Van Cleef & Arpels
New York, 1940s
18k gold, rubies, and sapphires
L: 8 x W: 5 cm / 3¹/₂ x 2"

Again, in the spirit of celebrating events, the owner of this piece probably visited Mexico and had this piece created in remembrance of his or her stay.

Mexican Landscape
Raphael Esmerian
1947
Yellow gold, platinum, rubies, emeralds, sapphires, jade, and white and colored diamonds
L: 9.5 x W: 8.5 x H: 5"

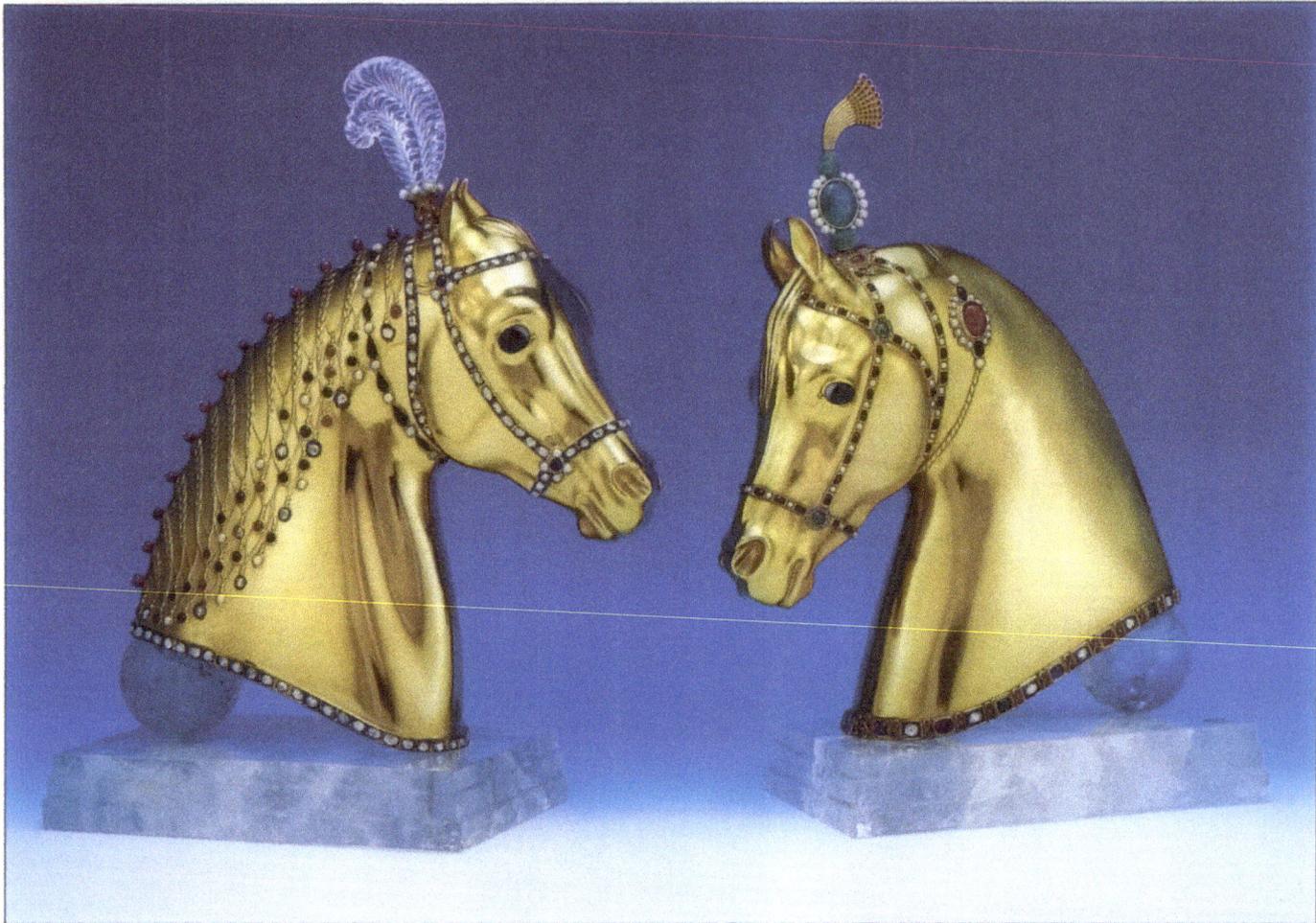

The stallion and mare pieces above were commissioned by American heiress, Barbara Hutton. They took the artist three years to complete. Haseltine studied in Europe and is best known as a sculptor of animals, primarily horses. He also created the statue of Man of War, at Kentucky Horse Park in Lexington. Many of his works are displayed in the Field Museum in Chicago.

Jeweled Sculptures Stallion and Mare
Herbert Haseltine
1949
24k gold, rubies, sapphires, emeralds, diamonds, oriental pearls, and rock crystal base
H: 15 x 14"

Other representations of mythological figures include Mogul Indian jeweled 24k gold stallion and mare sculptures, commissioned by the American heiress Barbara Hutton (above). The well-known sculptor, Herbert Haseltine, completed this three-year project in 1949 and drew his inspiration from Indian horse legends.

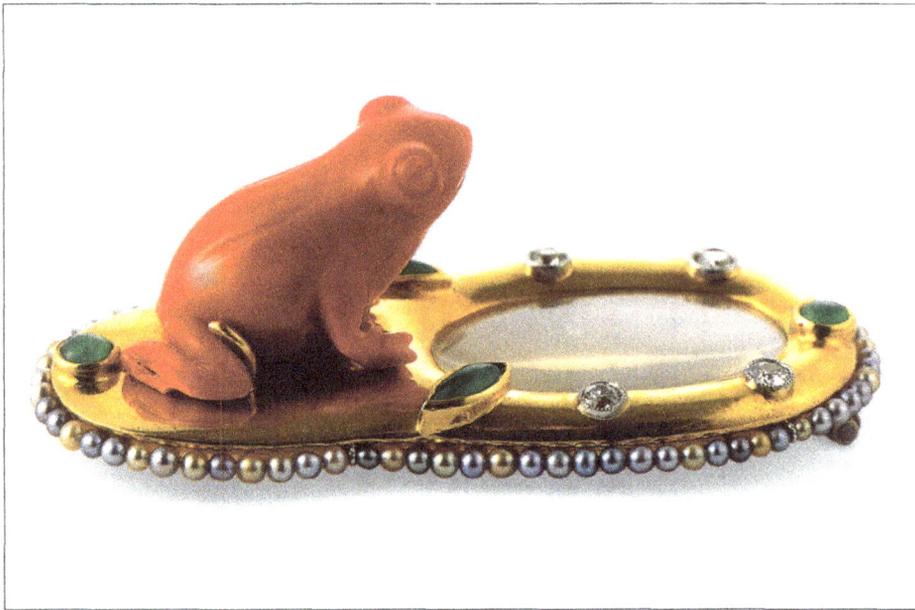

Frog and Pond Brooch
Wedderin
1950s
Coral, jade, pearls, colored diamonds, moonstone, and gold
L: 5.7 x W: 3.8 x H: 2.1 cm / 2^{1}/$_{4}$ x 1^{1}/$_{4}$ x 3/$_{4}$"

Knickerbocker Logo Brooch
Unsigned
1940s
Sapphires, 18k gold, rubies, and topaz
L: 7 x W: 6.5 cm / 2^{3}/$_{4}$ x 2^{1}/$_{2}$"

After World War II, the trend was to have jewelers recreate company logos into personal jewelry. An example of this is in the photo of the Knickerbocker Beer logo (pictured right), recreated with sapphires, rubies, and topaz.

Above we see an amusing Frog brooch, created in the 1950s by Wedderin, a retail firm started in New York. It is made in gold, moonstone, coral, jade, pearls, and diamonds. While the jewels used to make this brooch speak of committed artistry, this brooch is really quite playful. It is a perfect example of whimsical, American jewelry.

In the 1960s, Donald Claflin was the premier American designer. He came to Tiffany in the late 1960s, and helped the company develop a contemporary image. Among his creations were jeweled characters from animated films, in the spirit of Disney figures. On page 92 we see the walrus from "The Walrus and the Carpenter" from *Alice in Wonderland* in enamel, 18k gold, diamonds, platinum, and tusks of ivory. Also pictured on page 92 is an imaginary parrot, made in 18k gold, enamel, diamonds, turquoise, and emerald.

Nearly twenty years later, in the 1970s,

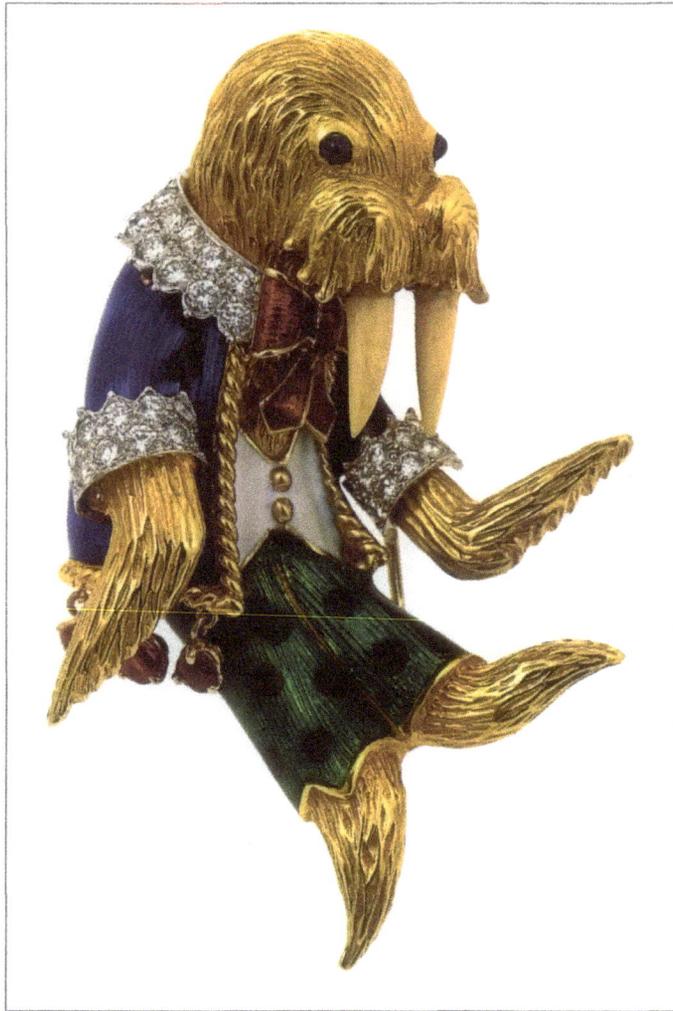

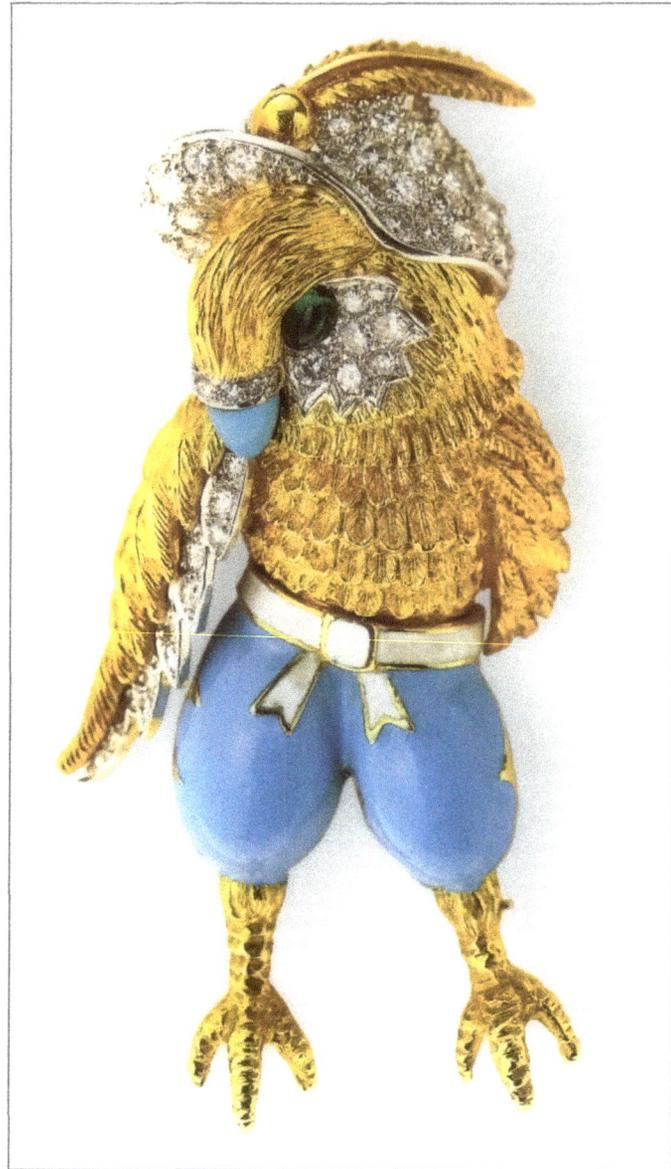

Donald Claflin came to Tiffany in the 1960s. His imagination enabled him to create a world of Lewis Carroll fantasy creatures. This walrus is inspired by Lewis Carroll's poem, "The Walrus and the Carpenter" from *Alice in Wonderland.*

Walrus Brooch
Donald Claflin
Tiffany & Co.
New York, 1965
Platinum, enamel, 18k gold, diamonds, and ivory
L:7 x W: 4.5 cm / 2³/₄ x 1³/₄"

Parrot Brooch
Donald Claflin
Tiffany & Co.
New York, 1965
18k gold, white enamel, turquoise, diamonds, and cabochon emerald
L: 7.5 x W: 3.5 cm / 2³/₄ x 1¹/₄"

the American artist Daniel Brush became a jeweler. Originally, Brush became fascinated with the goldsmith's techniques of ancient Greek and Roman jewelers. His research led him to create his own objects made from gold, steel, Bakelite, and other materials. Below we see the Bunny Bangle, which was exhibited at the Smithsonian in 1987 when Brush had a one-man show of his jewelry. It is made out of 1940s Bakelite material, with gold and pink diamonds.

By nature, Americans are optimistic. And during the twentieth century, American jewelers were able to capture the many spirits of America. America's spirit is fresh and confident, yet at the same time respectful of the traditions of the past. Americans can see the upside of all situations whether it is poking fun at Prohibition, showing off a company logo, or delighting in the whimsical side of nature. American jewelers have been able to celebrate all of these attitudes in their product.

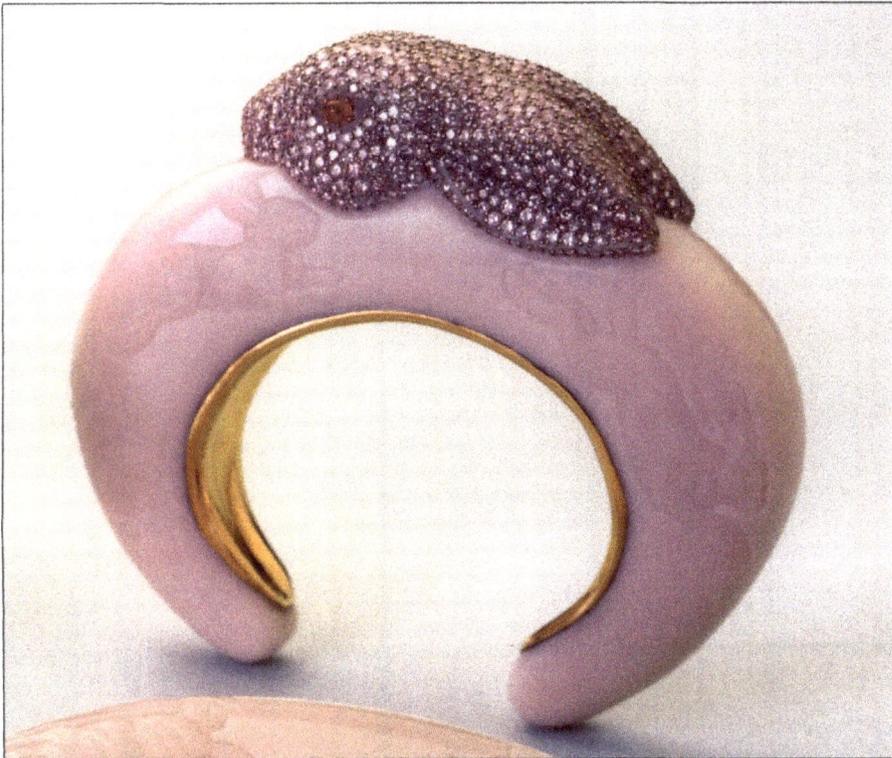

The popular American image of bunnies comes alive in this bracelet created by Daniel Brush.

Bunny Bangle
Daniel Brush
1988–1992
Bakelite, 24k gold, rubies, and pink diamonds
L: 7.6 x W: 10.2 x H: 2.5 cm / 3 x 4 x 1"

HIGH STYLE

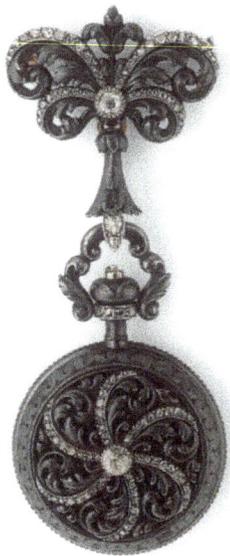

America's fascination with important jewelry can be illustrated by this excerpt from "Bernice Bobs Her Hair," by F. Scott Fitzgerald:

When a girl feels that she's perfectly groomed and dressed, she can forget that part of her. That's charm. The more parts of yourself you can afford to forget, the more charm you have But a girl has to be dainty in person. If she looks like a million dollars, she can talk about Russia, ping-pong, or the League of Nations and get away with it.

High style showed the sophistication of the jewelers. The earliest pieces in this section, which symbolize the most important jewels of the era, date back to 1860. We first see an unusually long, sapphire and diamond, gold chain necklace to match the fashions of the day (page 95).

Another early piece that shows high sophistication for the times is the Pendant Watch Brooch (pictured left) created by Tiffany & Co. in the Renaissance revival style, which was made out of gun metal steel. But it was set with diamonds!

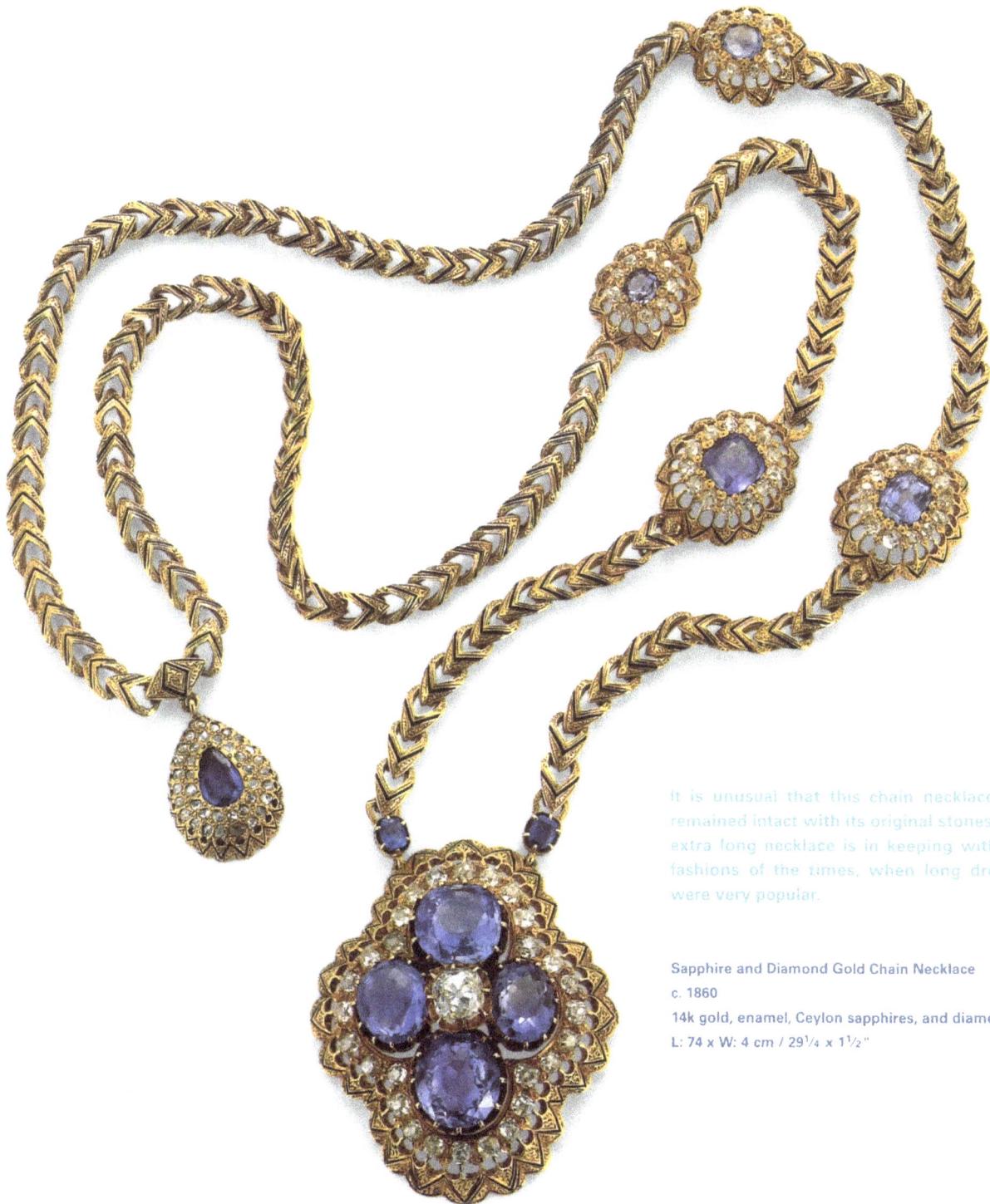

It is unusual that this chain necklace has remained intact with its original stones. The extra long necklace is in keeping with the fashions of the times, when long dresses were very popular.

Sapphire and Diamond Gold Chain Necklace
c. 1860
14k gold, enamel, Ceylon sapphires, and diamonds
L: 74 x W: 4 cm / 29 1/4 x 1 1/2 "

Diamond Pendant Necklace
Tiffany & Co.
New York, 1900
Diamonds, platinum on gold
L: 36.5 x W: 8.5 cm / 14.2 x $^3/_4$"

Pictured above we see an extraordinary necklace from about 1900 that belonged to the socially prominent Wade family of Boston. What makes this necklace unusual is that it represents the beginnings of platinum work combined with gold in a very intricate design set with diamonds.

The late nineteenth century was a time of rediscovering an archeological past. Chinese myths and legends were a great source of inspiration to American jewelers.

Dragon Pendant on Chain
Marcus & Co.
New York, 1880
Zircon and 18k gold
L: 2$^3/_4$ x 2$^1/_4$"

In the Art Nouveau period we see a proficient use of opals. Opals were considered bad luck to wear in parts of Europe, but in England and America, opals were very desirable. The piece designed by Marcus & Co. (featured on page 97) also used platinum on gold.

In 1909, when Cartier opened at Fifty-second Street and Fifth Avenue, they became the first European jewelers to be synonymous with high style in America. The company got an additional boost in 1917 when Mrs. Morton Plant traded her townhouse on Fifth Avenue and Fifty-second Street to Pierre Cartier (who was operating across the street) for a string of pearls valued at one million dollars. Incidentally, Pierre Cartier got the better of the trade with Mrs. Plant. With the advent of cultured pearls, prices plummeted, and at her death in 1956, Mrs. Plant's pearls fetched some $150,000 at auction.

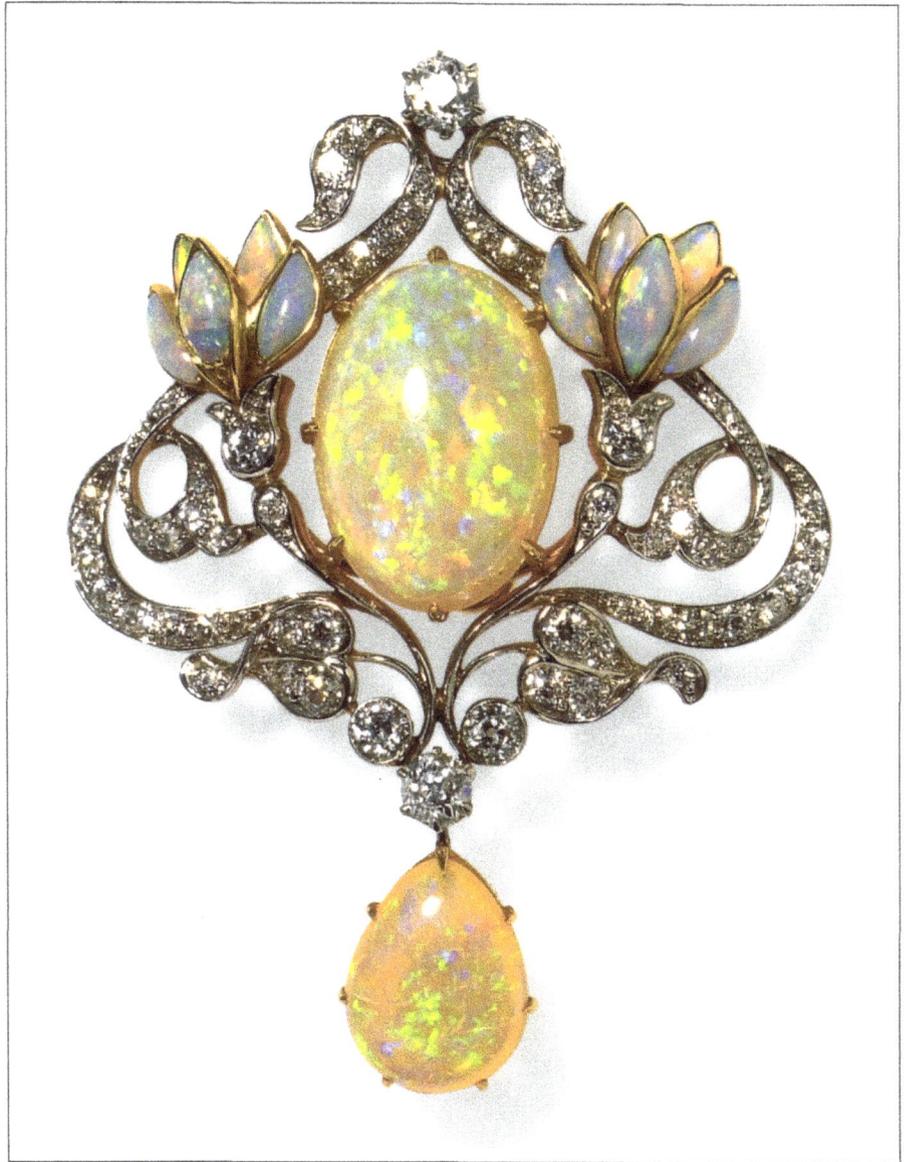

The Art Nouveau style featured opals, as evidenced in this brooch.

White Opal Brooch
Marcus & Co.
1905
White opals, diamonds, and platinum on gold
L: 6 x W: 4.5 cm / 2³/₈ x 2"

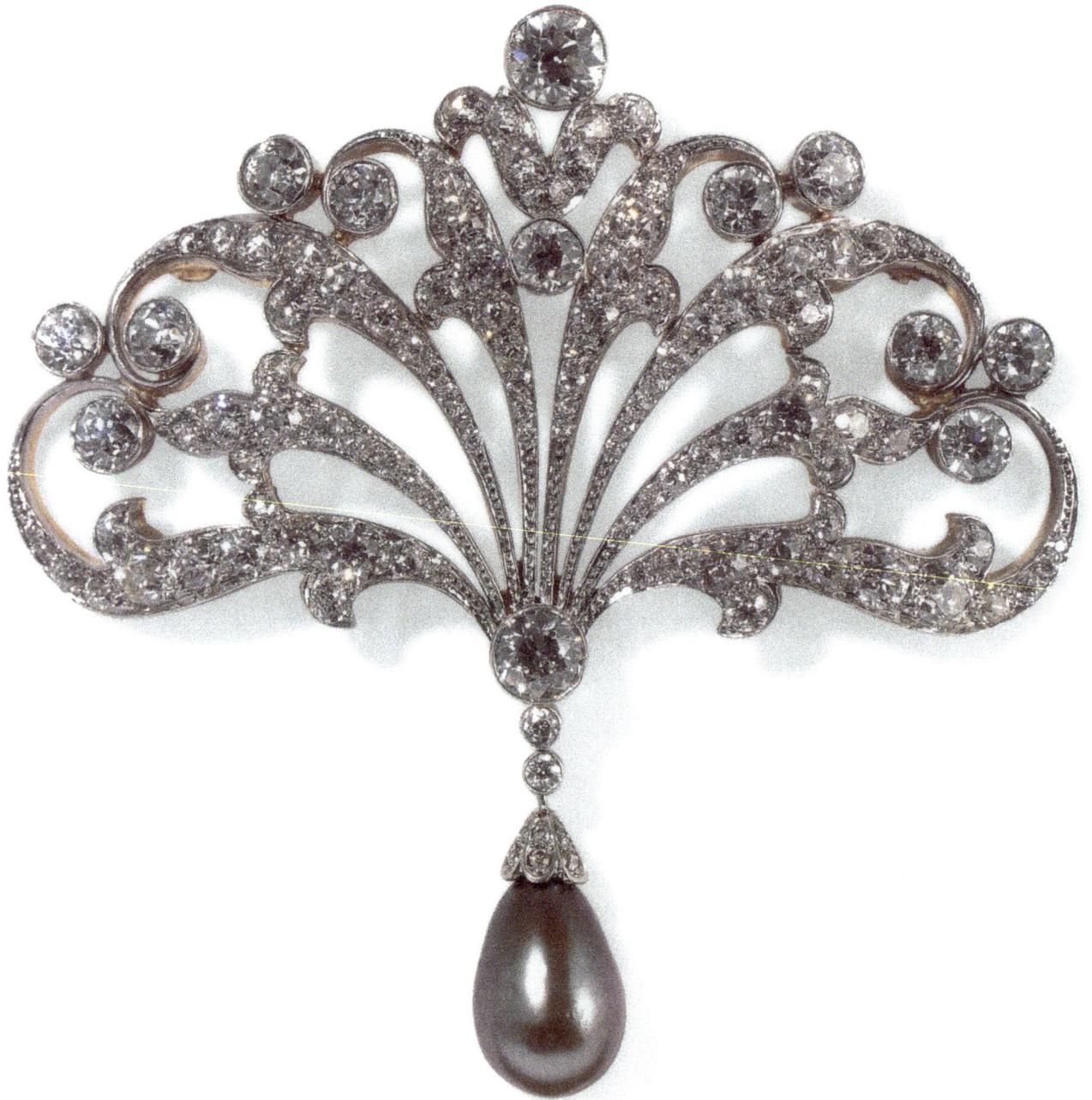

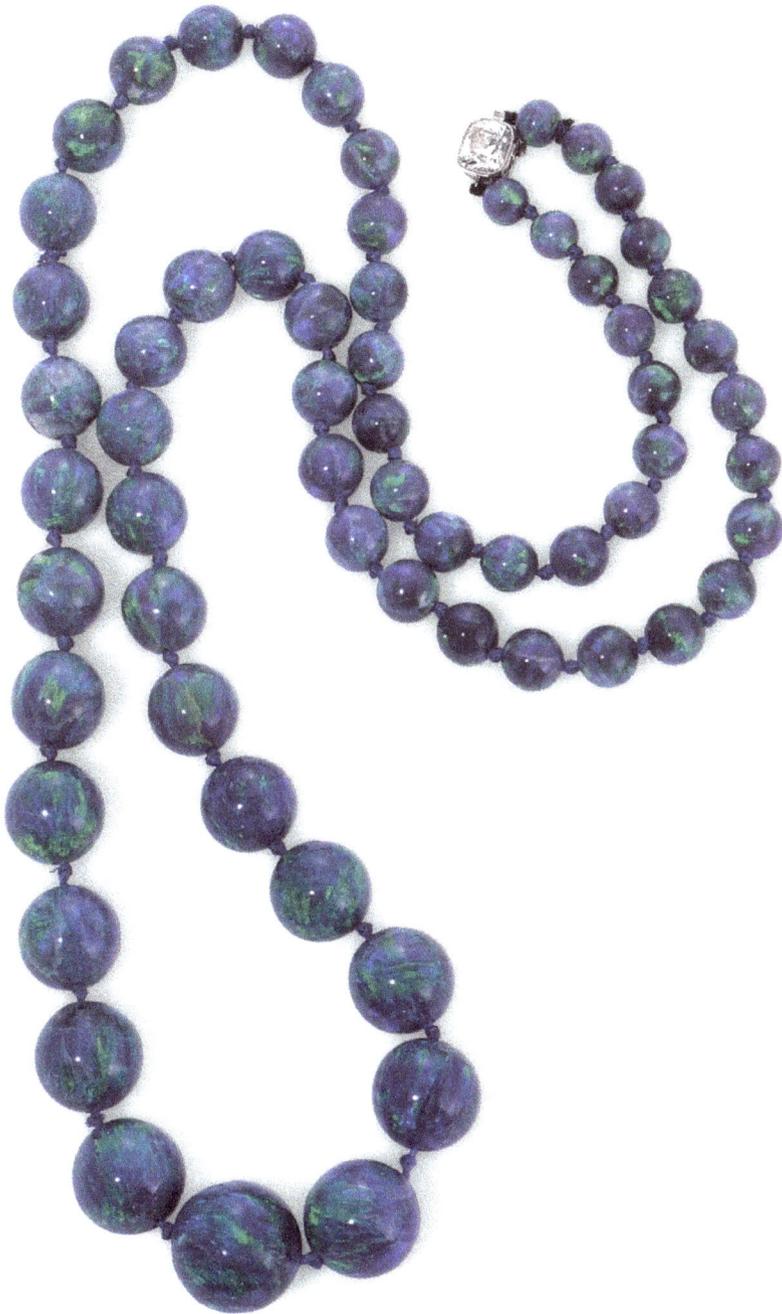

(Page 98) This brooch has a very classical design.

Natural Black Pearl Drop and Diamond Brooch
Tiffany & Co.
New York, 1915
Black pearl, diamonds, platinum on gold
L: 6.5 x W: 7.2 cm / 2⁵/₈ x 2³/₄"

(Page 99) Carved from one piece of black opal rough, the quality of these beads remains unique to this day.

Black Opal Beads
Tiffany & Co.
New York, 1900
Black opal, platinum, and diamonds
L: 71.5 cm / 28¹/₈"
16.3 mm–6.3 mm

Loretta Young

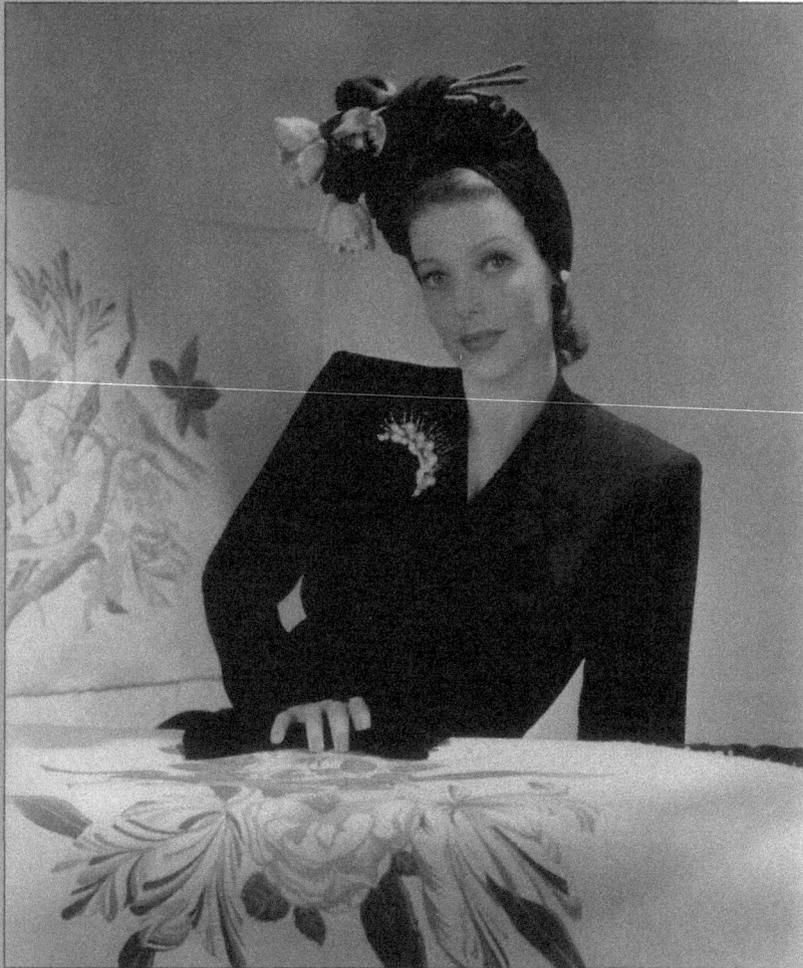

She was the perfect movie, and then, television star. Can anyone ever forget her high cheekbones, her perfect hair and makeup, or the gowns she wore when she swept down the curved banister to host *The Loretta Young Show*?

Roots

She was born Gretchen Michaela Young in 1913 in Salt Lake City, Utah. She was the younger of two sisters and also had a younger brother. When she was three, her father left and never returned, and her mother was forced to move to Los Angeles. When Loretta was five, she began to work as an extra in the movies and made her acting debut in 1926 in Mervyn Leroy's *Naughty But Nice*.

Her name then changed from Gretchen to Loretta. In the 1930s, her career took off and she worked for Twentieth Century Fox and Warner Bros. Her movies at this time included *Shanghai* with Charles Boyer and *Call of the Wild* with Clark Gable. To the public she was extremely religious and conservative, but behind the screen there was a very different person. Many biographies talk about her

quick marriage and divorce at age eighteen, her affair with Spencer Tracy (who was very much married), and two years later, an affair with Clark Gable that produced her child, Judy, whom Loretta first claimed was adopted.

Lucre

Loretta Young kept reinventing herself. From 1927 to 1953, she appeared in nearly ninety movies and was making a six-figure income. Approaching thirty and observing that her career could potentially decline because of her age, she began to look for more mature roles. Producer Dore Schary offered her a role (á la Jennifer Lopez) where she played a maid who gets elected to Congress (*The Farmer's Daughter*). For this performance she won the Oscar® for Best Actress in 1947. Miss Young was fiercely independent and counted on her own resources for money. The survivor in her showed when, in 1953, when television was relatively new, she started *The Loretta Young Show* on NBC. She won three Emmys for her shows, and her fans confirmed their acceptance with applause.

Taste

During her film and television careers, she was not known for her parties or entertaining guests. She preferred to keep to herself and a few friends. She moved to Palm Springs later in life and married Jean Louis, her fashion designer, in 1993.

Style

Loretta Young will always be remembered as the woman who swept down the stairs to welcome us into her "television home." She was always elegant and loved by her audience.

Gems

Like a Hollywood diva, Loretta Young loved jewels. She was a client of Ruser, a favorite among the Hollywood crowd, but in her own elegant and refined way, she chose jewels that were glamorous, yet not over the top. In December of 2000, at Sotheby's in New York, the possessions of her estate were sold. Included (and seen in this portrait by John Rawlings) is a brooch that is designed as a floral spray with diamonds and pearls.

By the 1920s the House of Cartier had hit its stride. As an inspiration for its Art Deco pieces, Cartier went to India and then to China and Japan. The results are incredible. This period in jewelry and design saw a reflection of the exuberant design of furniture and textiles like Puiforcat, Dunand, or Emile Jacques Ruhlmann. There was color and geometric design, which used diamonds, rubies, and emeralds rather than semiprecious stones.

Shown on page 106 is Cartier's legendary design, later referred to as "tutti frutti," which Cartier adapted in the 1920s, incorporating Indian Mogul design into contemporary Art Deco style. Cartier's creative genius in the Art Deco period was their ability to adapt designs from the ancient cultures of Mogul India, China, Aztec, and Japan.

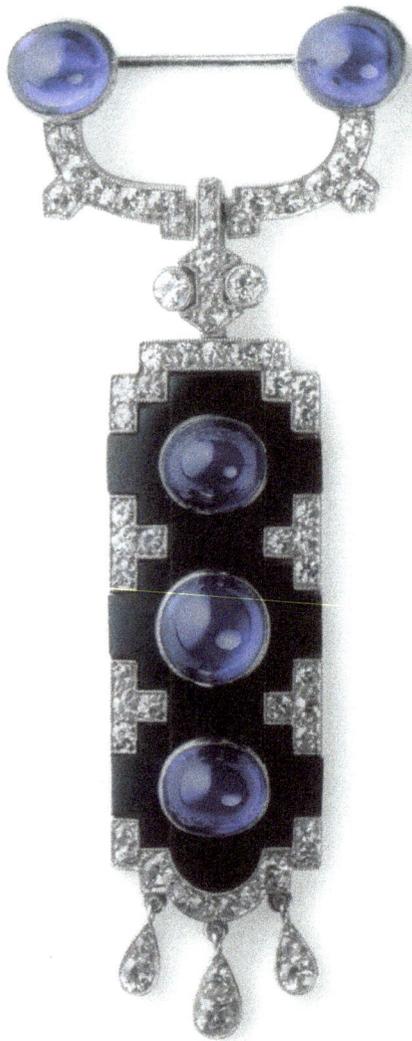

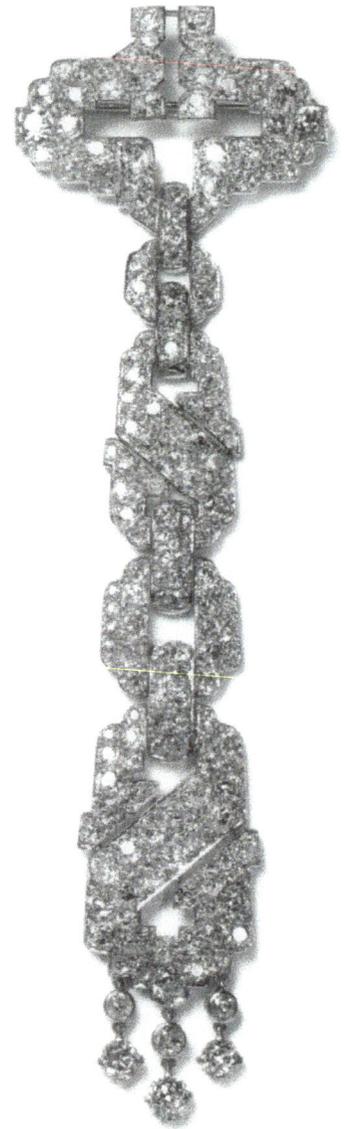

Sapphire and Diamond Pendant Brooch
Cartier
New York, 1920
Platinum, cabochon sapphires, diamonds, and black onyx plaques
L: 7 x W: 2.9 cm / 2⁷/₈ x 1¹/₈"

Diamond and Platinum Brooch
Cartier
New York, 1928
L: 15 x W: 4.3 cm / 6 x 1³/₄"

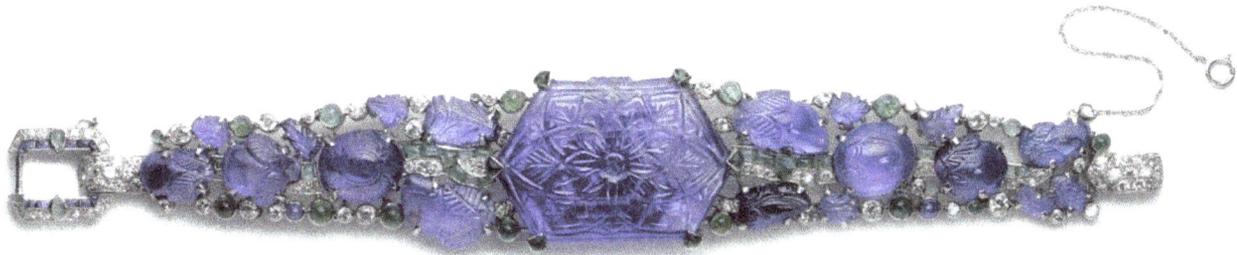

(Above) India continued to be a source of design and carved stones during the Art Deco period

Carved Sapphire and Diamond Bracelet
Cartier
New York, 1927
Sapphire, emerald, diamond, and platinum
L: 16 x W: 2.5 cm / 6³/₈ x 1"

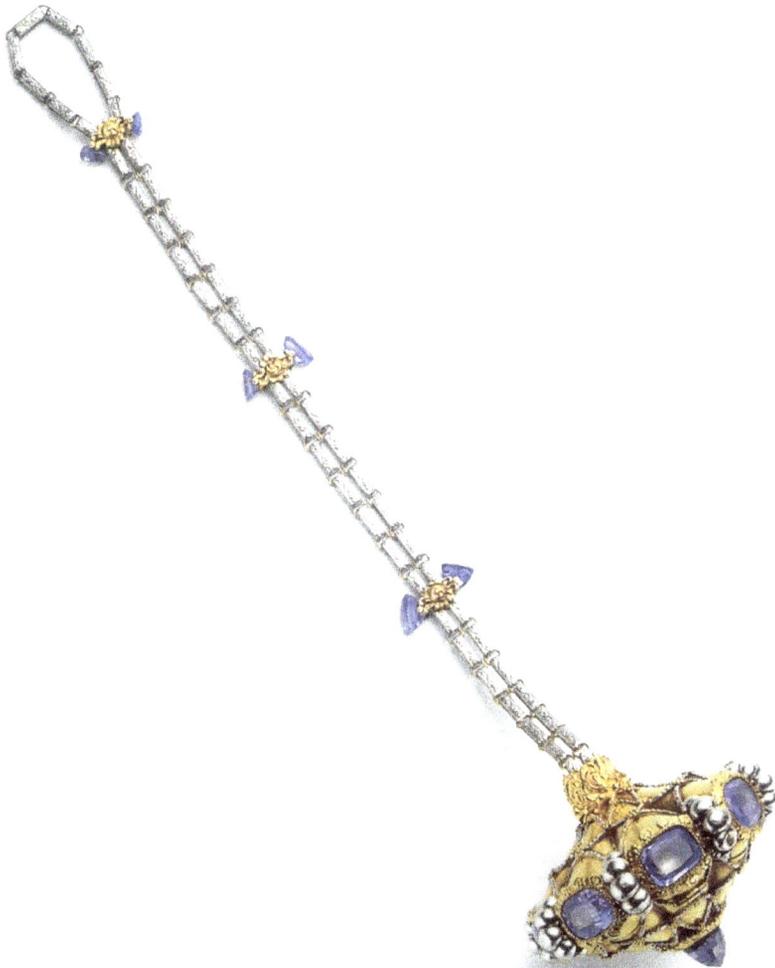

(Left) A bonbonnière was a piece of jewelry used for holding candy or smelling salts. This piece, which was shown at the 1889 Paris Expo, is in the arabesque style.

Jeweled Bonbonnière
Paulding Farnham
Tiffany & Co.
New York, 1889
Sapphires, platinum, and gold
H: 27.5 x W: 8.4 cm / 10.8 x 2.5"

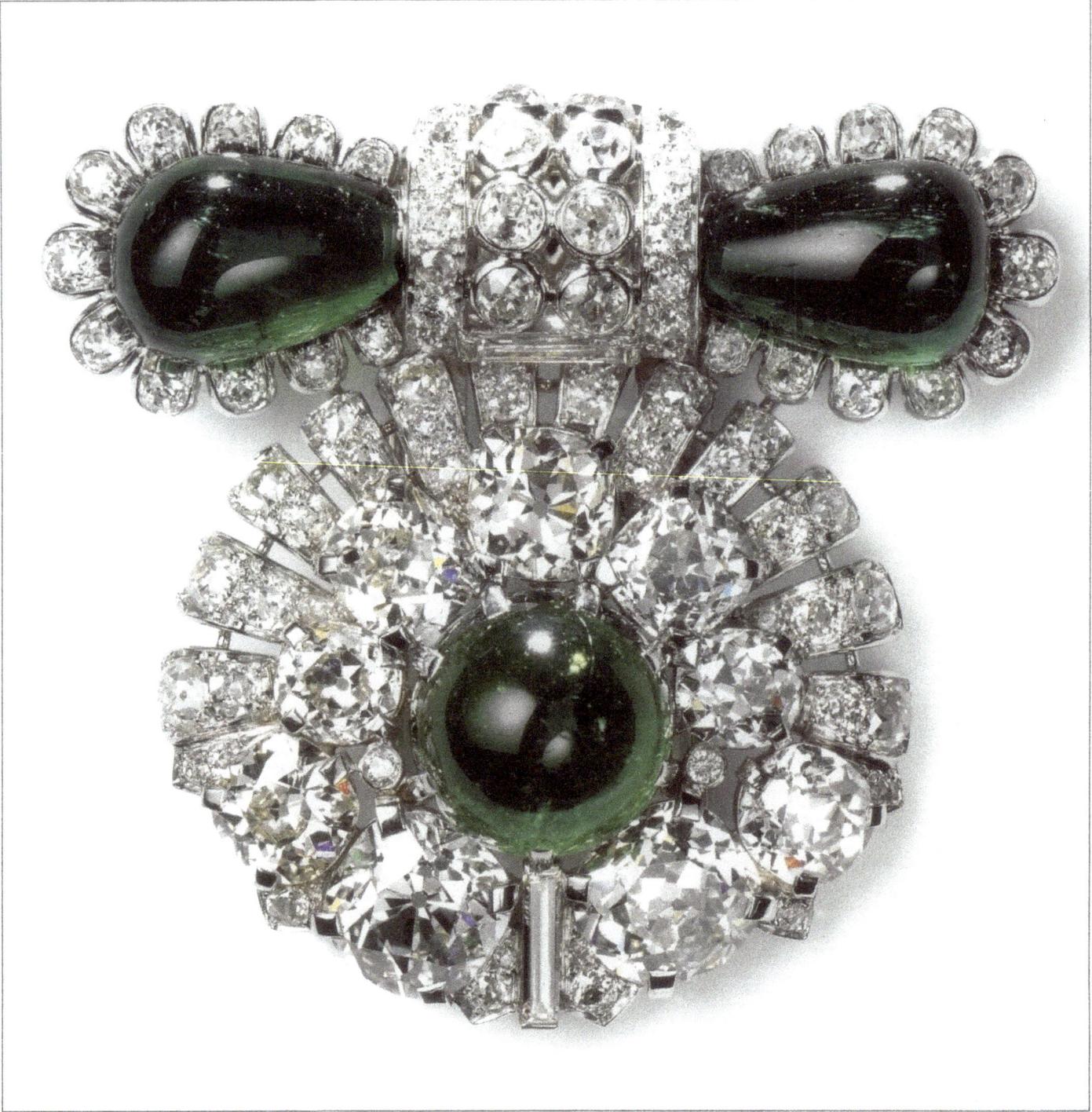

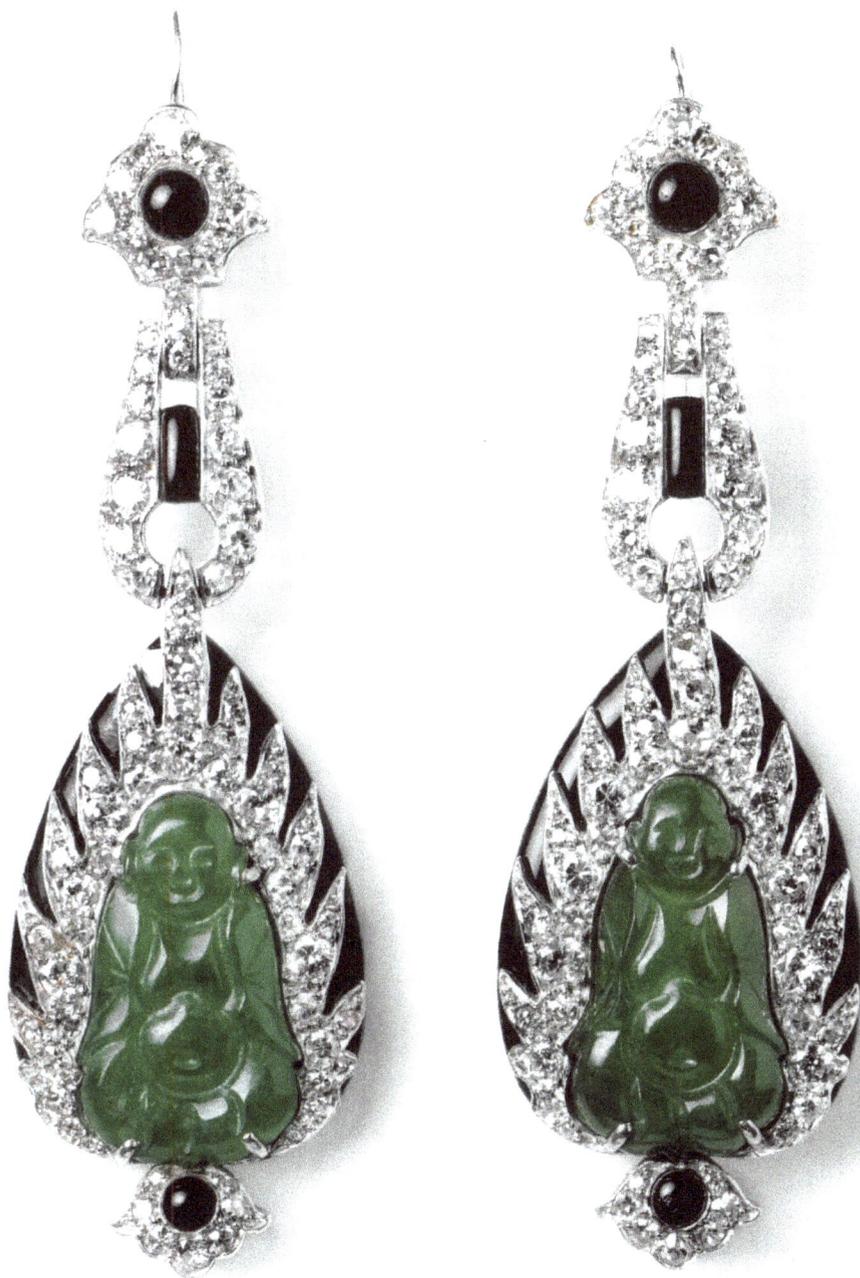

Cabochon Emerald and Diamond Brooch
Cartier
New York, 1937
Cabochon drop emeralds, diamonds, and platinum
L: 5 x W: 5.5 cm / 2 x 2$^1/_8$"

(Left) These earrings are done in a Chinese style. The details of the manufacturing illustrate Cartier's consistent quality of design.

Buddha Earrings
Cartier
New York, 1928
Jade, onyx, diamond, and platinum
L: 7.2 x W: 2 cm / 2$^5/_8$ x $^3/_4$"

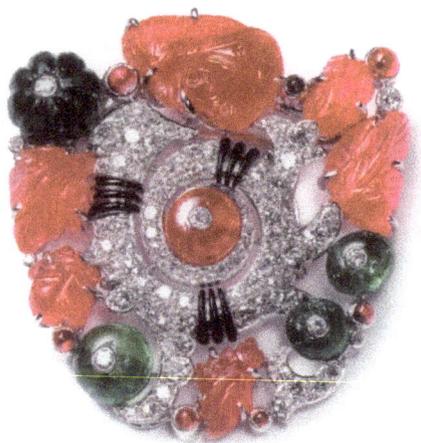

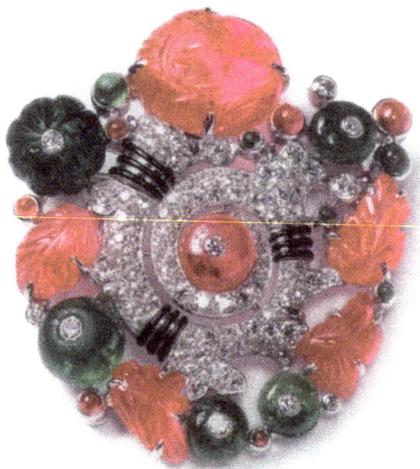

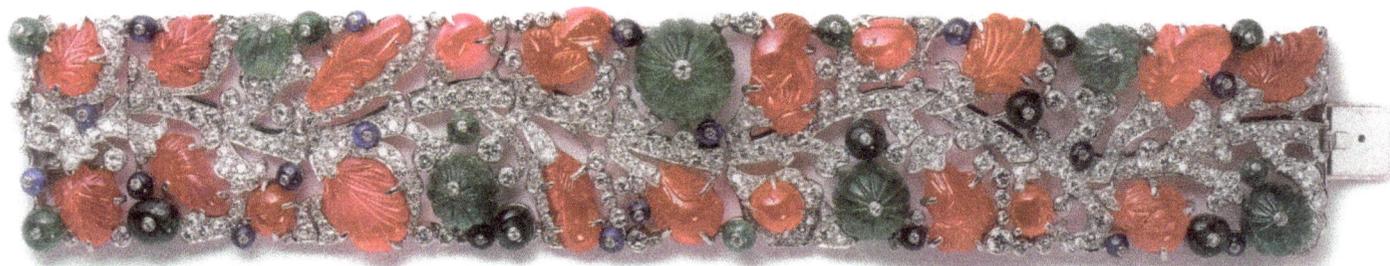

The Spanish word for pendant earrings is fantasias, meaning fantasies or dreams surrounding your head. What greater dream than to have these extraordinary jade diamond and onyx earrings (page 105) with a Buddha motif?

Some in the jewelry business might say the Cartier brooch on page 104 is bold because of the more primitive cabochon cut of the emeralds set into a compact diamond chip. The piece was commissioned in 1937 by Irving Berlin.

While bigger was still better, in the 1930s, Hollywood and its icons played an important role. Joan Crawford was a major buyer of jewels in the '30s and she favored Raymond C. Yard, known for his bunnies (see Humor).

On page 109 we see the glamorous diamond and platinum bracelet designed by Yard and owned by Joan Crawford. She is wearing it in her portrait on page 108.

At this time, among Paul Flato's most famous clients were Linda and Cole Porter. Pictured on the right is an exquisite necklace made out of rubies and aquamarines. It looks like a basic belt, and that is the beauty. It is unique in its sheer simplicity.

Hollywood stars in those years and continuing up to the 1960s, preferred to own or commission their own jewels. They did not borrow, they bought! At times, they even wore their own jewels in the movies!

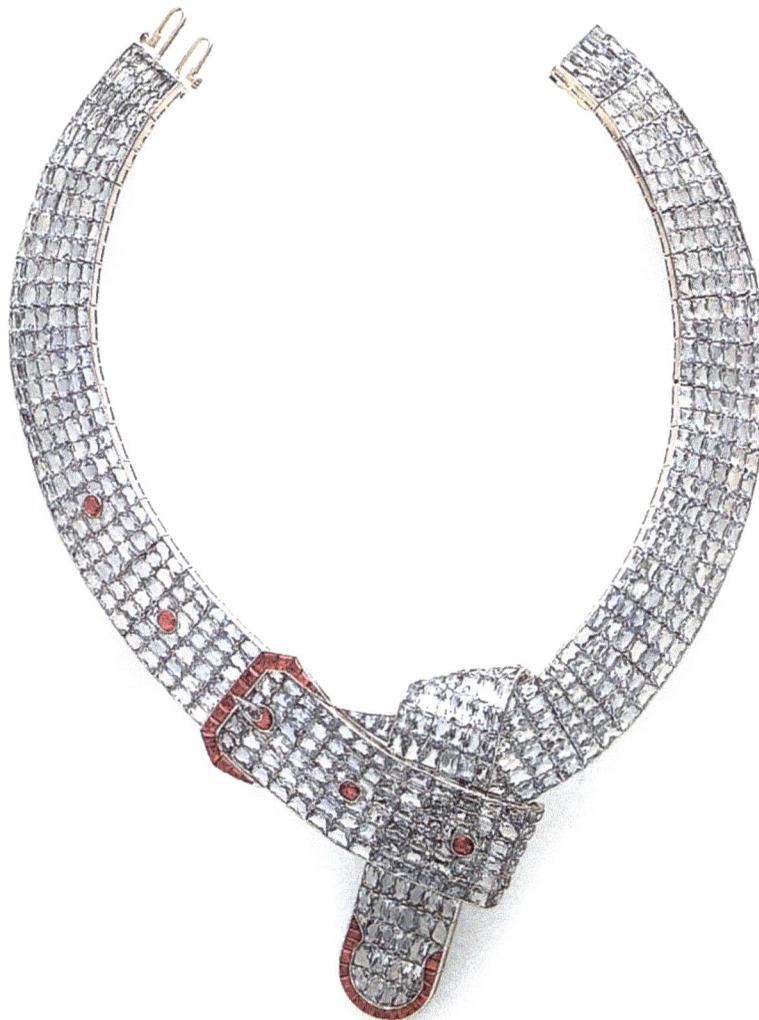

(Page 106, Top) These two beautiful brooches (or clips) are encrusted with diamonds, black enamel bands, engraved ruby leaves, and ribbed emerald berries. Both are studded with a diamond.

Tutti Frutti Clips
Cartier
New York, 1929
Platinum, diamonds, emerald beads, and rubies
L: 3.9 x W: 3.9 cm / 1½ x 1½"

(Page 106, Bottom) Cartier incorporated Indian designs into contemporary jewelry.

Tutti Frutti Bracelet
Cartier
New York, 1928
Platinum, diamonds, emerald beads, and rubies
L: 18.8 x W: 3.5 cm / 7³⁄₈ x 1³⁄₈"

(Above) Paul Flato created this aquamarine and ruby belt buckle necklace for Mrs. Linda Porter. It looks like a belt, and yet it is a highly stylized piece of jewelry.

Belt Buckle Necklace
Paul Flato
New York, 1940
Aquamarines, rubies, and platinum
L: 49 x W: 2.5 cm / 19 x 1"

Joan Crawford

Persona

Our image of Joan Crawford is not entirely accurate. We see her as tall, but she was only 5'4". We see her as petite, but her broad shoulders were athletic. The fact is, Joan Crawford worked hard to create the image of Joan Crawford. She was imperious, and she was difficult. What sums her up is her comment, "I never go out unless I look like Joan Crawford, the movie star. If you want to see the girl next door, go next door."

Roots

Lucille Fay LeSeuer was born in Texas in 1904, to a dirt-poor upbringing. In one biography, it says that Lucille's mother cleaned other people's homes. Lucille vowed that she would never do that! Her mother soon remarried the owner of a local theater in Oklahoma. Lucille became entranced in vaudeville and began dancing in Chicago. While in the chorus of *The Passing Show of 1924* she was discovered by MGM. In 1925, the studio, with *Photoplay* magazine, held a magazine contest to find a better name for her. The result was Joan Crawford. By 1929, she had starred in a succession of movies. She married Douglas

Fairbanks, Jr. and gained Mary Pickford, who was only ten years her senior, as her step-mother-in-law. She made over eighty films, and won an Oscar® for *Mildred Pierce* (1945). Yet the legend of the screen never found success in the real life romance department. She married four times and adopted four children. A year after she died, her adopted daughter published *Mommie Dearest*, portraying Joan as an abusive and violent person.

Lucre

Having grown up in a poor household, Joan never felt rich, or even secure. Joan lived a rags to riches life.

Style

It is conceivable that she learned much from Mary Pickford. Mary collected jewels, and Joan was a quick study. On the screen, her specialty was the Cinderella story, but in real life she acted as a diva.

Taste

Joan was bold, and so was her taste in jewelry and clothes. She acted her role in every way. (She loved to wear her memories of success by assembling charm bracelets depicting her Oscar®, her pets, and even her many husbands.)

Gems

Joan loved gems, the bigger the better. The press started calling sapphires "Joan Blue" because of her love for them. From her husband, actor Franchot Tone, she received a 70-carat star sapphire engagement ring. At times she also wore a 72-karat sapphire, often on the same finger. From the 1930s to the 1950s, she bought heavily from Raymond C. Yard, and pictured above and in her photograph on page 108, we see her diamond and platinum bracelet.

Joan Crawford loved the jewelry of Raymond C. Yard, as he paid special attention to design and the use of fine-quality stones. In her portrait on page 108, Crawford admires her bracelet's craftsmanship and its simple yet elegant design.

Diamond and Platinum Bracelet
Raymond C. Yard
1935
L: 18 x W: 2 cm / 7 1/8 x 7/8"

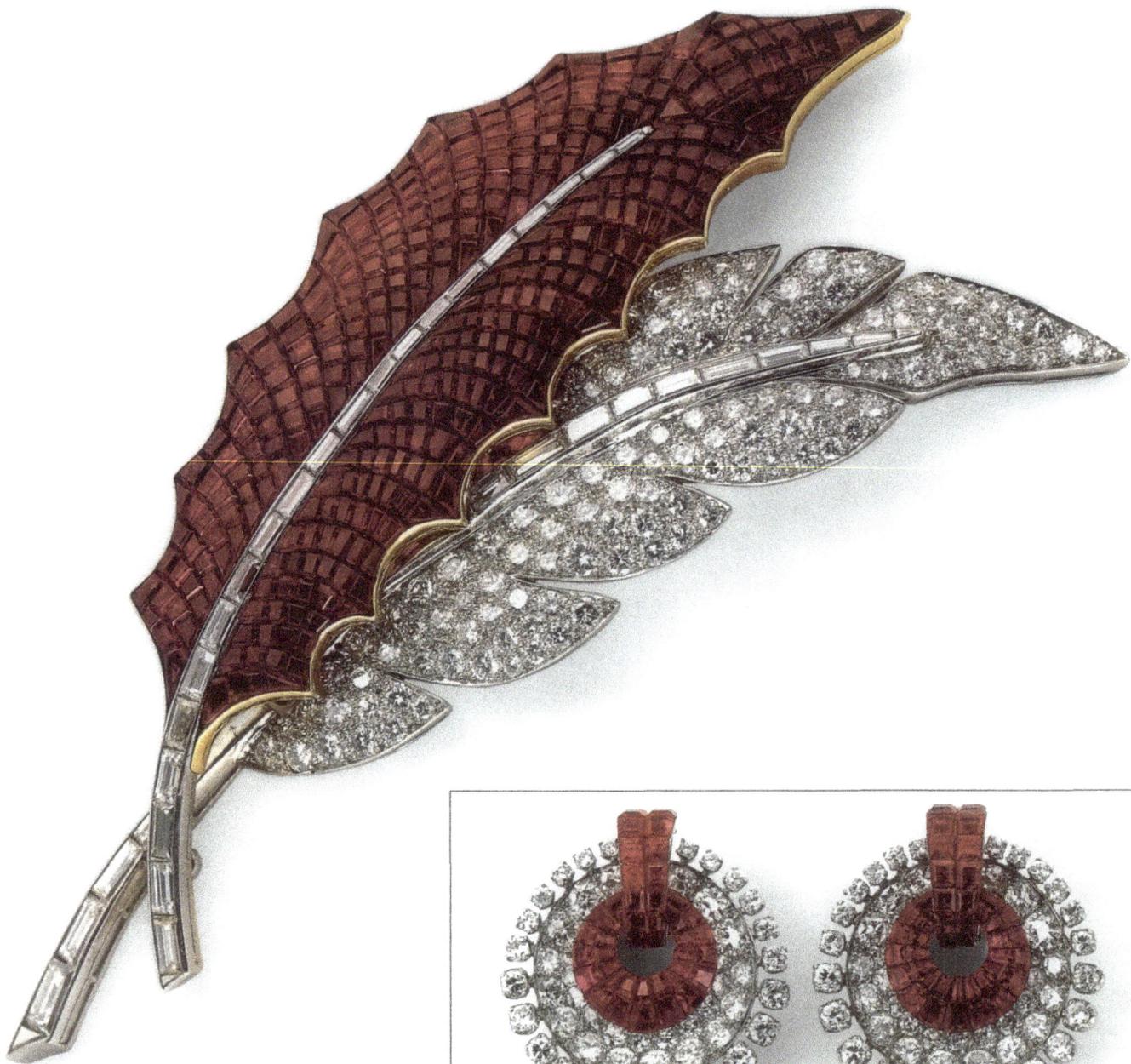

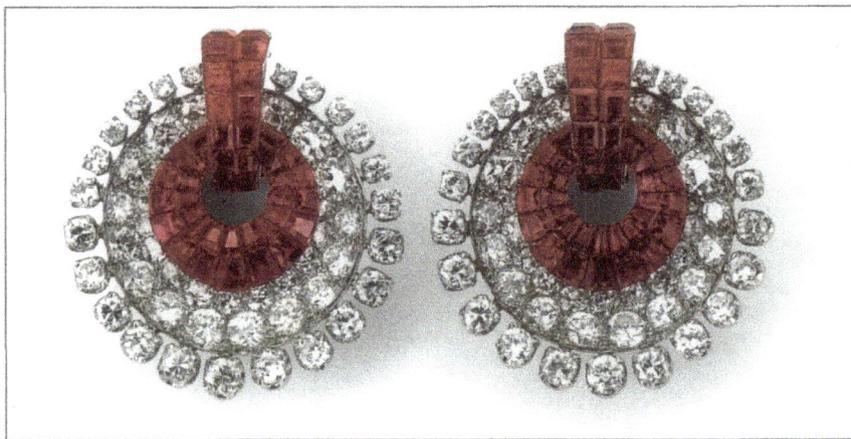

Another French, high-style jeweler featured is Van Cleef & Arpels. When World War II ended, Claude Arpels decided to remain in New York and opened his atelier at Fifty-seventh and Fifth Avenue. In the 1920s, in France, he had perfected the invisible setting and then brought it to America. With an invisible setting, the naked eye can only see the gems. There are no visible metal mounts. All these gems, whether rubies or sapphires, must be perfectly matched. Oscar Heyman and Bros. was among the first to work with Van Cleef and other jewelers on this setting.

One important, high style jewel represented here is the leaf brooch with invisible setting, signed by Van Cleef & Arpels (page 110). There were three of these made, and one was purchased by the American Wallis Simpson. It is set in rubies and diamonds, in yellow gold and platinum.

Also on page 110 are a pair of Van Cleef's ruby and diamond earrings. They seem as if they could accompany the leaf brooch. The earrings were owned by Walter Chrysler's daughter, Bernice Chrysler Garbisch. Another example that signaled that traditional design was changing is the abstract Winged Bird Brooch (pictured right) signed by Van Cleef & Arpels.

In the 1940s, Christian Dior proclaimed the "New Look" in Paris and influenced fashion throughout the world.

Winged Bird Brooch
Van Cleef & Arpels
New York, 1941
Citrine, diamond, and yellow gold
L: 11.8 x W: 10.5 cm / 4$^1/_2$ x 4"

(Page 110, Top) In the 1930s, Van Cleef popularized the "invisible setting." This involved cutting perfectly matched stones that are then grooved and slid along a hidden metal tract. On the surface, no metal can be seen. The Duchess of Windsor purchased one of the three sets made.

Invisibly set Ruby and Diamond Leaf Pin
Van Cleef & Arpels
New York, 1950s
L: 10.5 x W: 6 cm / 4 x 2$^1/_4$"

(Page 110, Bottom) Here is another example of the invisible setting. These ruby and diamond ear clips were owned by Bernice Chrysler Garbisch, the daughter of automotive tycoon Walter Chrysler.

Invisibly set Ruby and Diamond Circle Ear Clips
Van Cleef & Arpels
New York, 1941
L: 3 x W: 2.9 cm / 1$^1/_4$ x 1$^1/_8$"

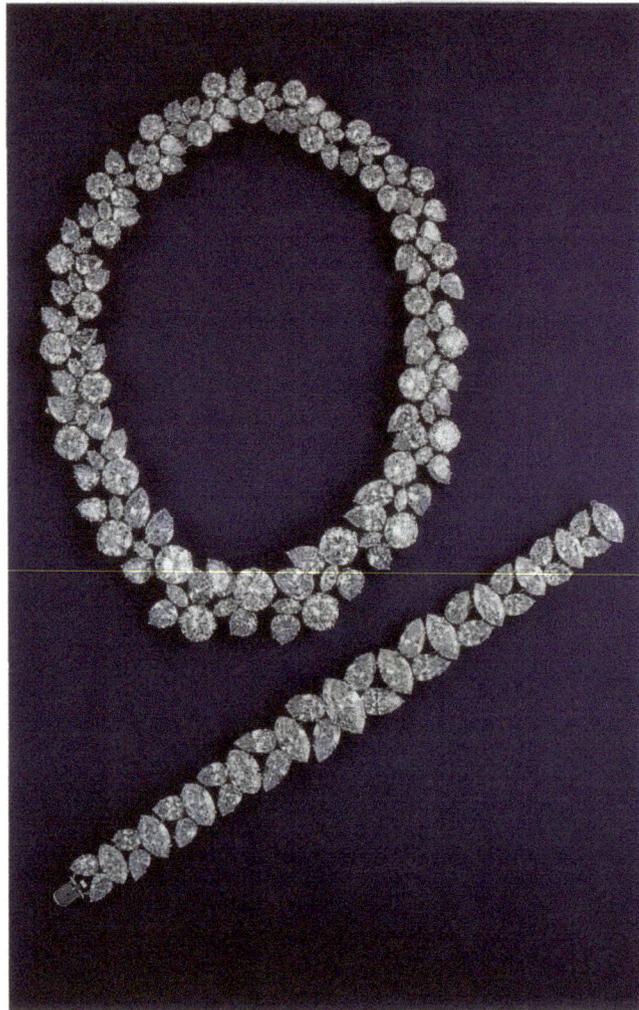

Diamond Necklace and Bracelet
Harry Winston
c. 1960
Round, pear shaped, and marquise diamonds and platinum
Necklace: L: 18 x 1½"
Bracelet: L: 7 x ¾"

The "New Look" featured cinched waists, narrow shoulders, full skirts, and tight tops that emphasized the bust and waistline. Jewelers wanted to stay current with the emerging fashion trends and began to create exquisite, all-diamond jewelry. One of the most creative in accomplishing this was Harry Winston, who emphasized a free-form abstract approach in contrast to traditional design. In fact, the diamonds looked as if they were floating in air.

Winston became a jeweler in 1932, and his motto was "Rare Jewels of the World." Two years after he started his business, he acquired the Jonker Diamond, which was the world's seventh largest rough diamond at that time. He became a major source of jewelry for the Duchess of Windsor and sold her the McLean diamond. He then proceeded to collect such jewels as the important Hope Diamond, which he later donated to the Smithsonian Institute in Washington.

(Below) Paul Flato's creativity and daring are illustrated in this bracelet of sapphires and emeralds—a blue and green palette totally devoid of white diamonds.

Sapphire and Emerald Platinum Bracelet
Paul Flato
New York, Late 1930s
L: 16.5 x W: 1.2 cm / 6¾ x ½"

The famous French jeweler Mauboussin opened a branch in New York immediately before the Wall Street Crash in 1929. Rather than close down the operation, they arranged for Traebert & Hoeffer to purchase them. Mauboussin soon became the favorite of the Hollywood stars— it is very likely that this bracelet belonged to a Hollywood starlet.

Jeweled Cuff
"Reflections" Series
Traebert Hoeffer-Mauboussin
1940
Gold, diamonds, topaz, and amethyst
H: 6.7 x W: 6.5 cm / 2$^{1}/_{2}$ x 2$^{1}/_{8}$"

Grace Kelly

Persona

She was the American Princess. To all who saw her on the screen, Grace was elegant, sophisticated, beautiful. She reeked of class, even when playing against such idols as Cary Grant and James Stewart. When she wed Prince Rainier III of Monaco in 1956, she became a real princess.

Roots

She was born in 1929 in Philadelphia, to a family that became wealthy. Her father, John, worked as a bricklayer and later became a general contractor. She was the third of four children. While there only was one son, all her siblings were avid sports enthusiasts. Grace preferred to stay inside. Grace's family had two important members working in the theatre: actor Walter Kelly and Pulitzer Prize winning dramatist, George Kelly. They gave her parts in plays which propelled her to the American Academy of Dramatic Arts in New York, where she graduated in 1949. She debuted on Broadway, in a revival of *The Torch Bearers*, her uncle's comedy. Two years later she appeared on the screen in *Fourteen Houses* (1951) and appeared as Gary Cooper's

wife in the classic, *High Noon* (1951). This movie made Hollywood take notice of her. The next year she played in *Mogambo* and was nominated for an Oscar® as Best Supporting Actress. Director Alfred Hitchcock considered her the perfect woman and cast her in *Dial M For Murder* in 1954. That same year, she won the Oscar® for Best Actress for her role in *Country Girl*.

Lucre

While Grace came from a wealthy environment, she never felt she had the emotional backing of her family until she won the Oscar®.

Style

She was always a perfectionist. Known for her classic daytime suits and chiffon evening gowns, she was definitely a fashion icon. Not only did she appear in ads while working as a model at the American Academy of Dramatic Arts, but after she began appearing in films the media loved to cover her. When Grace married Prince Rainier of Monaco, Hermès re-christened her handbag to be known as "The Kelly Bag."

Taste

Her taste was always elegant. However, Grace herself was approachable. Once, when Princess Grace was entertaining guests at her summer home, the doorbell rang. It was a friend of her children's tutor. Grace answered the door herself and told the guest that she was making martinis for everyone, including the actor David Niven, and would he care for one? He did and, by the way, Princess Grace made an excellent martini!

Gems

In her classic style, Grace favored pearls and diamonds. In that period, pearls were definitely synonymous with European aristocracy. Her portrait was done by Howell Conant (see page 114).

This brooch was designed by Jean Schlumberger before he worked for Tiffany in 1947. He created it for Millicent Rogers. It highlights a morganite, a stone known as pink beryl before it was named for J.P. Morgan around 1900.

Crown of Thorns Brooch
Jean Schlumberger
1947
Morganite, diamonds, and 18k gold
L: 8.25 x W: 6.35 cm / $3^{1}/_{4}$ x $2^{1}/_{2}$"

In the 1960s, President Kennedy and his wife Jackie ushered in Camelot. In his book, *Jackie: Her Life in Pictures*, James Spada writes, "By the time the Kennedys arrived in Paris, the country was in a Jackie swivit. Rather than crying 'Vive l'Amerique' Parisians chanted 'Jac-Lien! Jac-Lien!' At the Elysée Palace in Paris, Jackie seems to glitter as much as the crystal chandeliers."

Her gold cuffs from Van Cleef & Arpels (page 119 and shown in her portrait on page 118) show a youthful, yet traditional, look. People now all wanted the Jackie style.

By the time the 1970s arrived, all the jewelers realized that there were more working women. Women had become more independent. They decided on their purchases themselves, and the days of only American princesses and Hollywood stars purchasing their own jewelry would soon be over.

Wide chokers became popular in the 1890s and early 1900s. The Princess of Wales (later Queen Alexandra) wore them, and many fashionable women followed suit. What makes this collar even more interesting is that it remains contemporary.

Dog Collar
Paulding Farnham
Tiffany & Co.
New York, 1893
Enamel, yellow gold, tuquoise, pearls, and diamonds
L: 35.5 x W: 3.2 cm / L:14 x W:1.25"

117

Jackie
Kennedy
Onassis

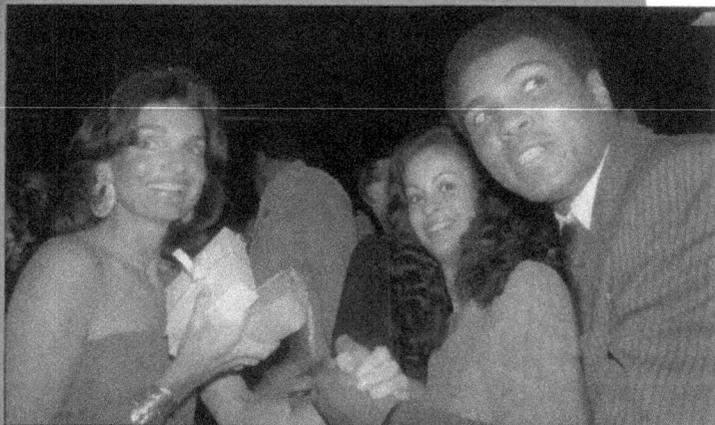

Persona

When young socialites are interviewed by the press, they invariably say their idol is Jackie O. She has been dead ten years, and yet the mystique surrounding her is greater than ever. Whether it was the result of her very rarely speaking to the press, her incomparable beauty, or her permanent status as the First lady of Camelot, her public wanted her. While JFK was President, she charmed dignitaries and brought the best of culture to Washington. In 1962, she did a first—hosting a dinner for forty-nine Nobel Prize Winners in the White House.

Roots

Jacqueline Lee Bouvier was born in New York to Janet and John Bouvier. Her mother then married Hugh Auchincloss, a socially prominent and wealthy investment banker. For schooling, Jackie went to Chapin, graduated from Miss Porter's, the proper eastern finishing school for girls, then entered Vassar College. She studied at the Sorbonne, and after Paris, began working at the *Washington Times-Herald*. Her background was privileged, including a Park Avenue home and summers on Long Island.

Lucre

While Jackie came from an affluent background, she saw herself as a working person. She was an editor at Viking Press and was highly occupied in art and historic preservation. As a result of Jackie's effort, Grand Central Station in New York and Lafayette Square in Washington still stand.

Style

When Jackie was presented as a debutant in 1947, Cholly Knickerbocker, the social columnist of his day, wrote, "Every year a new 'Queen of Debutants' is crowned. Queen Deb of the Year is Jacqueline Bouvier, a regal brunette who has classic features and the daintiness of Dresden porcelain. She has poise, is soft spoken and intelligent—everything the leading debutant should be." The best line everyone remembers, a testament to her poise and style, came after JFK and Jackie visited Paris, where Jackie had been a smash hit with dignitaries and locals alike. Upon leaving, JFK said: "I am the man who accompanied Jacqueline Kennedy to Paris."

Taste

Jackie reeked of glamour and star quality. Although inimitable, whatever she wore had people rushing to find out the manufacturer so that they could buy it themselves. She loved antiques, art, and design. We remember her for pillbox hats, coats with large buttons,

and even her soft voice. She spoke French and Spanish and became one of the most admired women in America. Also, what was more outstanding was the fact that she raised two children as a widow.

Gems

While Jackie loved jewelry, her taste was neither gaudy nor showy. She liked simple jewelry, such as Jean Schlumberger for Tiffany's bangle bracelets that became known as "Jackie bracelets." Another jeweler identified with her was Van Cleef & Arpels. In 1953, her diamond and emerald engagement ring came from VC&A. In 1977, Jackie lent her presence to the party for the annual Robert F. Kennedy Tennis Tournament at the Rainbow Room. In this photograph (page 118) with heavyweight champion Muhammad Ali and his wife, Veronica, Jackie is wearing a pair of gold cuffs from VC&A. The cuffs are elegant, simple, and yet are nearly 3¼" inches wide.

Nearly 3¼" in width, these gold cuffs belonged to Jackie Kennedy Onassis. On page 118 we see her wearing them to a party with Mr. & Mrs. Muhammad Ali.

Gold cuffs
Van Cleef & Arpels
New York, 1970
18k gold
W: 3¼"

There was a difference between American and European women. American women worked, and they loved bold jewelry. They didn't have to be demure. Clothes were now mini skirts, and Halston and Studio 54 were the buzz words. Day-to-Night wear jewelry was introduced. Bulgari hired Tiffany & Co. designer, Donald Claflin (who unfortunately died suddenly within a few years) to make New York, not Rome, the center of their jewelry universe (see his work pictured to the left). After Claflin's death, Rome again became the center for the company.

In the 1990s, the bigger-is-better trend in jewelry continued. The film *Wall Street* demonstrates if you got it, flaunt it! However, this time the fashion was to have a designer attached to the jewelry. The label was now as important as the jewel.

Multicolor Jeweled Lamp
Manufactured by Carvin French Jewelers
New York, 1980s
Aquamarine, jade, and 18k gold
H: 30 x W: 12 cm

One American designer who earns international recognition today is Joel Arthur Rosenthal or "JAR." Born in New York, he had a major show in 1987 at the National Academy of Design in New York. The piece on page 123 is from that show. It is a butterfly brooch with Montana sapphires and diamonds. His works are rare and can take years to complete.

There continues to be an insatiable desire for high style jewelry marked by greater appreciation for past styles in updated and modernized forms. JAR's work embodies that idea in contemporary jewelry. People look longingly in windows whenever new watches or jewelry are displayed. The universal fascination with jewelry, old and new, continues.

Tahitian Pearl Necklace
Assael International
1990s
Tahitian pearls, diamonds, and platinum
L: 47 cm / 15 x 12.4 mm

(Above) Blue Butterfly
Joel Arthur Rosenthal (JAR)
c. 1987
Montana sapphires, diamonds, silver, and gold
L: 12.2 x W: 9 cm / 4$^{3}/_{4}$ x 3$^{1}/_{2}$"

HOLLYWOOD
SPARKLE

AN INTERVIEW WITH DOMINICK DUNNE

BY JOHN ORTVED

Dominick Dunne moved to Hollywood in the late 1950s. As a set designer and producer, he moved among

Hollywood's most socially prominent circles. His friends and fellow party guests are among Hollywood's great-

est names: Elizabeth Taylor, Loretta Young, Gary Cooper, and the Rat Pack's Peter Lawford, just to name a few.

Mr. Dunne has a vault of stories worth more than any monetary sum. He remembers a Hollywood many of us

can only dream about: the stars, their glamour, and their jewelry. For this book, Mr. Dunne was kind enough to

share some of these memories with us, and let us glimpse inside the world of dreams.

Tell us about the Hollywood you remember——the stars, their style, their jewelry.

I was a young man in Hollywood during the last, great days of Hollywood, in the days when movie stars dressed

like movie stars, gave parties and dances, which movie stars don't do any more. There was a whole rigid society

in Beverly Hills and the Hollywood crowd.

They were real parties. The most glamorous parties were given by Humphrey Bogart and Lauren Bacall, at

which Judy Garland sang, and Sinatra sang. And people ended up in the swimming pool.

Later, when I was still very young out there in Hollywood, I went to another glamour party given by Wendy Stark's parents: Ray and Fran Stark. Ray, the movie mogul, and Fran were called Hollywood royalty, in that she was the daughter of Fanny Brice. Fran Stark had exceptionally beautiful jewelry, all of which she inherited from her mother, Fanny Brice, the great comedienne, who had wonderful taste. They used to have an expression, the day after that kind of party, they'd always say: "Oh, everyone went to the vault yesterday," meaning, to get the jewels out to wear to the party. Everybody wore whatever they had that was the best that they had. They were not jewels you kept at home. They were *that* valuable.

At that party, there was a sight I've never forgotten. Merle Oberon was from Tasmania, and she became, through the years, not only a great movie star (she was in *Wuthering Heights* with Laurence Olivier)—but she became a great international society figure. Merle would have people like Prince Phillip for dinner, with whom she was alleged to have an affair. After her first marriage, to Sir Alexander Korda, the great British film produc- er Merle became Lady Korda. There are pictures of her at the Bastigi Ball in Venice. And she had the greatest emeralds of her era: "Merle's Emeralds."

I went into the Stark's house with my wife, we were newly married, and there in the corner, in deep animated, witty conversation were Gary Cooper, the handsomest man who ever lived, I think, and Merle Oberon. Merle was incredibly sexy in this grand way, and she was in a pale blue, satin evening gown. She didn't have the emeralds that night, she had the big diamonds on. And that's the romantic Hollywood picture I've always retained, just the sheer glamour of those two gorgeous people.

When Merle Oberon died, Mrs. Aaron Spelling, Candy, the famous Candy, who had a huge and very impor- tant jewelry collection, probably the most important in Hollywood, bought Merle's emeralds. Candy doesn't need one of those loupes to tell you how many karats a diamond is. There was a great event one night in Hollywood, and Candy Spelling was going to wear the emeralds. Somebody told her that Merle Oberon's widower was going to be at the same party, and she shouldn't wear them, that it would make him sad. But she wore them.

Another one who had incredible jewelry was Mrs. Jack Benny, Mary Benny, also a big hostess of the time. She had the biggest diamond ring, and her daughter now has it. Both mother and daughter did the same thing: when they're not wearing the diamond, instead of putting it in the vault, they hang it from a chandelier, because it fits in with the prisms. It is a nice little touch. And it's of that size.

Tell me about other Hollywood divas and their love of jewelry.

When you started a movie with Elizabeth Taylor, those in charge, like the producer and director, were meant to give her a piece of jewelry. Instead, we found a pair of boudoir lamps; and we thought, "What a wonderful gift for Elizabeth," and we presented her this gift. Well that wasn't what she expected at all.

She wanted jewelry. And so then I went back to Venice, to the famous jeweler there, and I bought her a ring, which was pink coral surrounded by three rows of diamonds, something you'd say was daytime jewelry. She absolutely adored it. She would say, "Oh, look what Dominick gave me. Look what Dominick gave me. Look. Oh, look." She just loved jewelry that much. And three or four days later, she lost it.

Elizabeth never disappointed, never. She wore the most beautiful jewelry I've ever seen.

Loretta Young was another big jewelry person. She was, you know, the velvet glove and the hand of steel. She was so sweet, and so nice, and so tough to the people who worked for her. Her movie days were over by the time I got to know her, and she was very much a great television star. She had a very successful show that went on for years, and she wore beautiful clothes designed by Jean Louis, who she later married.

She wore beautiful jewels all the time, she was a beautiful woman, and she was a devout Catholic. She talked about God, went to mass. And she had this thing about any dirty word: if anybody swore, she always carried with her, a little silver cup, something she could carry in her bag that you had to put money into. She had a collection, and it would go to for unwed mothers. And she raised all this money for them.

BIBLIOGRAPHY

Culme, John and Nicholas Rayner. *The Jewels of the Dutchess of Windsor*. New York: Vendôme Press, 1987.

De Tocqueville, Alexis. *Democracy in America*. Chicago: University of Chicago Press, 2000.

Diffusion Paris – Musèes. *The Art of Cartier*. Paris: Cartier & Structures, 2002.

Eleuteri, Lodovica Rizzoli, ed. *Twentieth Century Jewelry*. Milan: Electa, 1994.

Fitzgerald, F. Scott. *A Life in Letters*. Edited by Matthew J. Bruccoli. New York: Scribner, 1994.

Fitzgerald, F. Scott. *The Short Stories of F. Scott Fitzgerald*. Edited by Matthew J. Bruccoli. New York: Scribner, 1989.

Healy, Debra and Proddow, Penny. *American Jewelry*. New York: Rizzoli, 1987.

Hemingway, Ernest. *Ernest Hemingway: Selected Letters 1917-1961*. Edited by Carlos Baker. New York: Scribner, 1981.

Loring, John. *Louis Comfort Tiffany at Tiffany & Co*. New York: Harry N. Abrams, 2002.

Loring, John. *Tiffany Jewels*. New York: Harry N. Abrams, 1999.

Meyers, Jeffrey. *Hemingway: A Biography*. Cambridge: Da Capo Press, 1999.

Papi, Stefano and Alexandra Rhodes. *Famous Jewelry Collectors*. New York: Harry Abrams, 1999.

Robinson, Roxana. *Georgia O'Keeffe: A Life*. Hanover, NH: University Press of New England, 1999.

Smith, Sally Bedell. *In All His Glory: The Life of William S. Paley*. New York: Simon & Schuster, 1990.

Snowman, Kenneth A. *The Master Jewelers*. New York: Harry N. Abrams, 1990.

Spada, James. Jackie: *Her Life in Pictures*. New York: St. Martin's Press, 2000.

Thoreau, Henry David. *Walden & Other Writings*. New York: Modern Library, 2000.

Traina, John. *Extraordinary Jewels*. New York: Doubleday, 1994.

Twain, Mark. *Library of Humor*. New York: Modern Library, 2000.

Twain, Mark. *The Unabridged Mark Twain*. Philadelphia: Running Press, 1976.

Windsor, Edward. *A King's Story: The Memoirs of the Duke of Windsor*. London: Prion Books, 1998.

PHOTOGRAPHY CREDITS

All cover and interior photographs copyright © Zane White, except for the following:

Collection of American Folk Art Museum, NYC: pp. 13–15

© David Behl: pp. 67, 84–85, 89 (bottom), 90, 93, 112 (top), 120–123

© Cartier: front cover (top left), pp. 59, 81 (left), 102, 103 (top), 104–106

© Tiffany & Co.: pp. 8, 12, 16, 18–23, 26, 38–40, 42–43, 45 (top), 52 (right), 96 (left), 103 (bottom), 117

Mary Pickford, photograph by Edward Steichen / *Vanity Fair* © 1934 Condé Nast Publications, Inc.: p. 24

Clare Booth Luce, photograph by Horst P. Horst, ca. 1938. © Condé Nast / CORBIS: p. 32

Millicent Rogers, photograph by John Rawlings / *Vogue* © 1945 Condé Nast Publications, Inc.: p. 48

Duchess of Windsor, photograph by Baron Adolphe De Meyer / *Vogue* © 1976 Condé Nast Publications, Inc.: p. 56

Countess Mona Bismarck, photograph by Horst P. Horst / *Vogue* © 1941 Condé Nast Publications, Inc.: p. 68

Barbara "Babe" Paley, photograph by Horst P. Horst, ca. 1946. © Condé Nast / CORBIS: p. 74

Georgia O'Keeffe, photograph by Cecil Beaton / *Vogue* © 1967 Condé Nast Publications, Inc.: p. 86

Loretta Young, photograph by John Rawlings, ca. 1940. © Condé Nast / CORBIS: p. 100

Joan Crawford, Guy Lombardo (left) and Franchot Tone (right), photograph December 29, 1933. © Bettmann / CORBIS: p. 108

Grace Kelly, photograph by Howell Conant / *Vogue* © 1956 Condé Nast Publications, Inc.: p. 114

Jackie Kennedy Onassis, photograph August 26, 1977. © Bettmann / CORBIS: p. 118

Other Titles by
Judith Price
You May Enjoy

Masterpieces of Ancient Jewelry

In *Masterpieces of Ancient Jewelry,* author Judith Price showcases the largest collection of ancient jeweled objects ever assembled. Stunning photography and captions on every page reveal the history behind jeweled armor, weapons, jewelry, household objects and more, and the ancient Near East civilizations where they originated.

HARDCOVER ISBN 978-1-63561-034-5
PAPERBACK ISBN 978-1-63561-035-2

Masterpieces of Twentieth Century French Jewelry from American Collections

Featuring more than 80 stunning photographs, *Masterpieces of French Jewelry* offers a fascinating look at the twentieth century jewelry that became a symbol of status in a changing nation. With a focus on pieces acquired by notable Americans, this book explores French jewelry of the Victorian Era, up through the 1960s and more contemporary styles.

HARDCOVER ISBN 978-1-63561-036-9

Our books may be ordered from any bookstore or online purveyor of books, or directly through our Web site, www.echopointbooks.com. Or visit our retail store, located in Brattleboro, Vermont.

www.ingramcontent.com/pod-product-compliance
Lightning Source LLC
Chambersburg PA
CBHW061226150426
42812CB00054BA/2532